THE DUNK BOOK

Nike SB: The Dunk Book
Copyright © 2018, Introduction by Sandy Bodecker.

For Rizzoli:
Editor: Ian Luna
Project Editor: Meaghan McGovern
Production: Maria Pia Gramaglia
Production Coordination: Kayleigh Jankowski
Proofreader: Mary Ellen Wilson

Publisher: Charles Miers

Book Design: Nike SB Design Studio
Printed in Italy
2018 2019 2020 2021 2022 / 10 9 8 7 6 5 4 3 2 1
ISBN: 978-0-8478-6669-4
Deluxe Edition: 978-0-8478-6485-0
Library of Congress Control Number: 2018954408

THE DUNK BOOK

New York · Paris · London · Milan

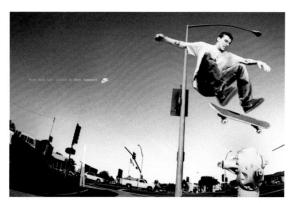

Nike Dunk Low. Colors by Eric Koston.

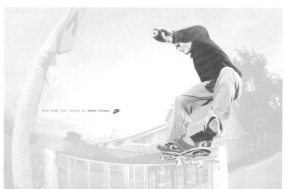

Nike Dunk Low. Colors by Reese Forbes.

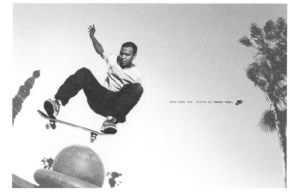

Nike Dunk Low. Colors by Danny Supa.

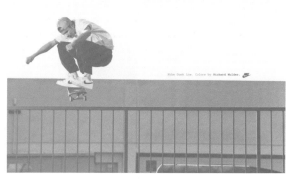

Nike Dunk Low. Colors by Richard Mulder.

DEAR SB DUNK

I was humbled—and a bit nervous—when asked to write the opening to your Biography. You come from a great family tree, sharing heritage with the AJ1, but you've carved out your own legendary place in sneaker history over all these years.

From the very beginning, you've been a unique blend of performance and style. I remember like it was yesterday when you showed up with college colors on the hardwood of the best colleges in the country—one of the first of many times you changed the game while still remaining democratic and adaptable.

Skaters found you early and have been loyal fans since day one. From the first chapter with Reese, Gino, Danny and Richard right through to today, you've been a foundational voice for skateboarding and youth culture. You've stayed true to your roots but evolved with the times, learning from the feet you grace and the boards you ride, always getting better with age.

I have great memories of working with you and all the great SB skaters and so many awesome creatives, with a special call-out for Lewis Marnell RIP, on creating great stories, memories and connections.

If sneakers could talk, I can only imagine the stories you could tell. You've given generations of skaters, artists, musicians, and collectors a blank canvas to tell their stories, while continually fueling the debate between Ride/ Collect. (I was always on the ride side.)

I know I speak on behalf of your millions of fans in saying that our lives have been enriched and inspired by what you've contributed to skate and popular culture. We all look forward to many more great stories and journeys in the future.

Much Love & Respect
Sandy Bodecker

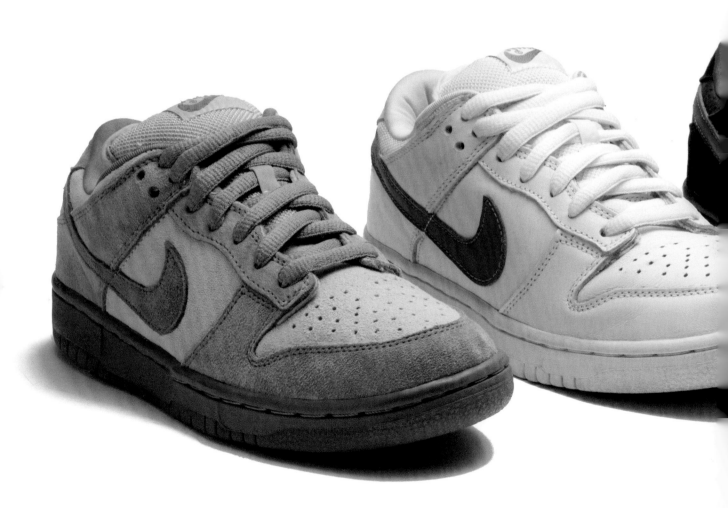

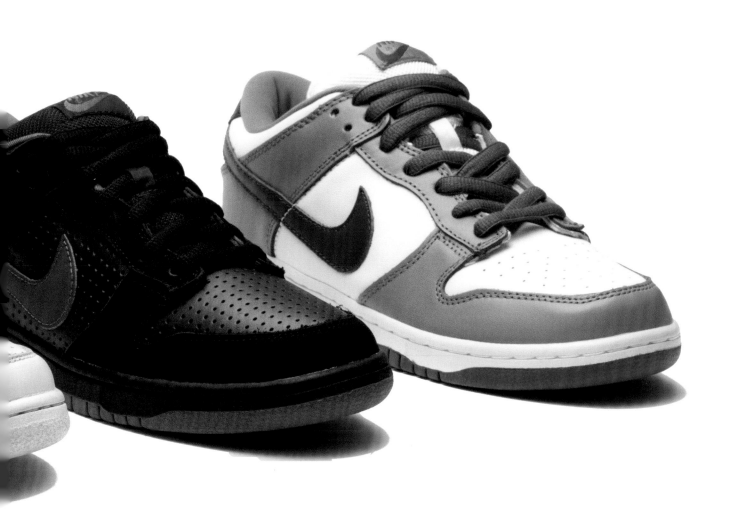

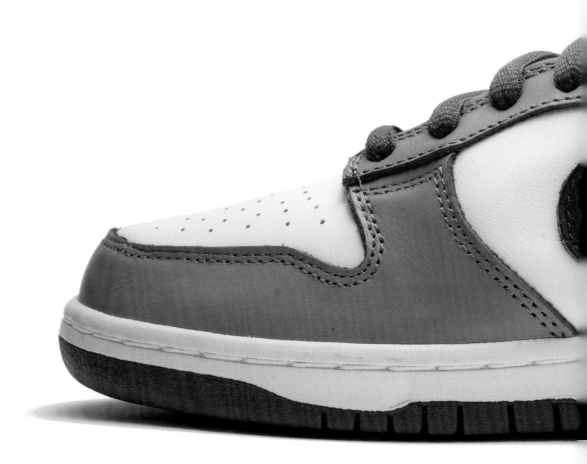

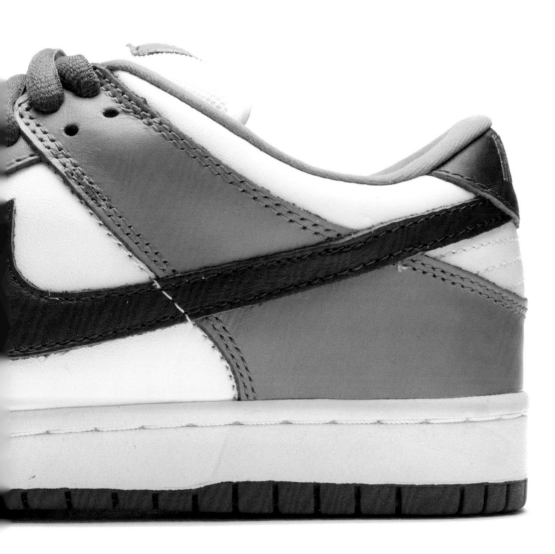

SAFETY ORANGE/HYPER BLUE-WHITE DANNY SUPASIRIRAT

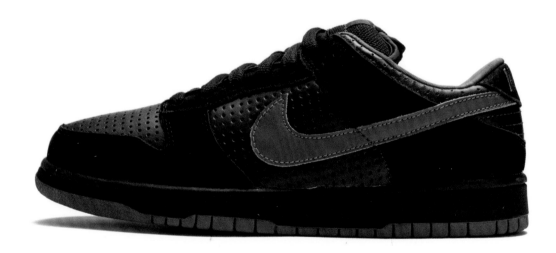

2002 OBSIDIAN/LIGHT GRAPHITE-BLACK GINO IANNUCCI

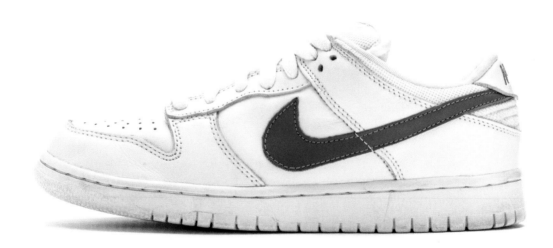

WHITE/ORION BLUE-WHITE RICHARD MULDER

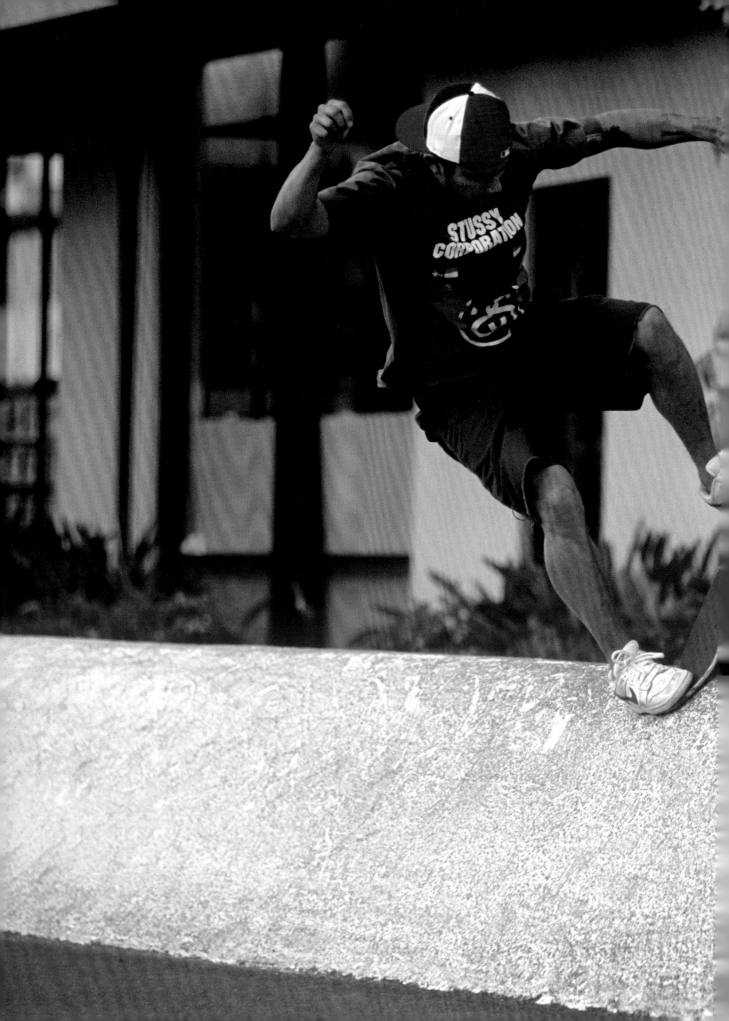

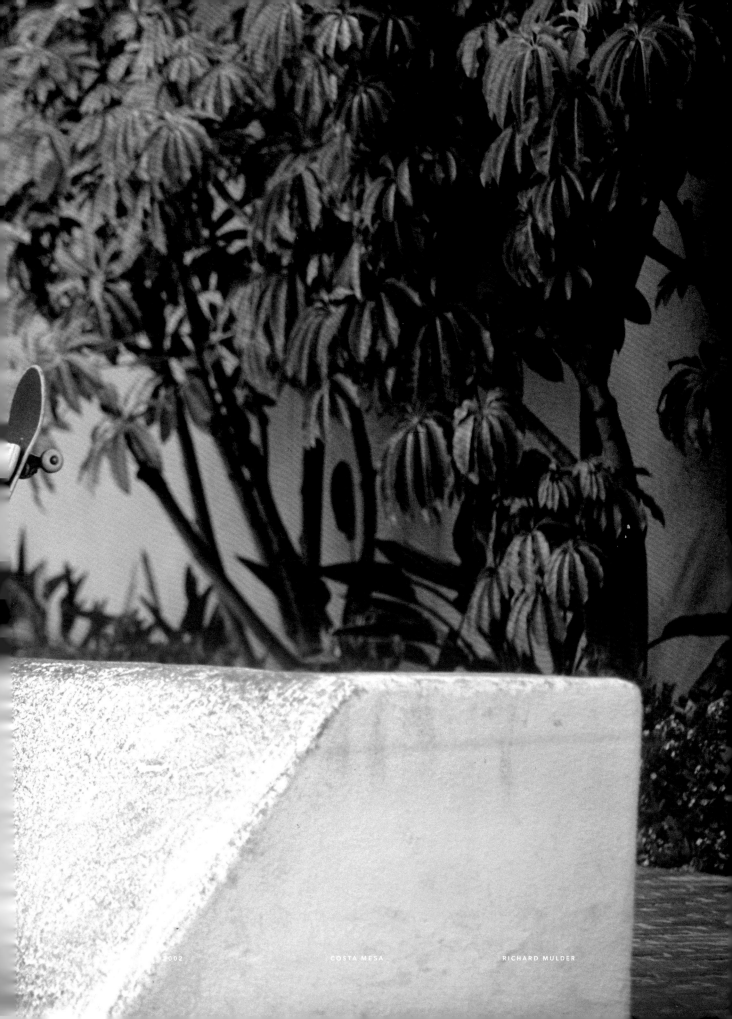

2002 COSTA MESA RICHARD MULDER

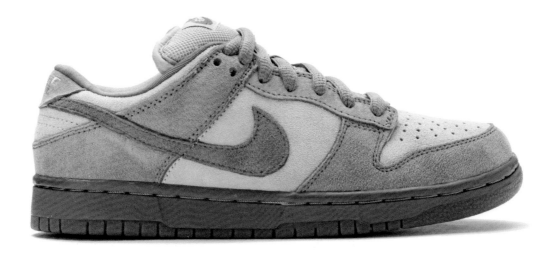

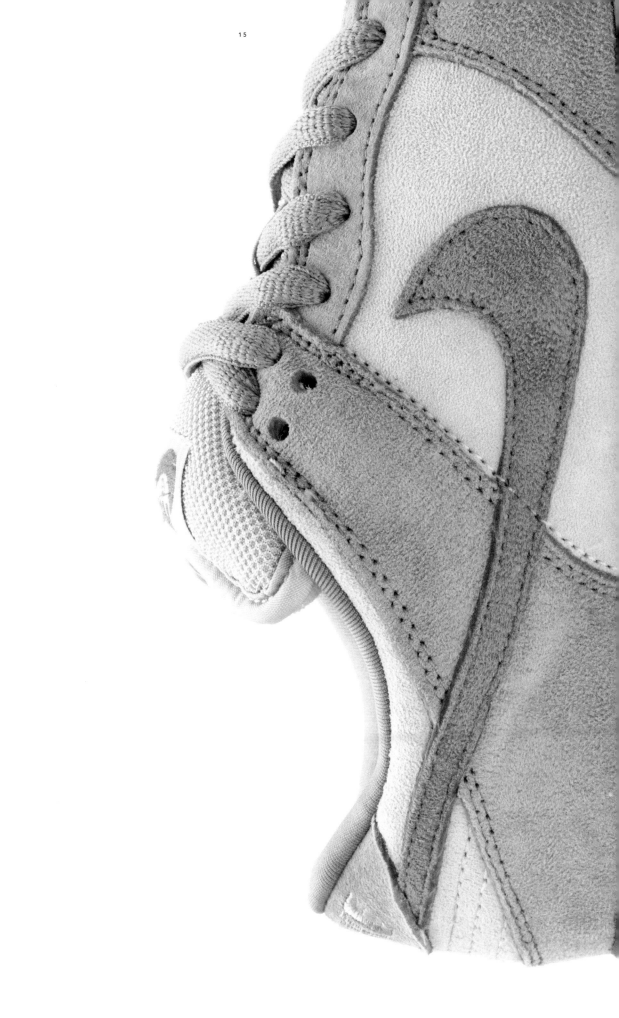

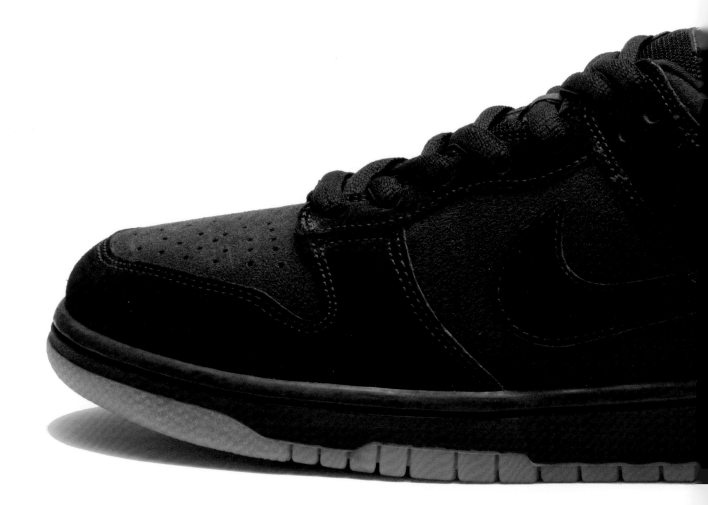

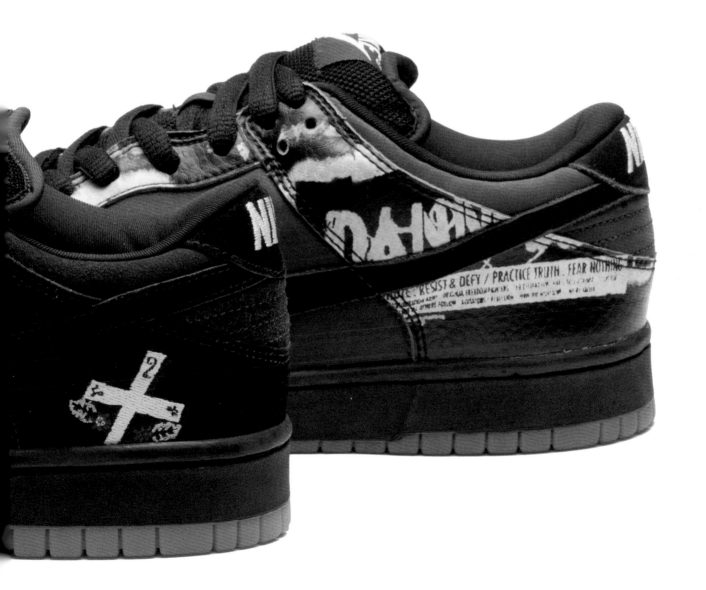

>18

SUPA DUNK

I was sort of apprehensive about the launch of Nike SB, like, "Oh here we go again." But I thought it was strategically smart and semiotically ingenious to go back to something that was classic and say, "look we've been here in the past and people have been wearing Nike shoes since the beginning." There's pictures of dudes skating Upland and Del Mar in Blazers.

Danny Supa said that Nike was gonna be behind it 100 percent and was really in support of it. Plus they wanted to do custom one-off versions of these Dunks, so I was like, "Okay!" I was very excited to get to make a pair of Dunks. That was sort of the beginning of all these limited edition drops and all this other craze that kind of evolved out of that.

Eli Gesner

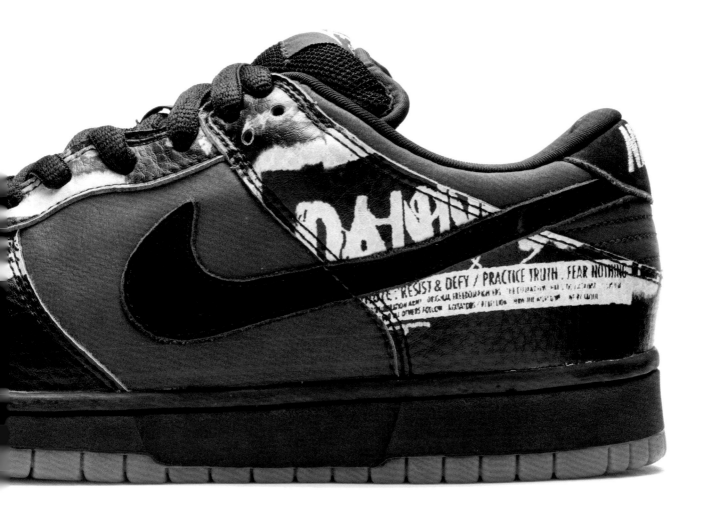

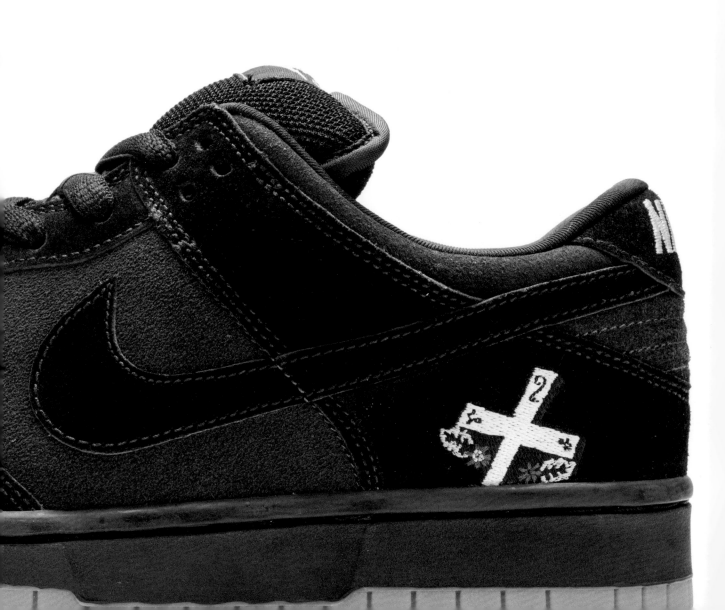

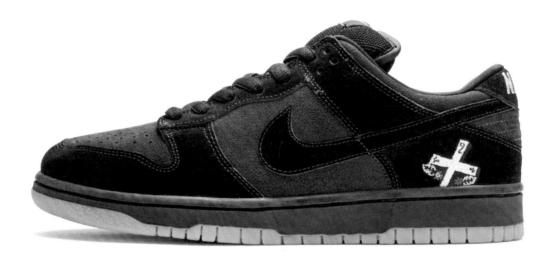

2002 ANTHRACITE/BLACK CHOCOLATE

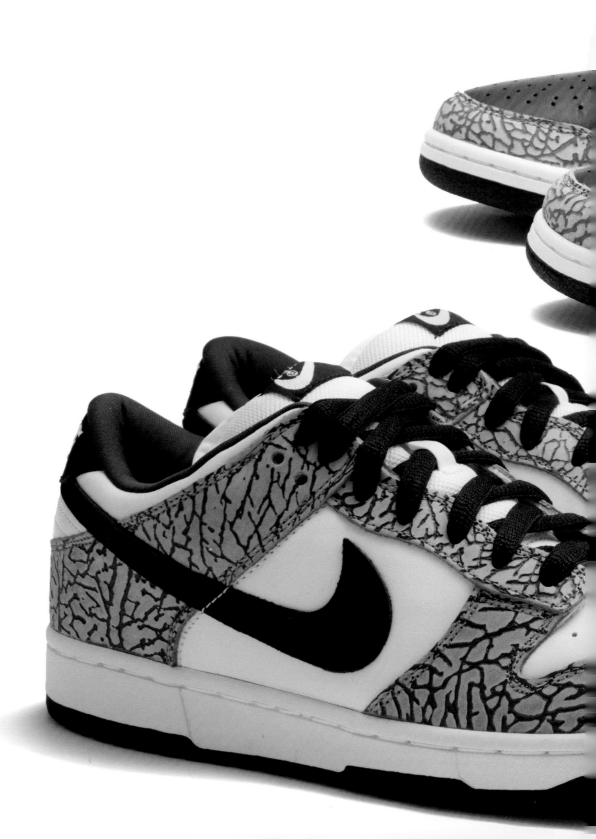

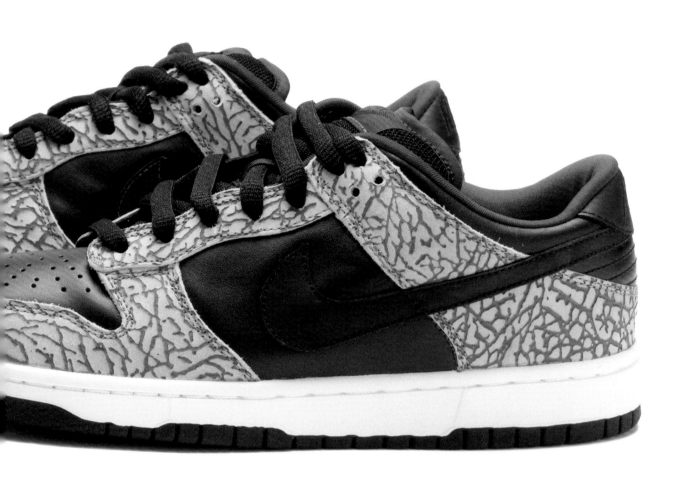

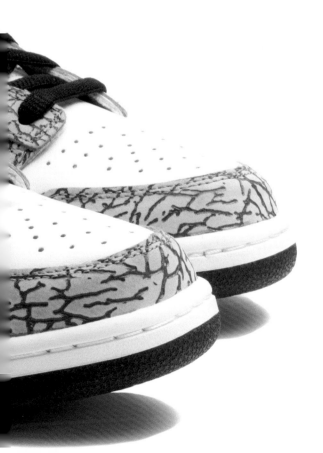

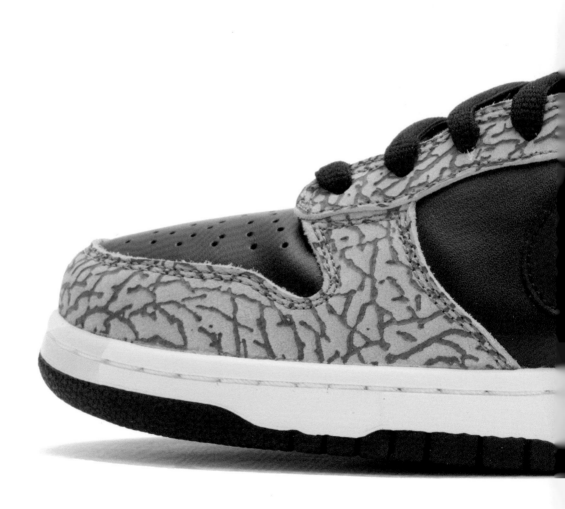

SUPREME X NIKE SB

When SB started, my favorites were the Supreme ones because of the elephant print. I saw Reese Forbes in a pair of them. He was skating in them—I forgot where we were, in Europe or somewhere—and I was like, "Whoa, they put elephant print on a Dunk, like, damn, that's really sick."

Eric Koston

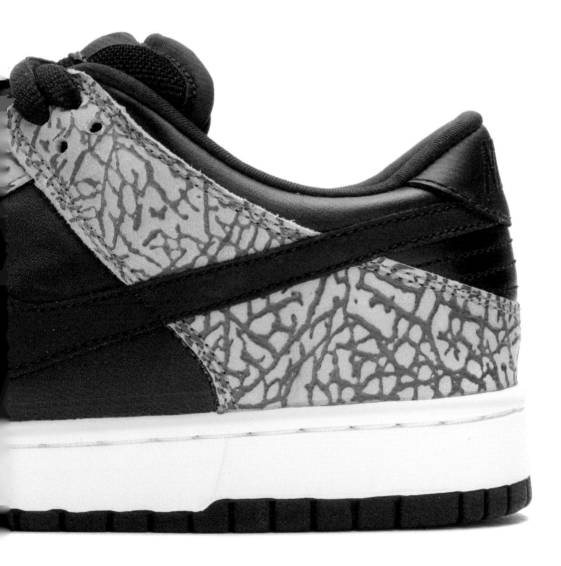

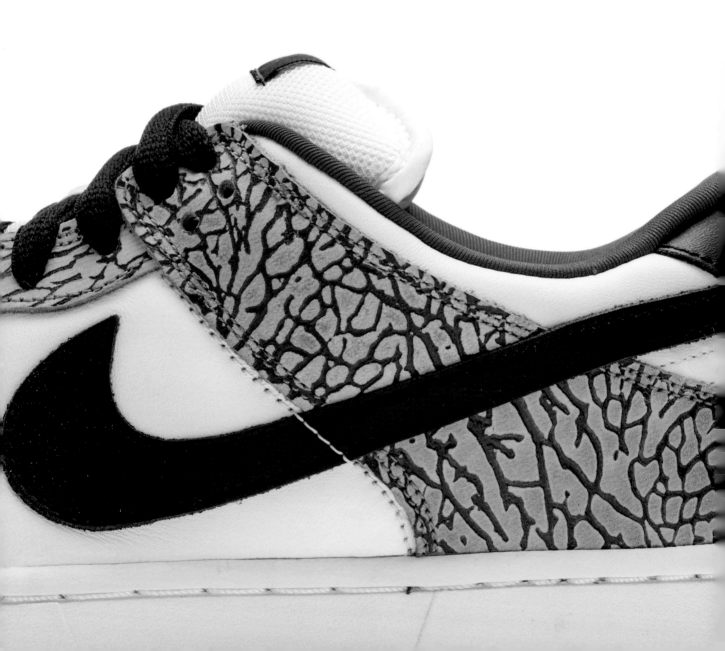

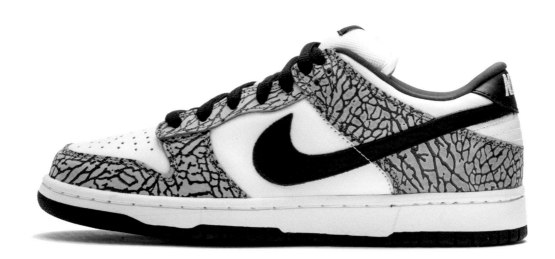

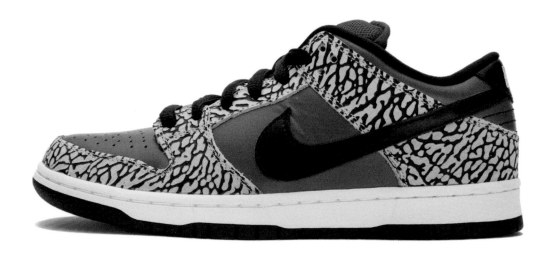

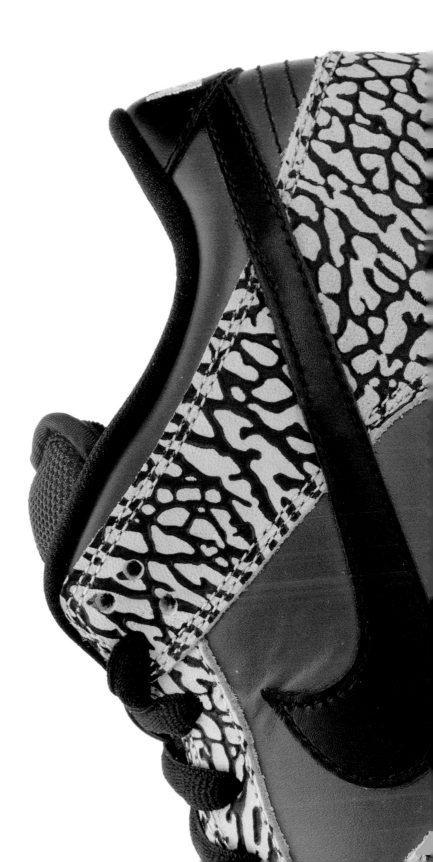

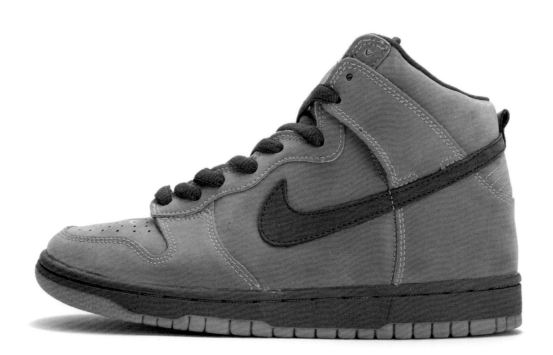

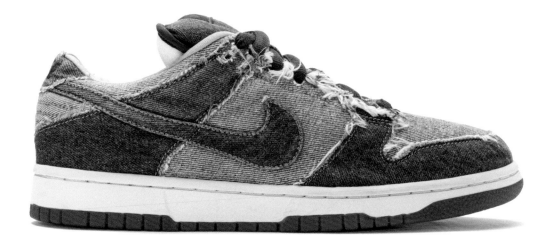

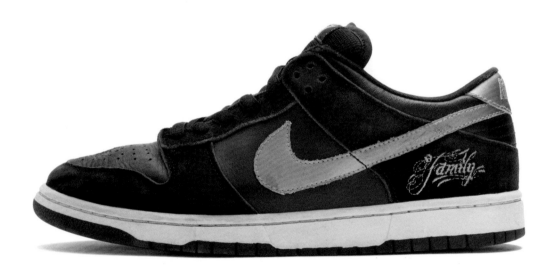

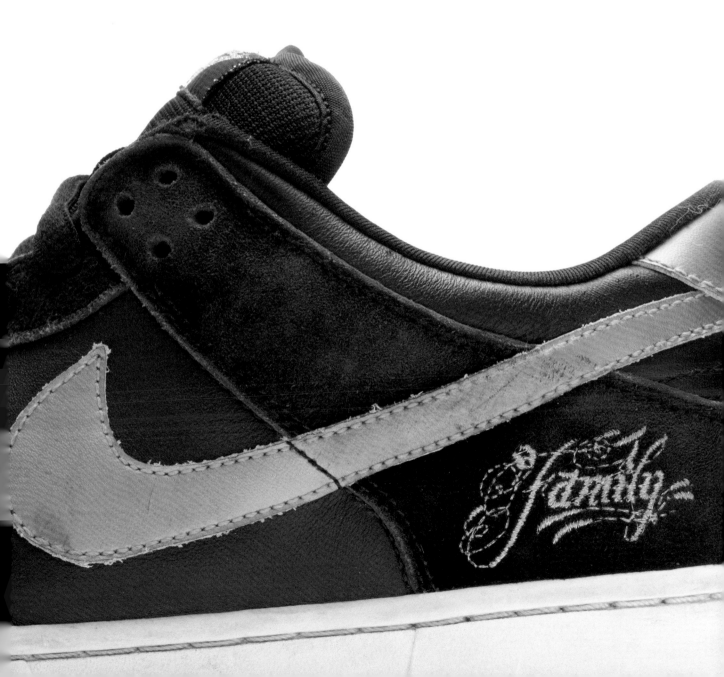

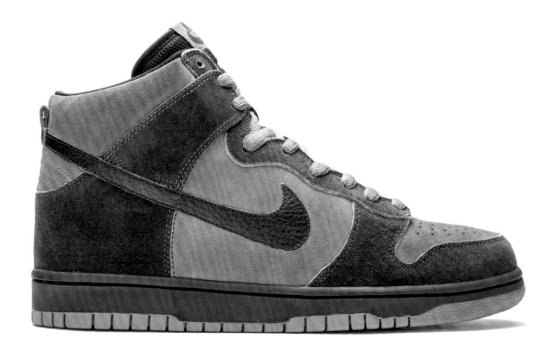

2005 CAMPER GREEN/BLACK-DEEP FOREST TODD JORDAN

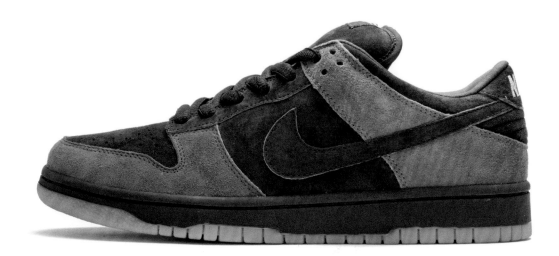

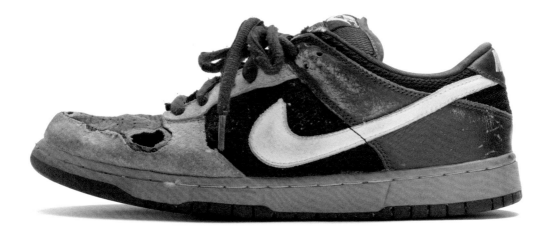

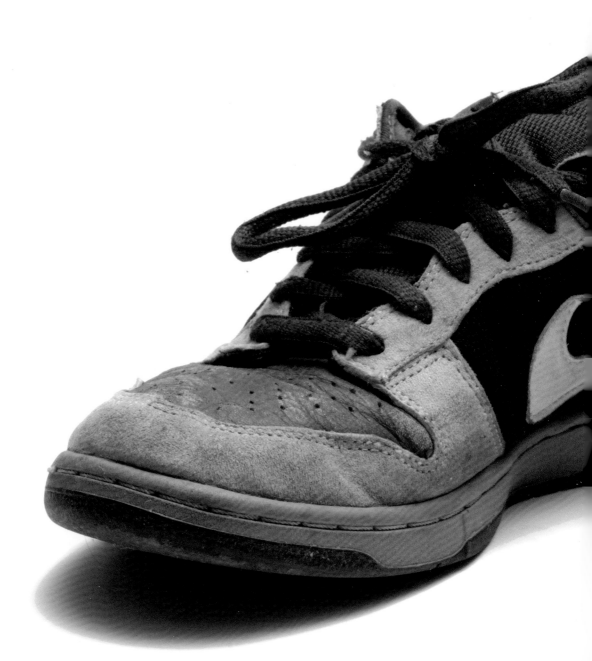

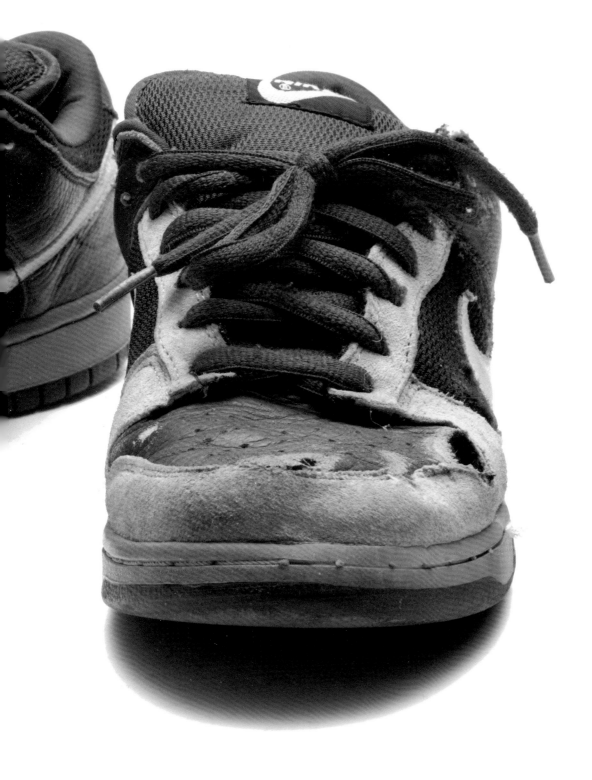

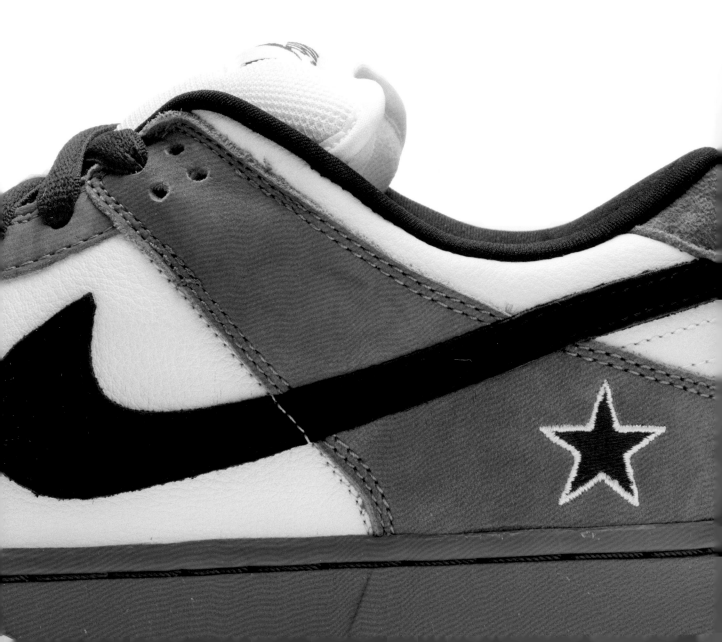

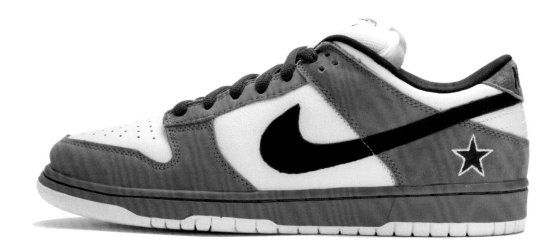

2003 CLASSIC GREEN/BLACK-WHITE-RED DUNK LOW PRO SB

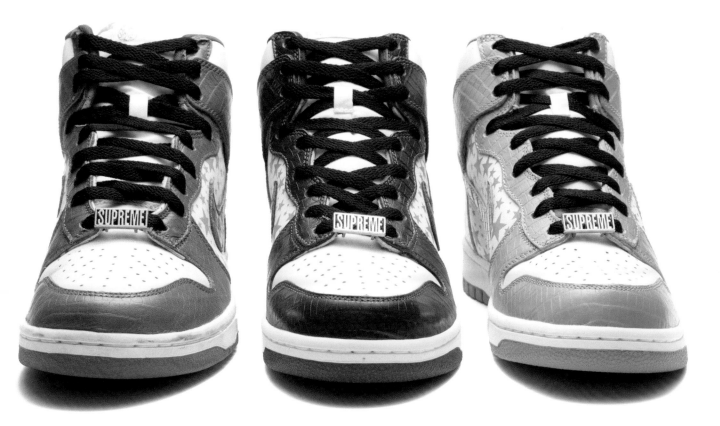

SUPREME

Right when I got on Nike SB I was only skating Dunks for that whole six months to a year before my shoe came up. The first pair I skated was the Supreme Dunks. They were orange with gold stars on the sides of the panels. I didn't know any better at that point, man. I literally didn't. Especially because I didn't even know the significance of Supreme at that point. You gotta understand, up until Nike, even still when I was on Nike, I lived in a cave. I lived in a box of skateboarding and that's it.

People are sneakerheads, I'm a skatehead. That's all I thought about, think about, do. I don't even know that another world exists about anything. I'm literally only looking at Koston, Tom Penny, Andrew Reynolds videos over and over and over and over. And going out and skating. When they send me the box, I'm like, "Oh these are a cool design." Not knowing shit about them. Just putting them on, thinking: "Alright, guess I'll skate them. Alright, it's gonna be my first ad. Let's go skate." Boom.

Paul Rodriguez

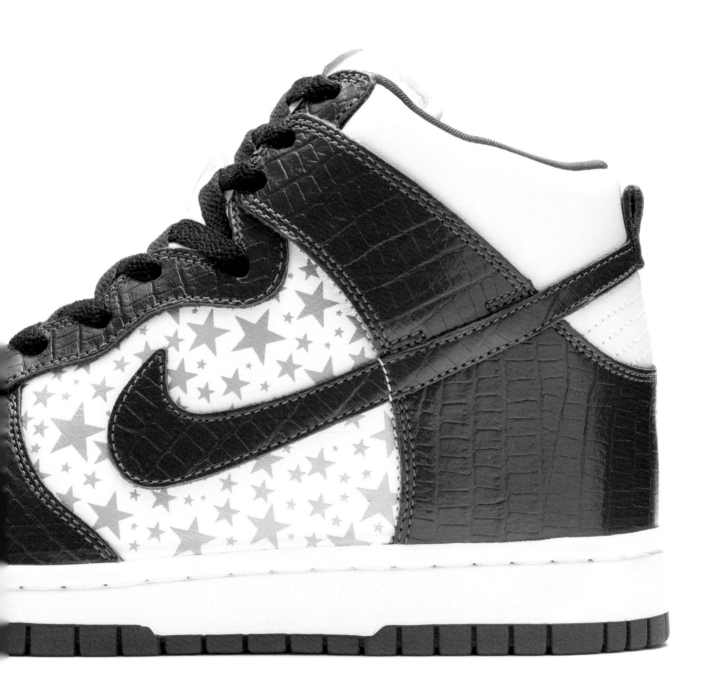

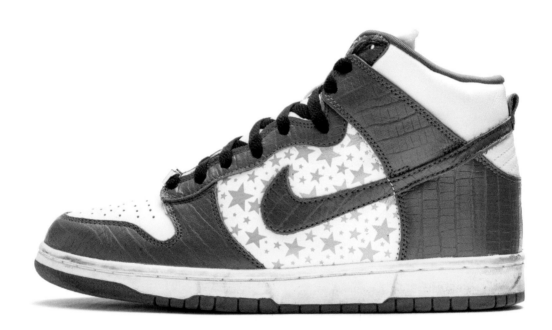

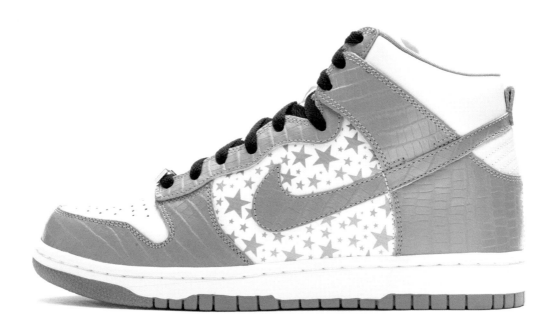

RICHARD MULDER

PALM SPRINGS

2003

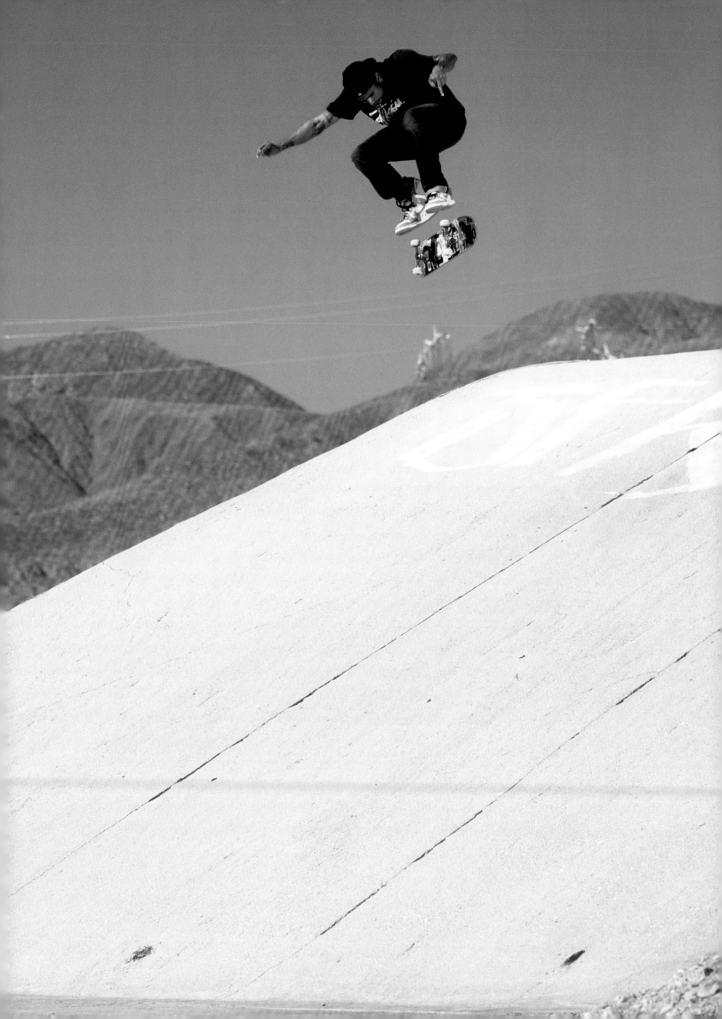

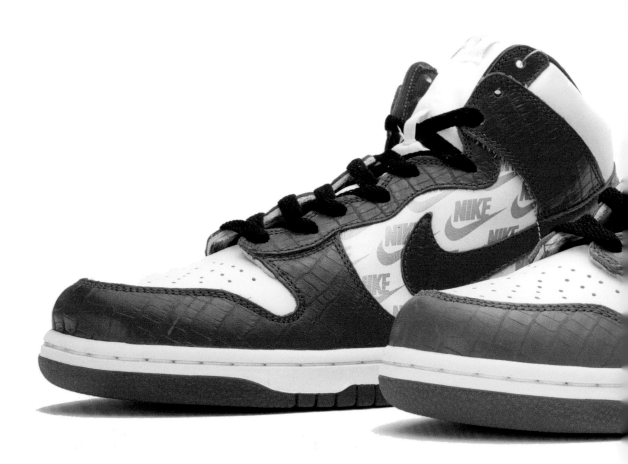

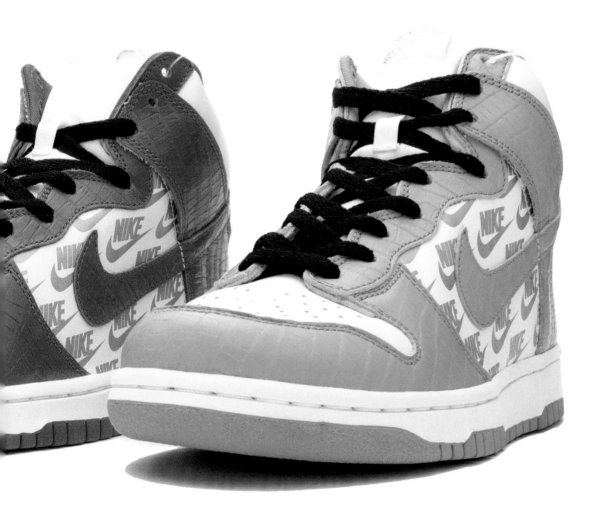

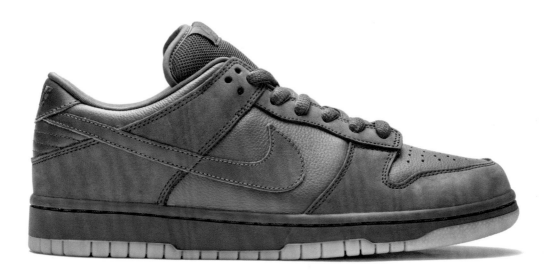

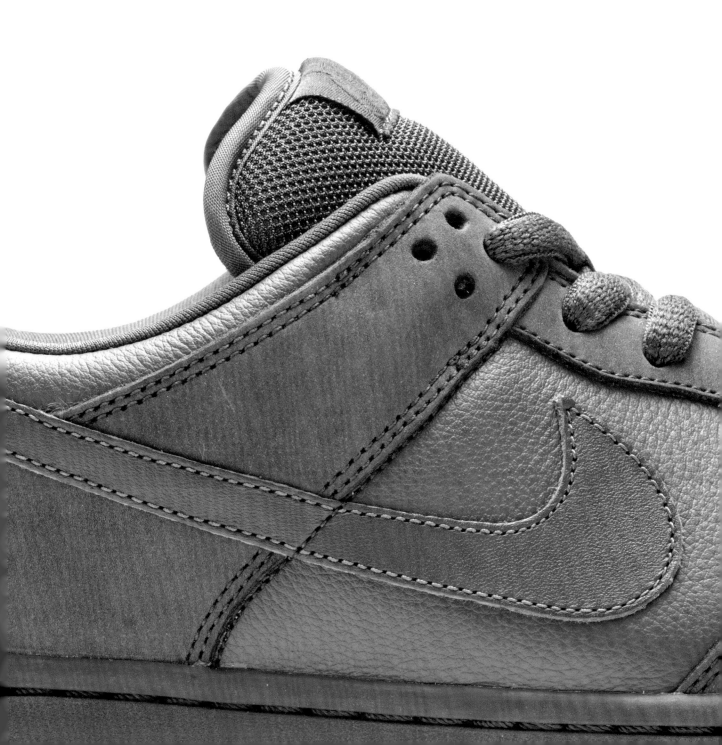

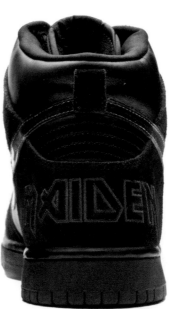

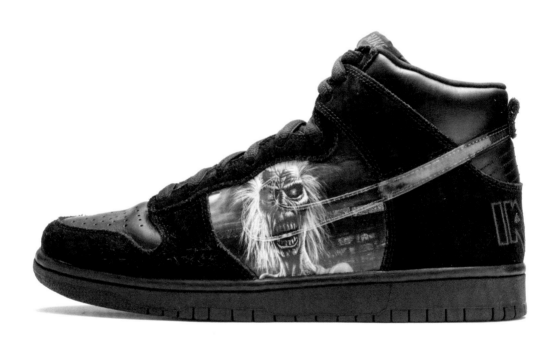

PROMO ONLY IRON MAIDEN

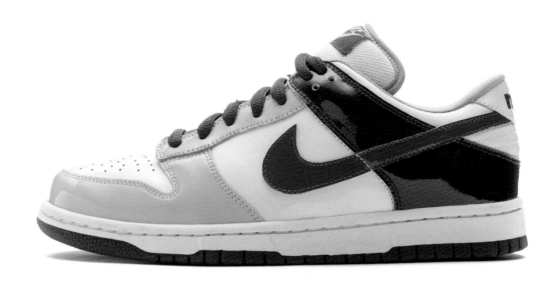

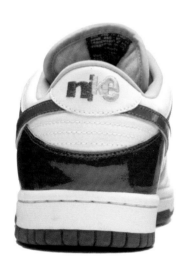
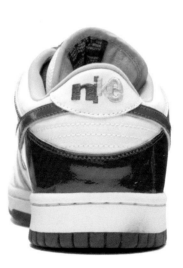

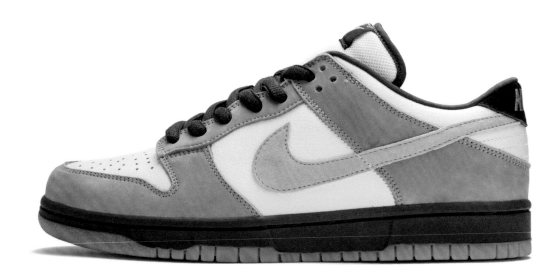

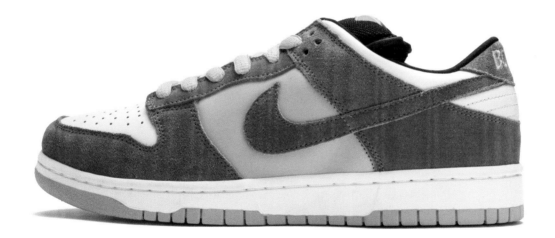

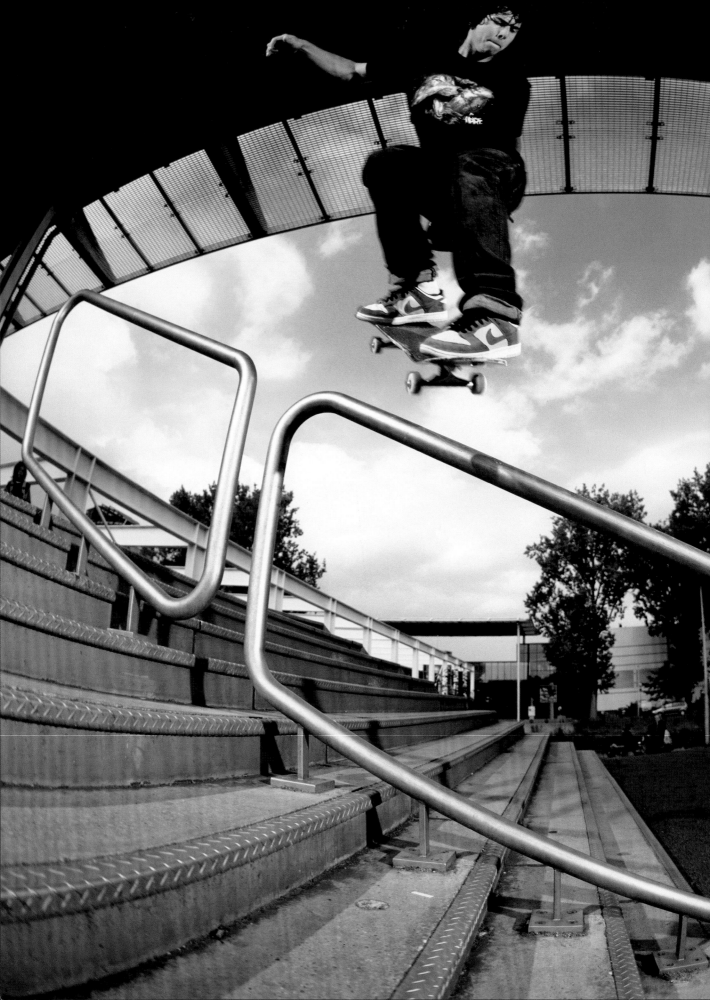

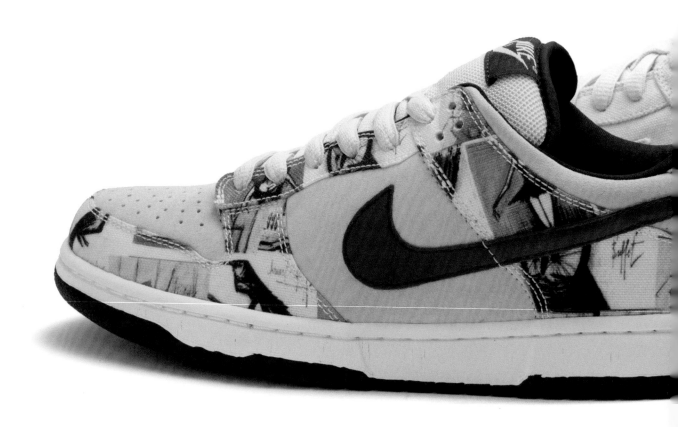

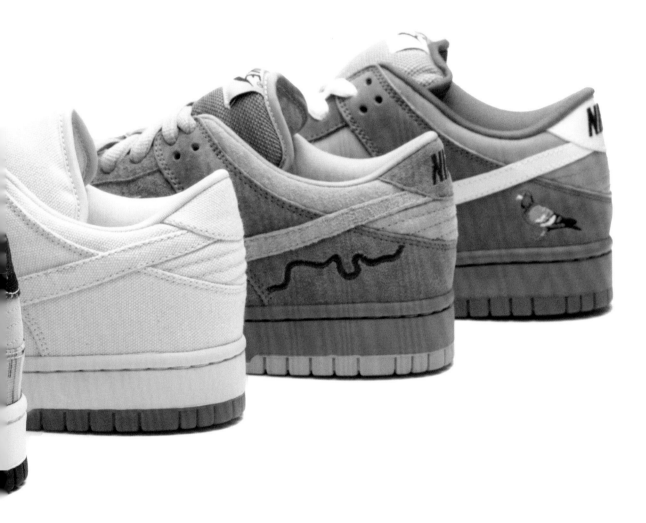

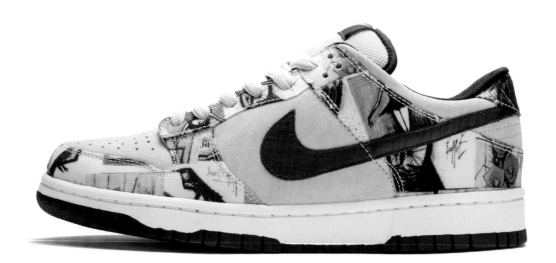

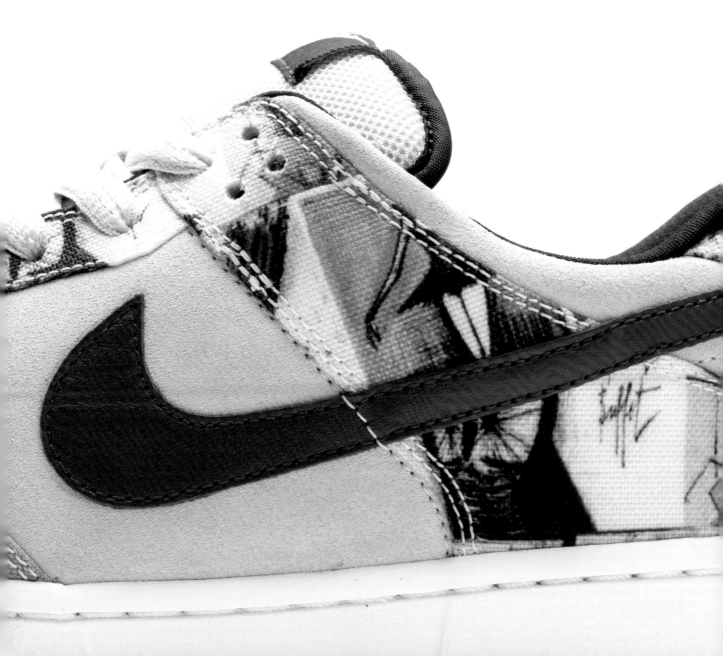

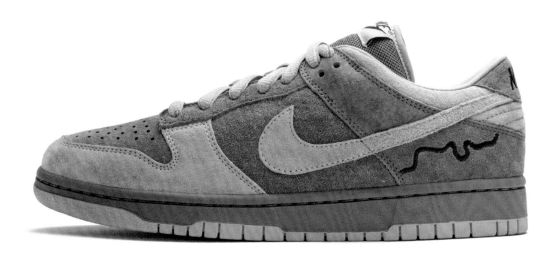

PIGEON

At the time, I had me and like, four interns, a couple of de-
signers helping out with the graphics. When I briefed them,
I said, "We have the opportunity to do a Dunk. It could be
anything we want. Let's think about something." So we were
like: "Oh my god, New York City Dunk. Statue of Liberty Dunk.
Taxicab Dunk. Subway Dunk." All these different things. Then
we were like, "Wait, what about this pigeon that we were
thinking about?" So we went with the Pigeon Dunk design,
mocked it up in Illustrator, sent it to Marcus, briefed him on
the idea, and Marcus is very trustworthy if he likes your vibe.
So he's like, "I don't really get it, but go for it." We didn't even
get a sample. He sent a photo of the sample, and it's funny
because all he did was put the shoe on a sofa and he took a
picture of it, and he's like, "Can we approve this?" I'm just like,
"What?" He's like, "We got to approve it." I was like, "Okay
then, it's approved."

Jeff Staple

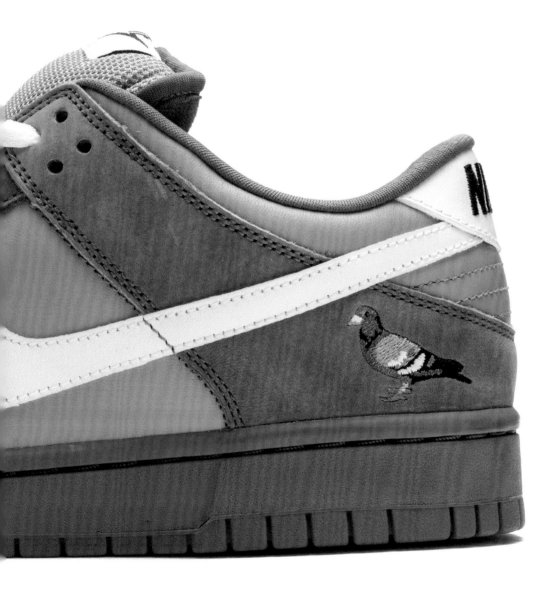

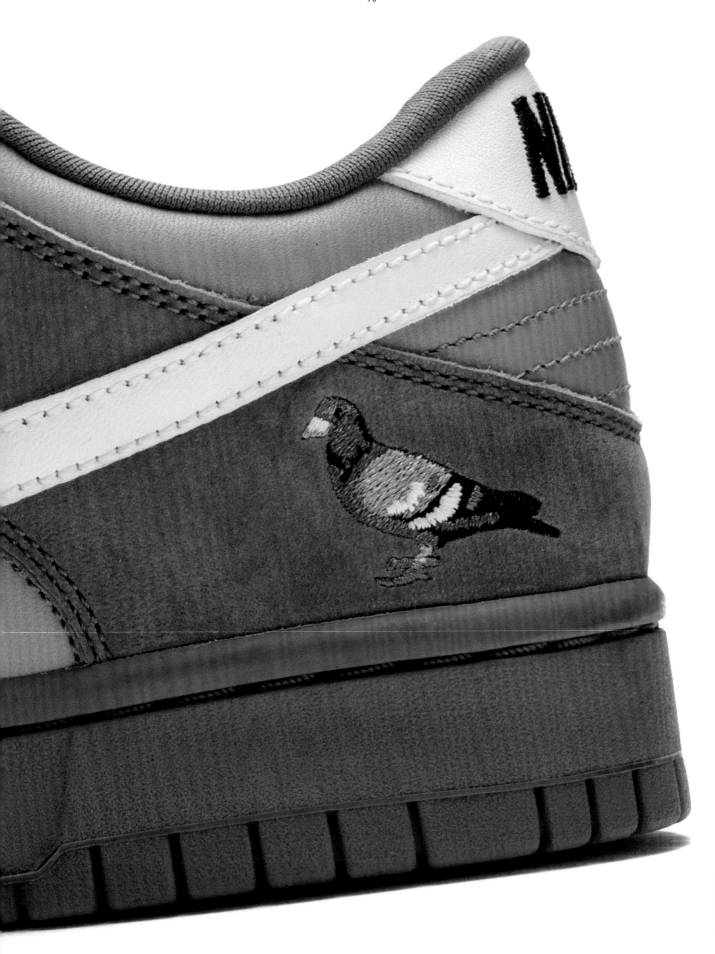

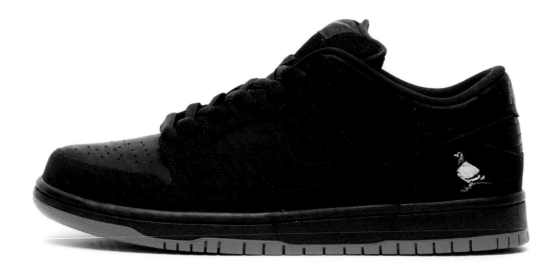

2017 BLACK, SIENNA-BLACK PIGEON II

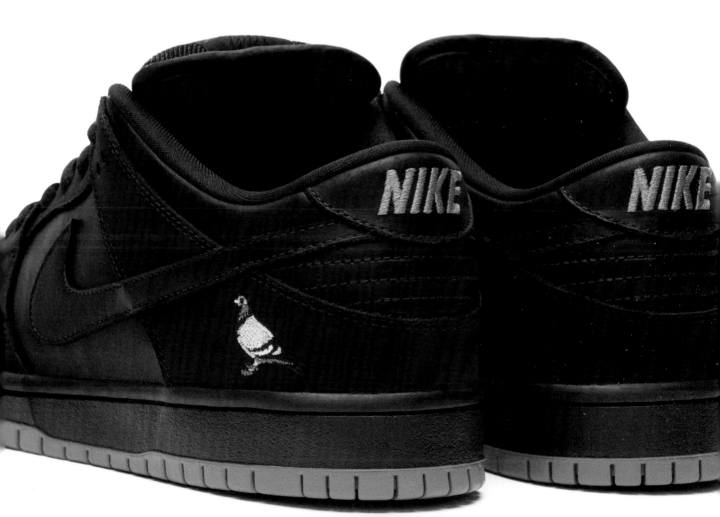

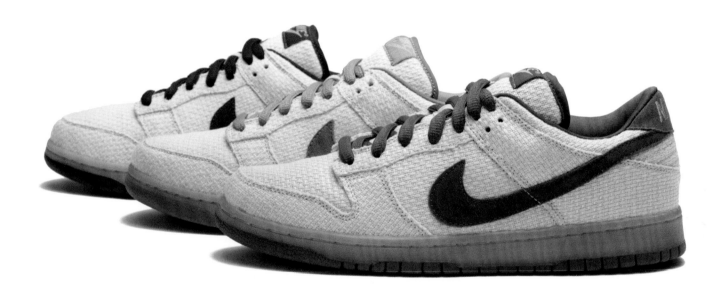

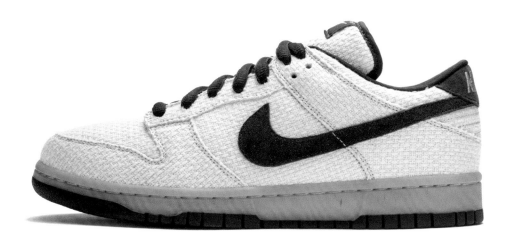

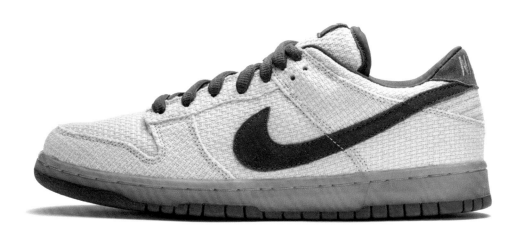

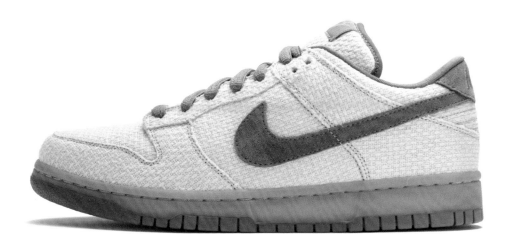

FOR LOVE OR MONEY

Mark Parker was very generous in offering me a shoe for my store that was opening in Fukuoka, Japan—Futura Laboratories—in 2004. And that's when I did the FLOM, the For Love or Money shoe. They sent me 24 pairs. It was for friends and family, and people that came out to Japan. I invited a lot of friends to come out and if they came to Japan, I would host them and hook them up with a pair of shoes.

I don't really know how I came to decide, "oh yeah, this is what I want to do on the shoe," but it was kind of a statement about the nature of the community at the time. FLOM was an acronym "For Love or Money," and it was a bit of a question to the community at the time: are you involved in everything you're doing because you're passionate? Or is it the beginning of people profiting in secondary markets?

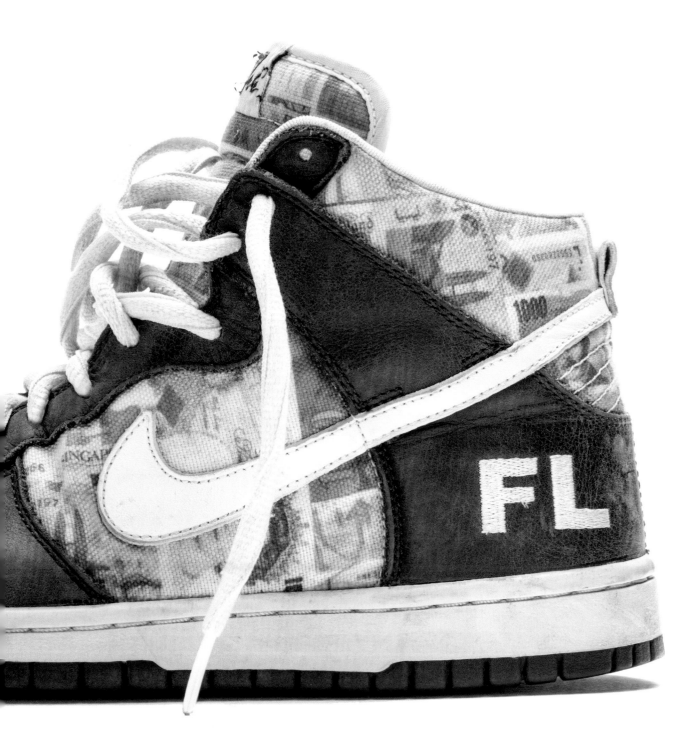

So, it was a kind of a, not a knock, but a subtle kind of question. And a lot of people got the acronym wrong over time. People write, FLOM, For Love OF Money. And that's completely wrong because "of money" changes it completely. If it's "or," then it's an option, if it's "of," then it's all about the money. So what I was trying to do was just throw a little jab at what was in the emerging sneaker culture. Since it was a giveaway, I felt like I could have a little more of a personal statement attached to it. Not like anybody really, really got it. I think people just saw the shoe, and were like, "Oh, shit, that's amazing. I just want that shoe."

I look back now and I'm super proud of the shoes I've worked on, and yeah, I think FLOM stands out as a unique kind of interesting shoe. Just given the whole thing around it, the limited-ness, and the special nature of it as a gift from my shop. I think that was just awesome.

Futura

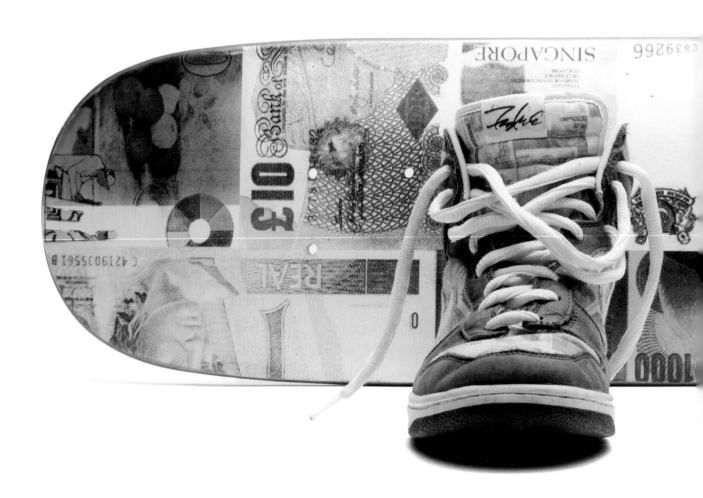

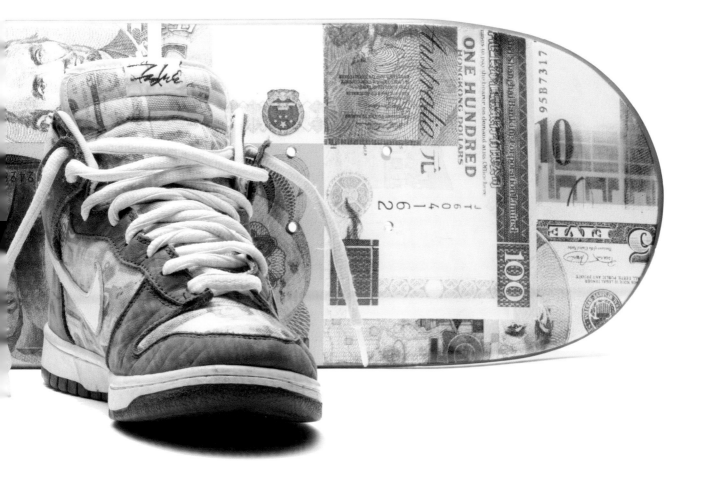

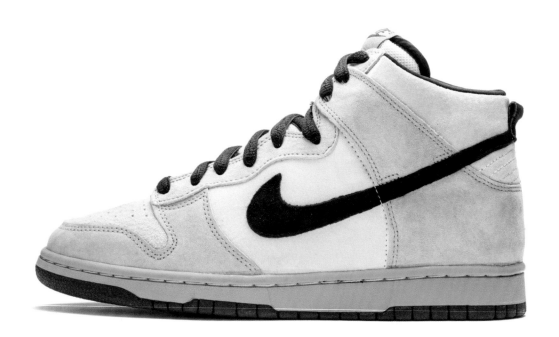

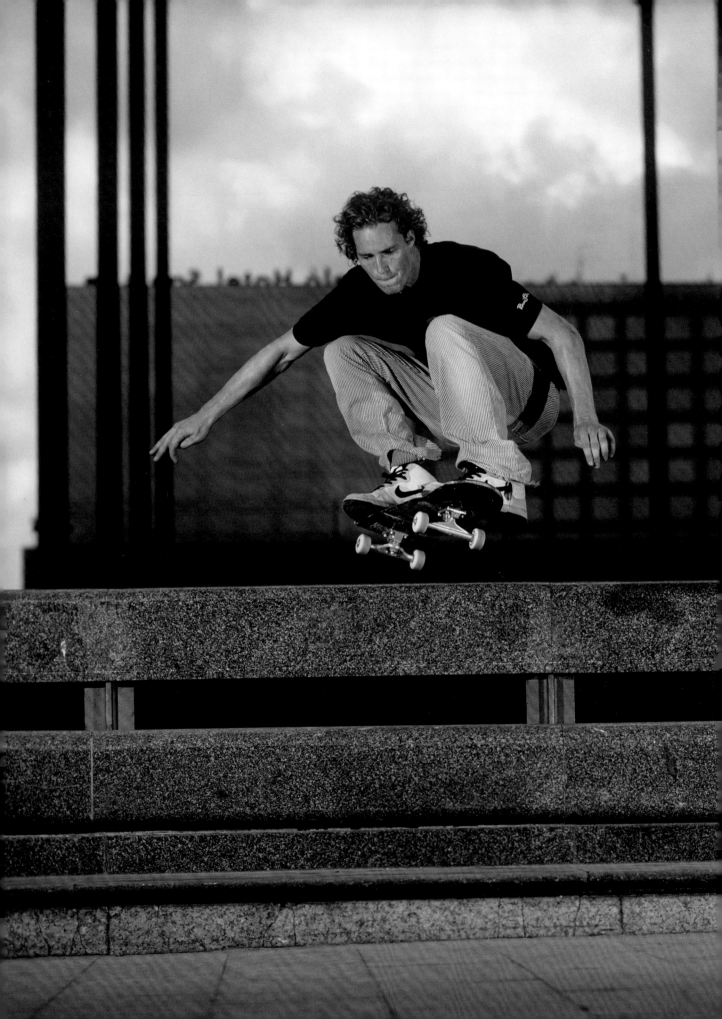

2004

BARCELONA

REESE FORBES

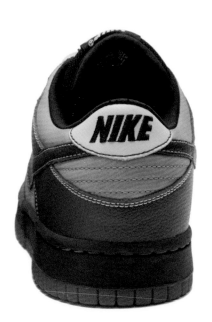

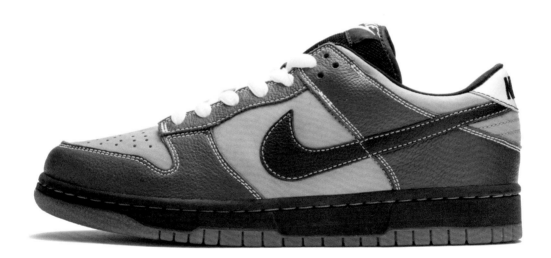

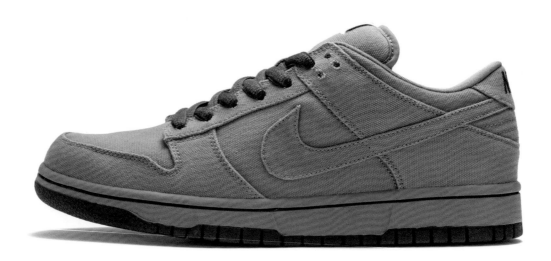

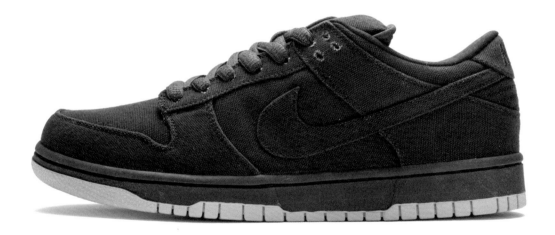

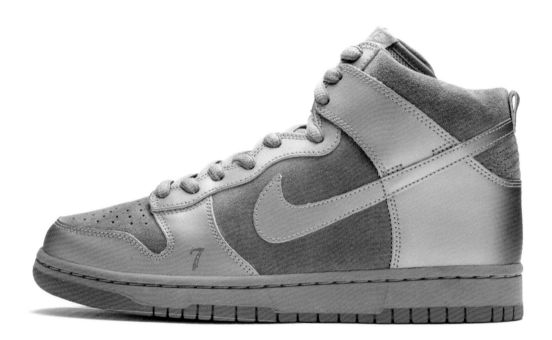

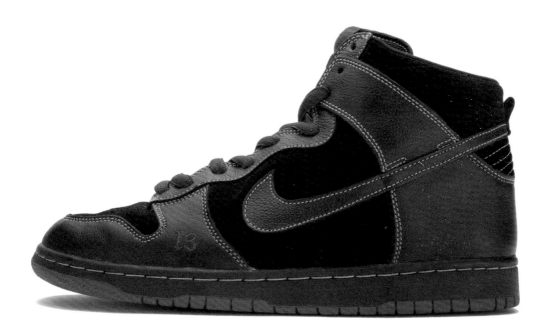

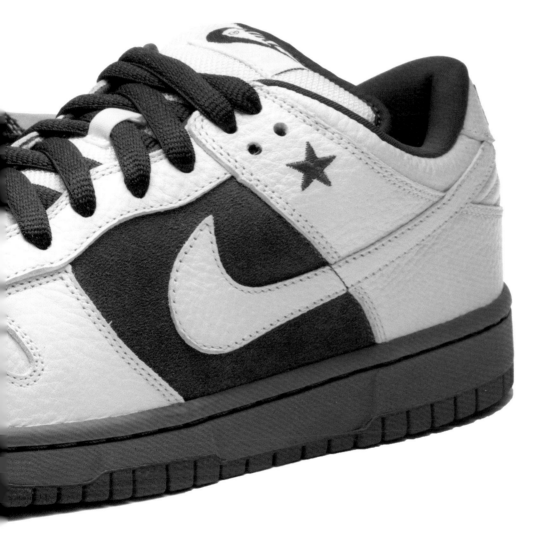

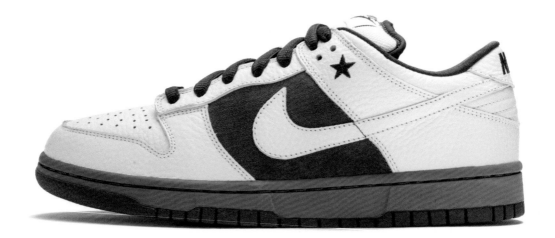

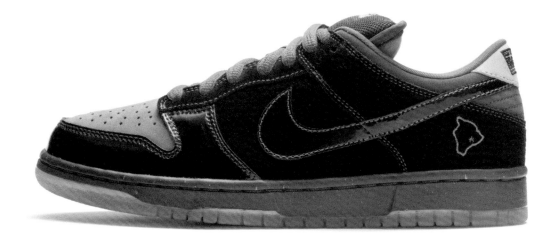

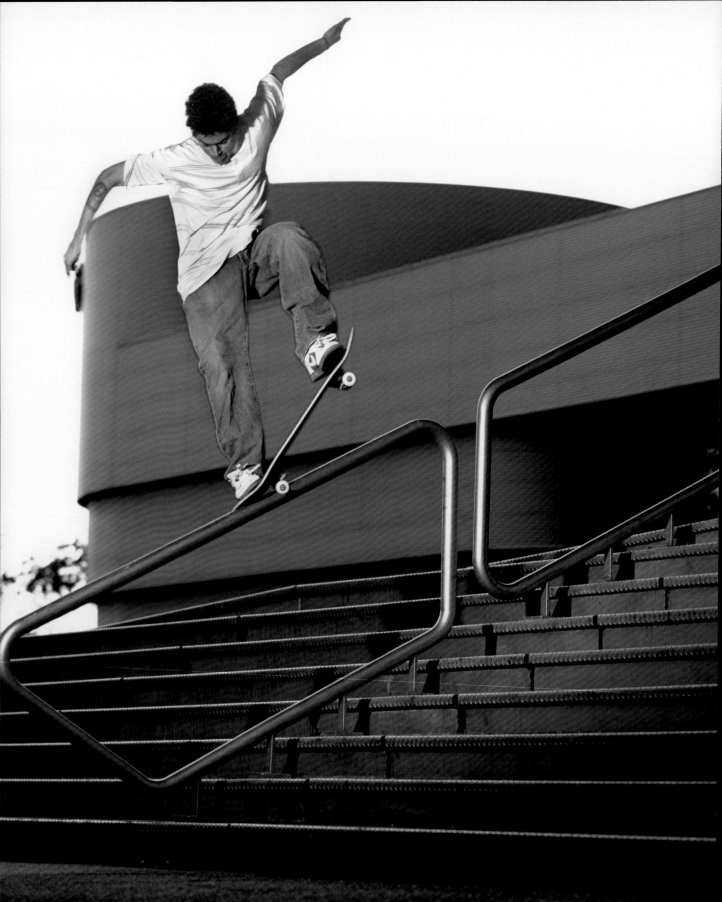

2005

UTRECHT

PAUL RODRIGUEZ

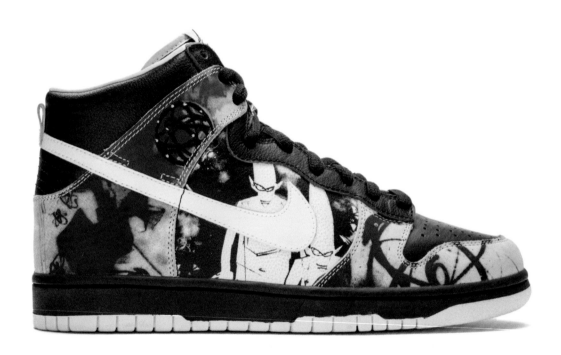

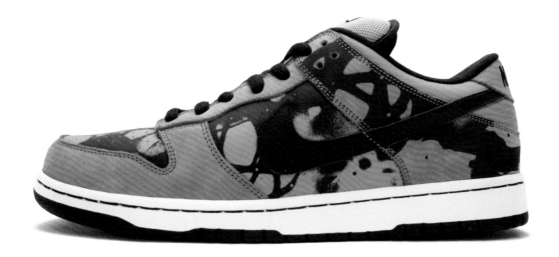

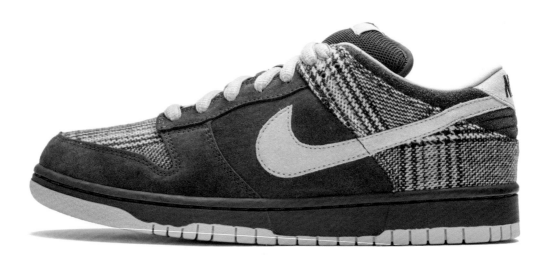

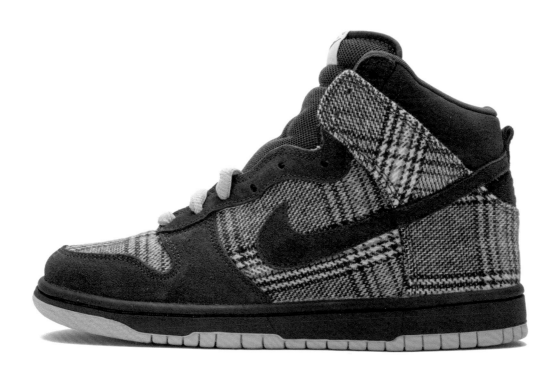

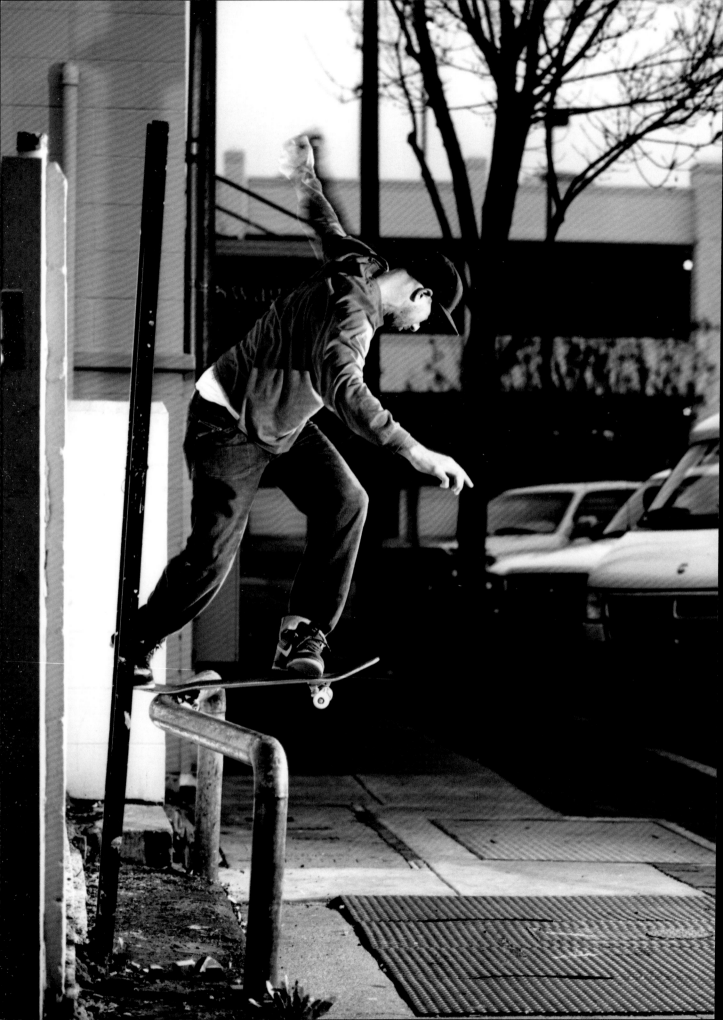

2006

CONCORD

BRIAN ANDERSON

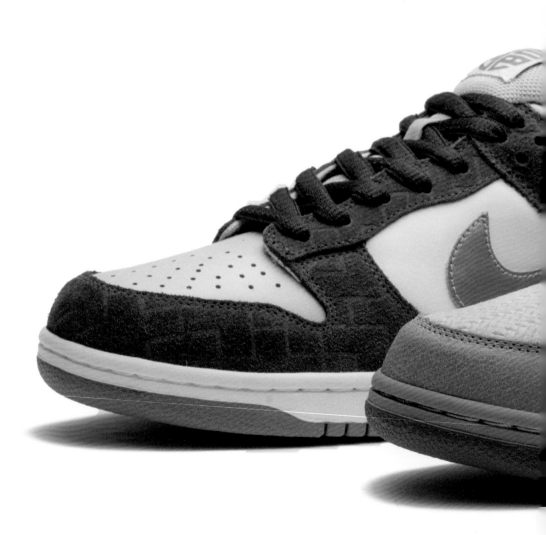

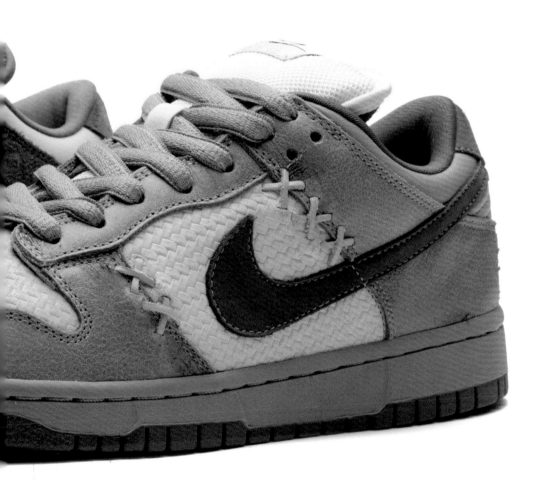

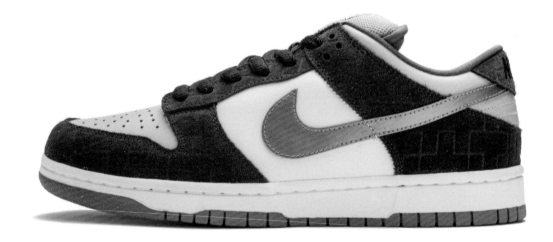

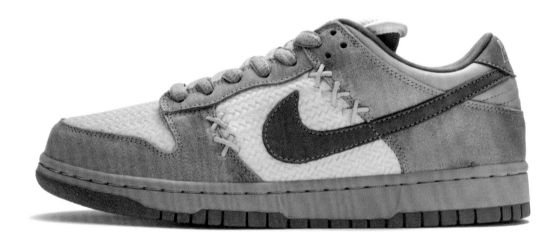

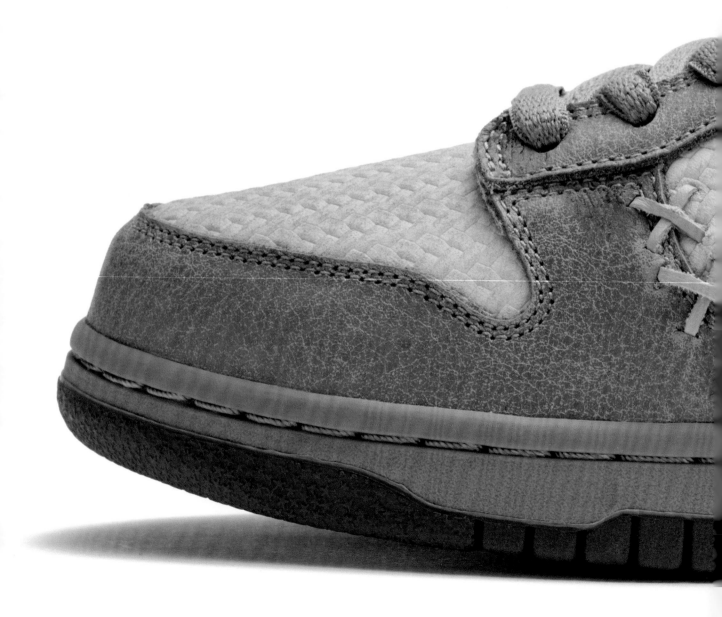

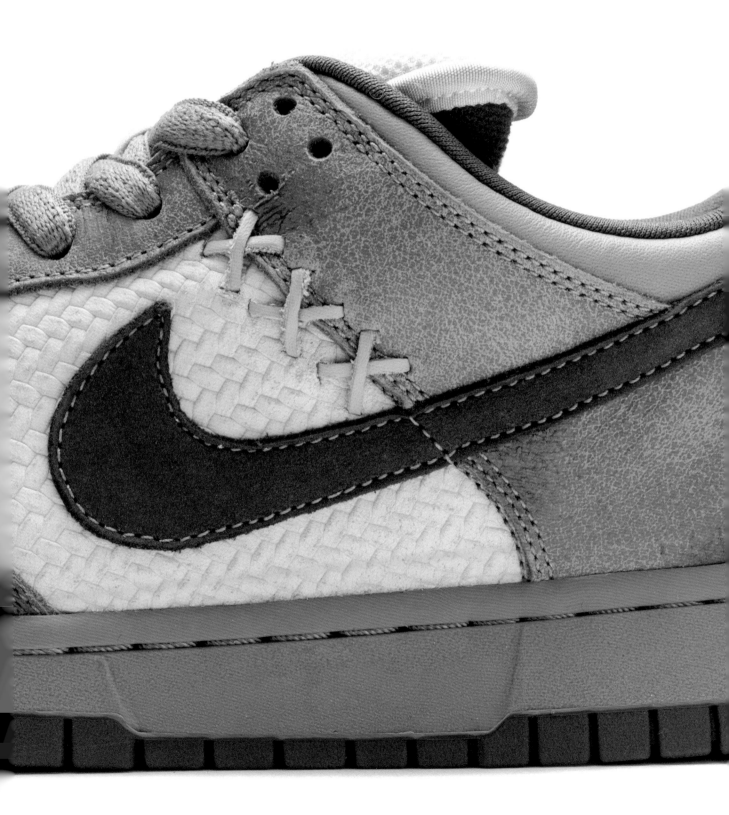

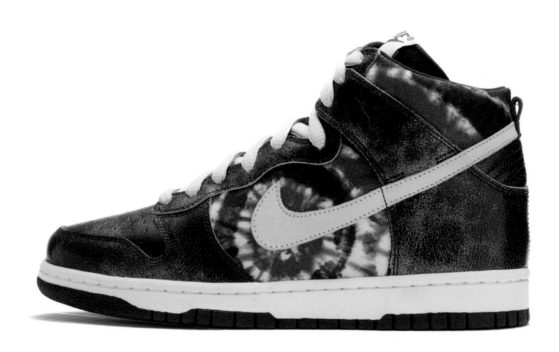

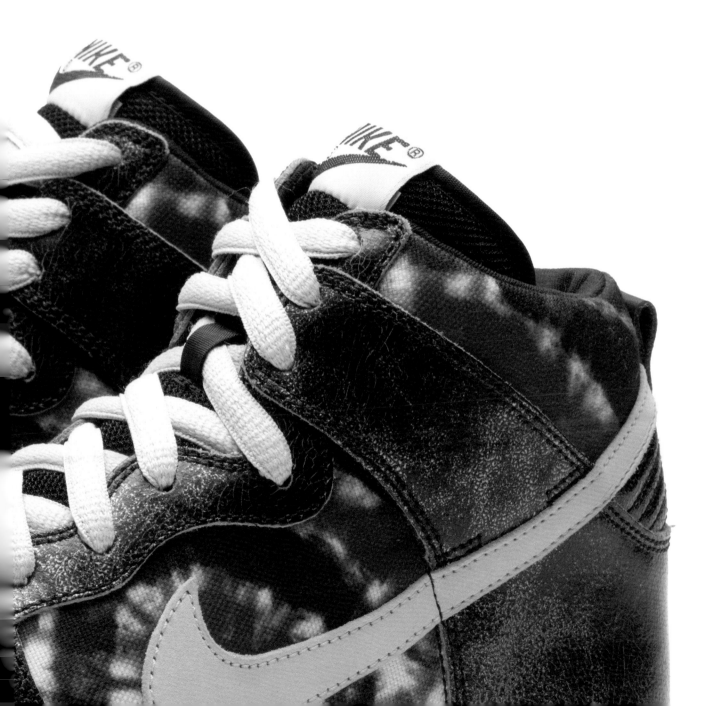

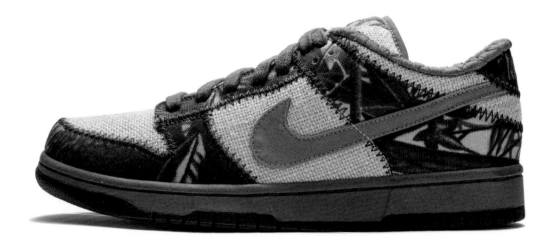

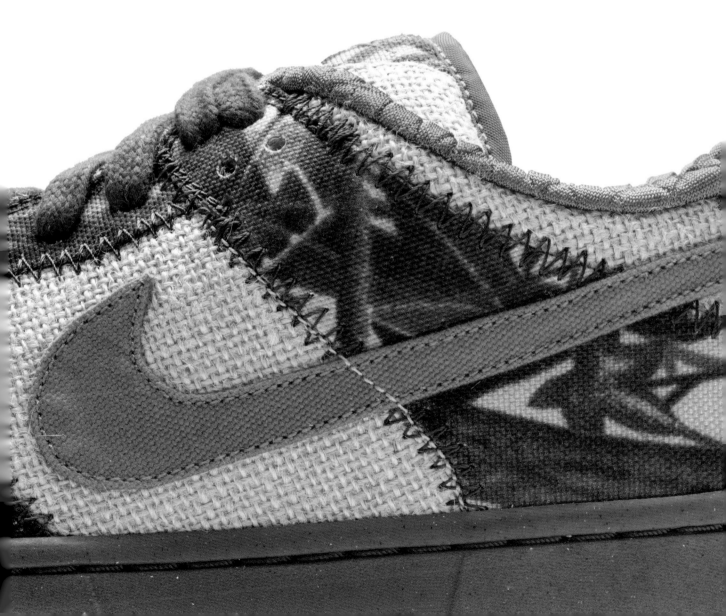

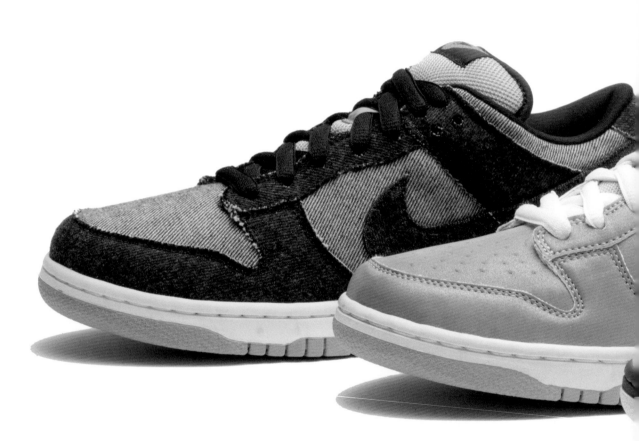

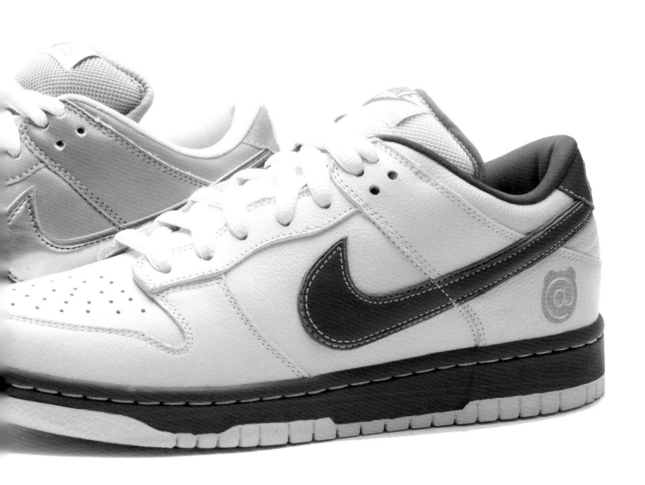

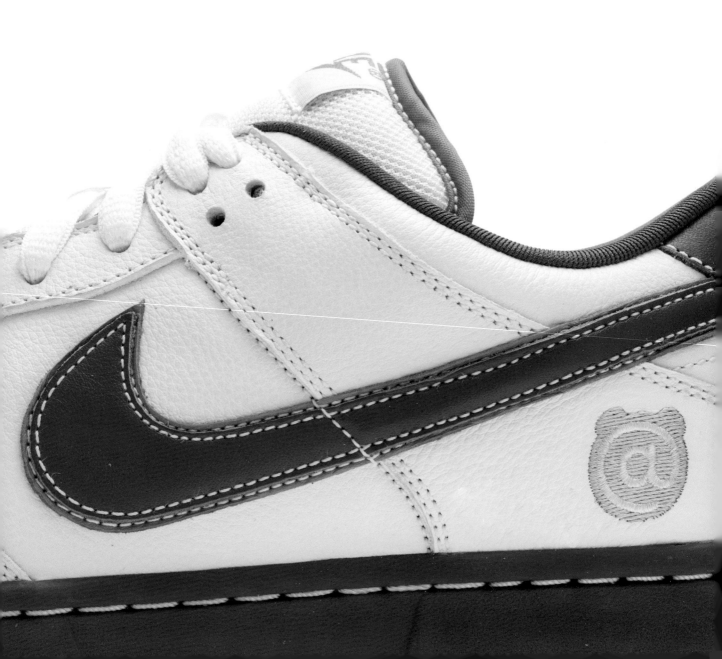

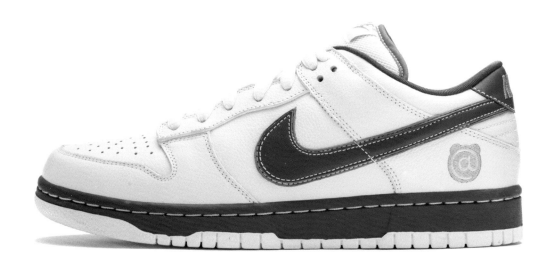

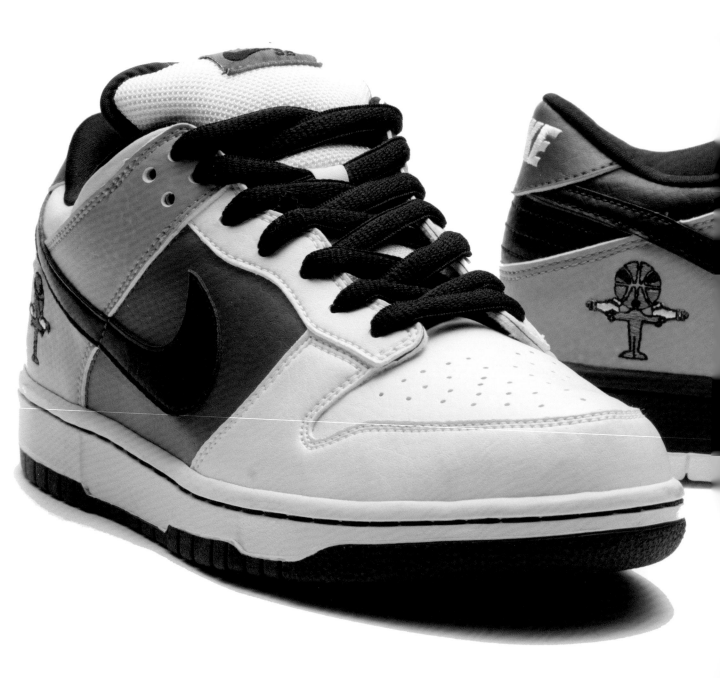

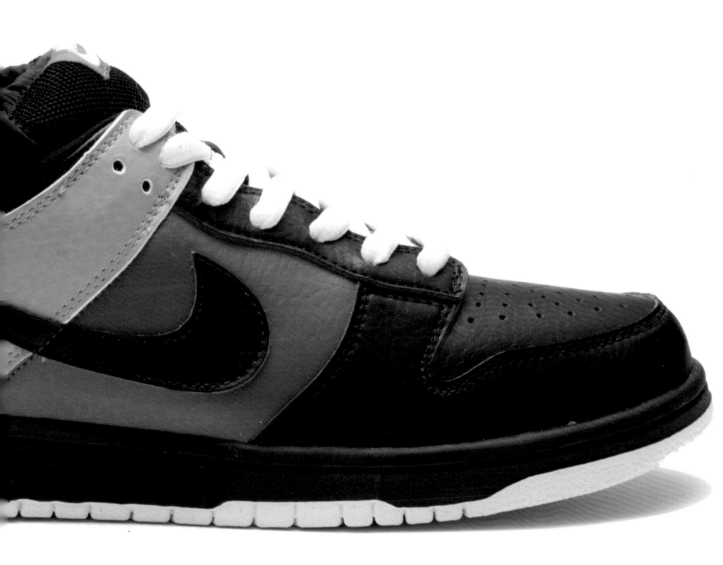

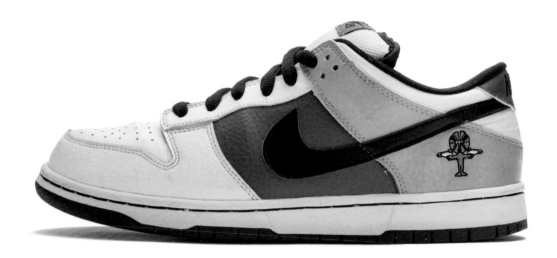

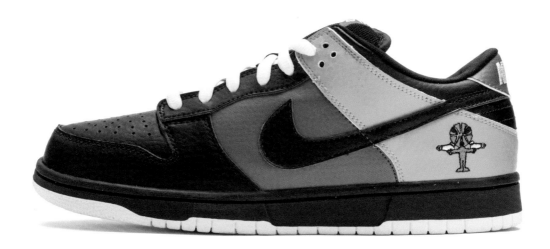

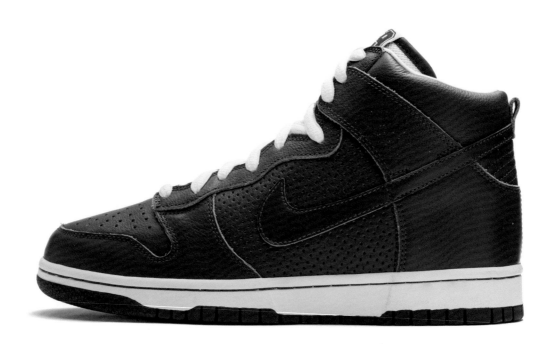

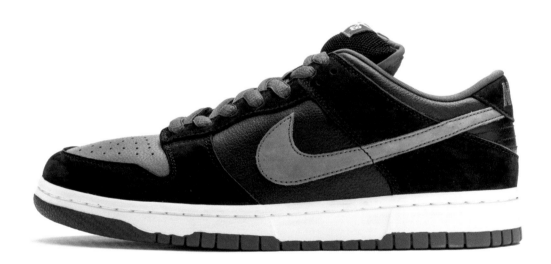

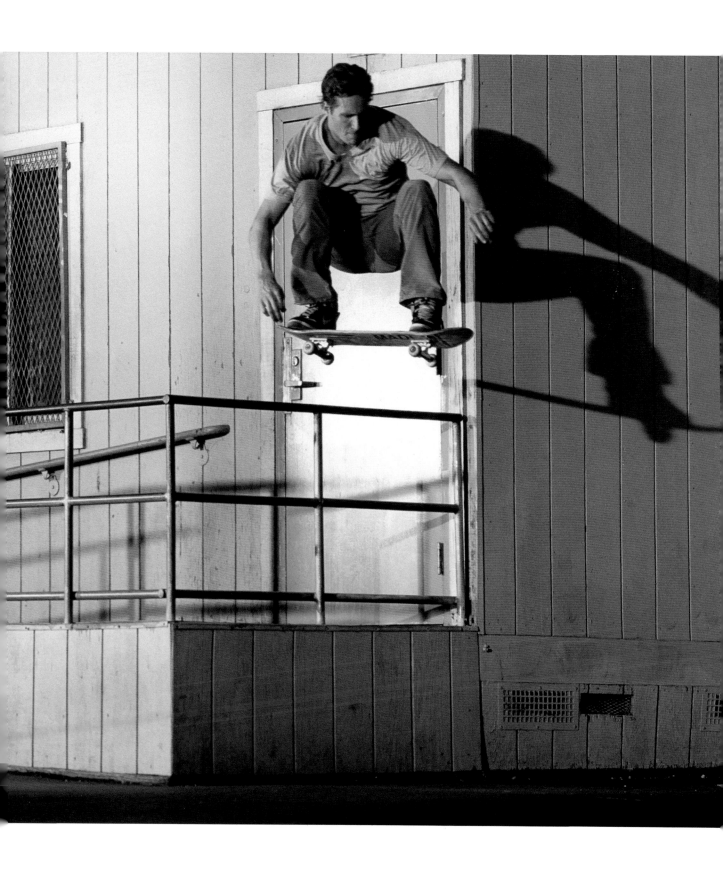

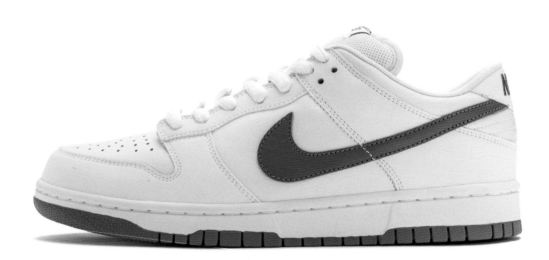

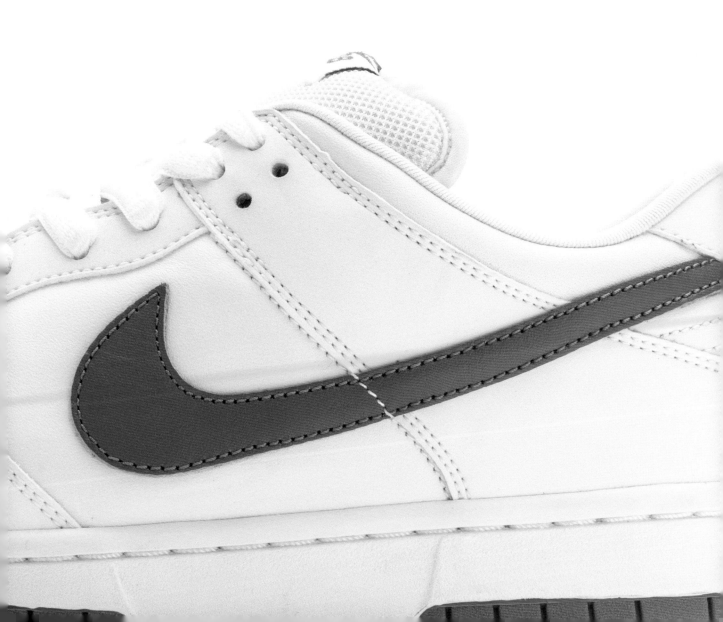

CINCO DE MAYO

The first X Games I won was in the Cinco de Mayo Dunks. I still have them. Since I'm Mexican, it was a big moment for me. It was awesome that it all came together.

Paul Rodriguez

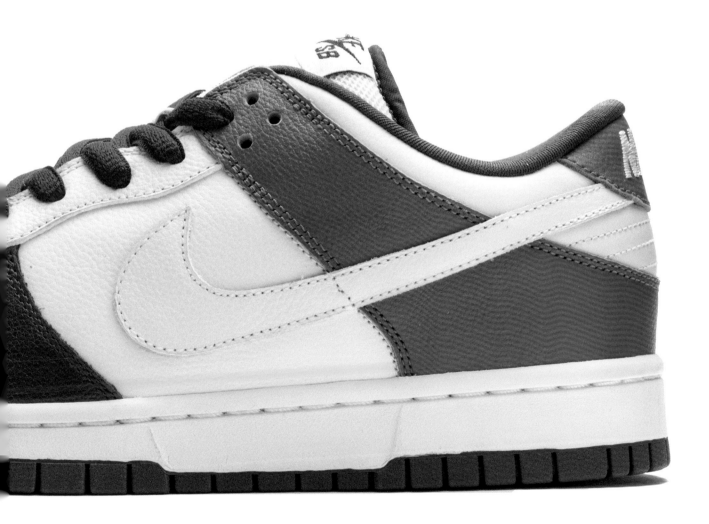

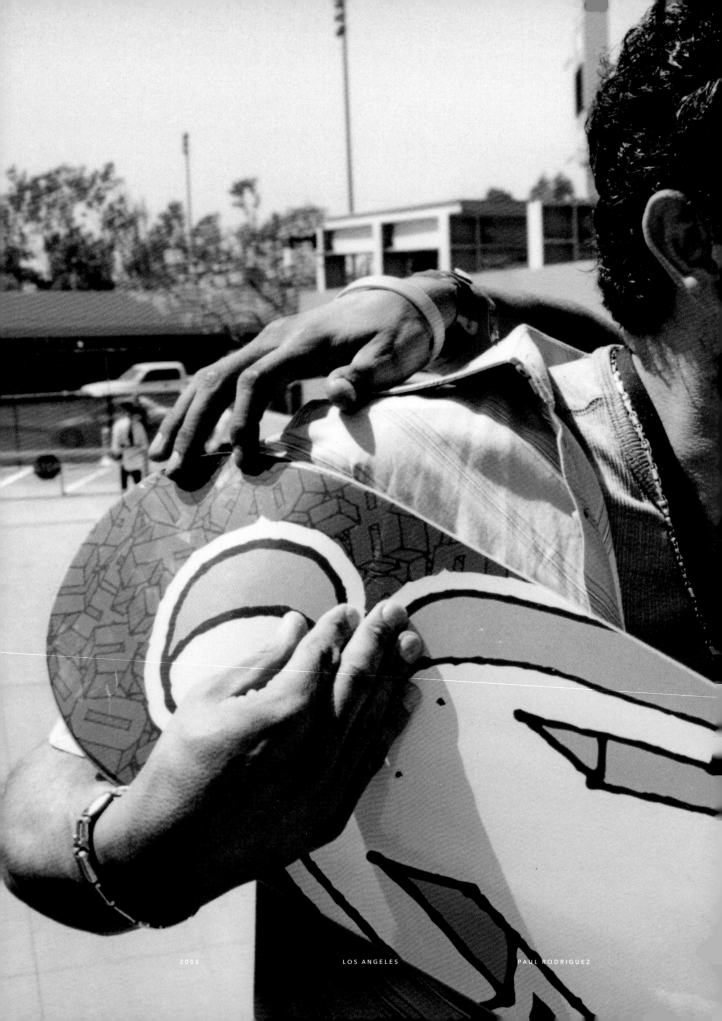

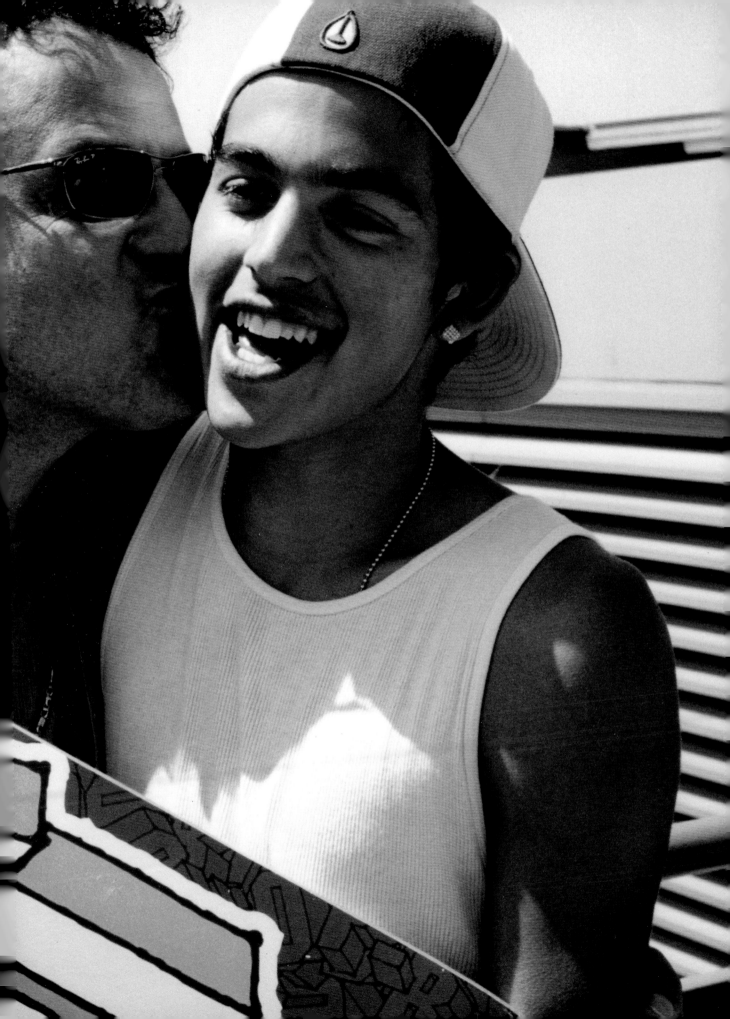

DIAMOND

When the second sample of the original Tiffany Dunk came back, I had Andy Mueller take a photo of me holding the shoe and posted it. I remember I left work and I stopped by my friend's shoe store and he was like, "Yo, what's up with those shoes?" And I was like, "Oh, you saw them?" He was like, "What do you mean? The whole world's seen them."

I didn't know shit about that world because I was only a skateboarder, you know. I'd seen NikeTalk before, but I wasn't a member or anything. He was like, "Yo, look it's on SoleCollector and NikeTalk." And there's thousands and thousands of comments and photos of the shoe I posted. He's like, "Yo, this is going crazy, everybody's freaking out over this shoe." I was like what the fuck? No way. This was a whole crazy world. I'd never seen this much hype over something.

Nick Tershay

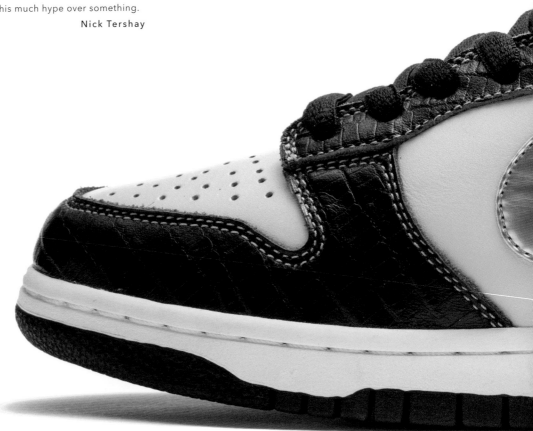

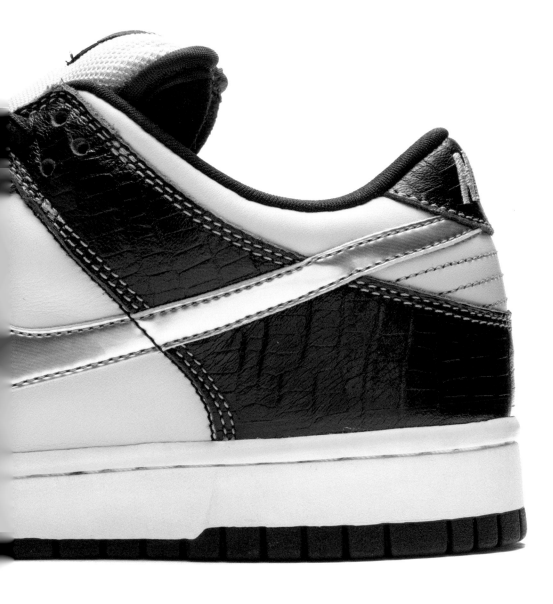

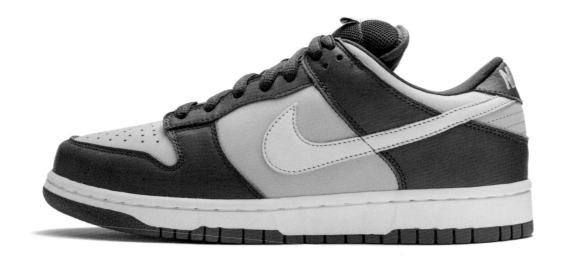

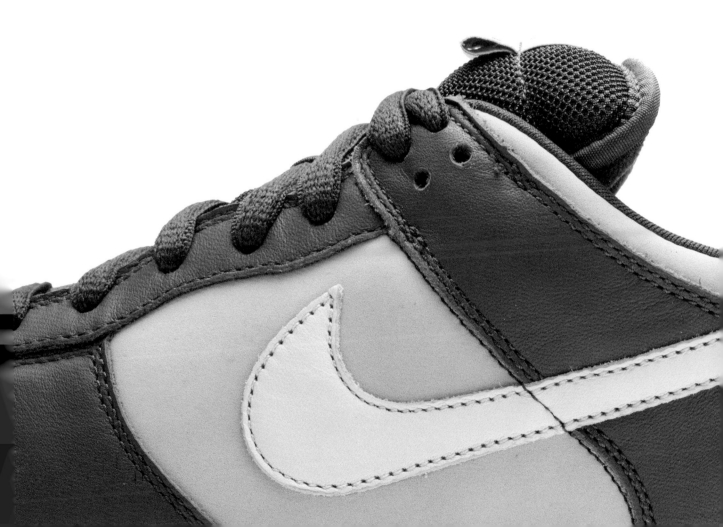

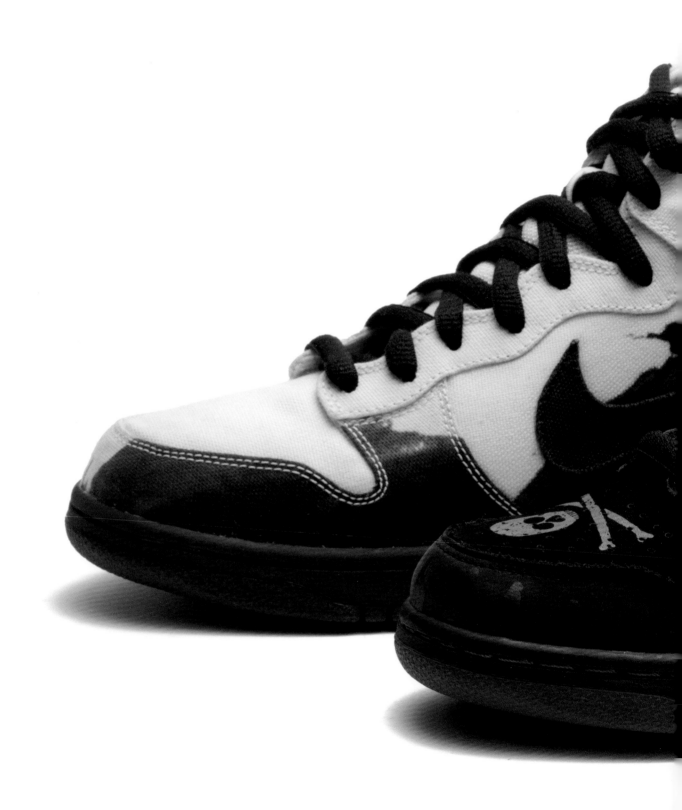

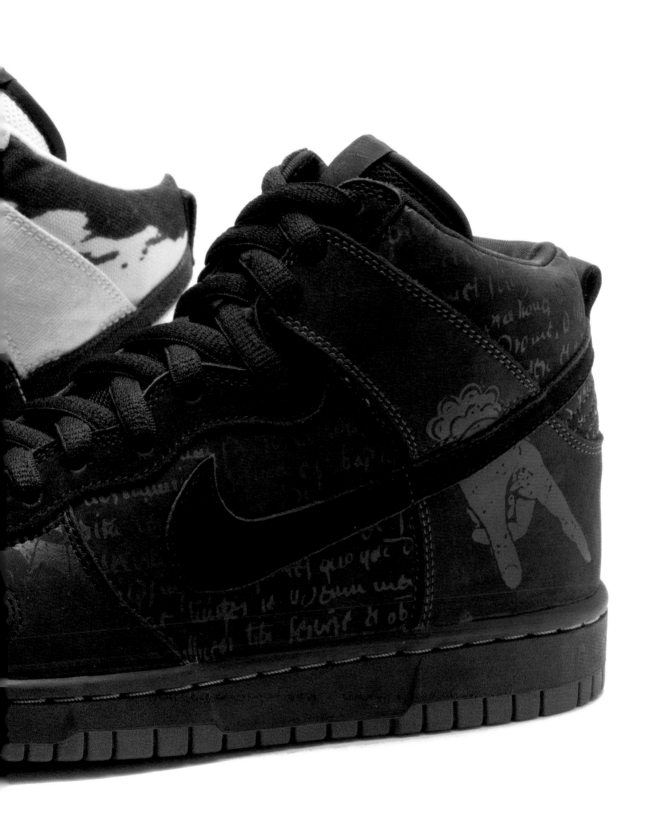

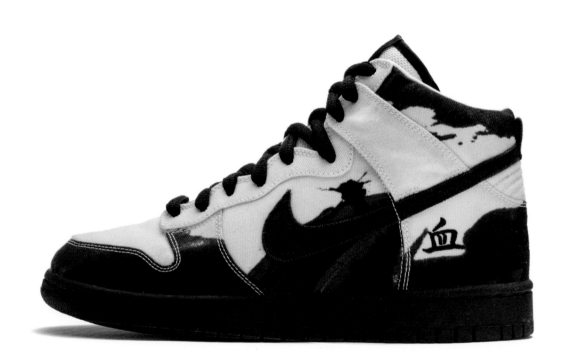

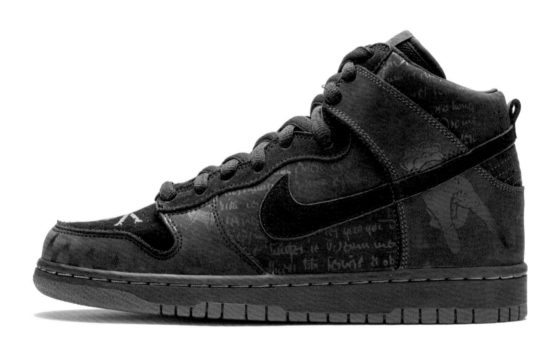

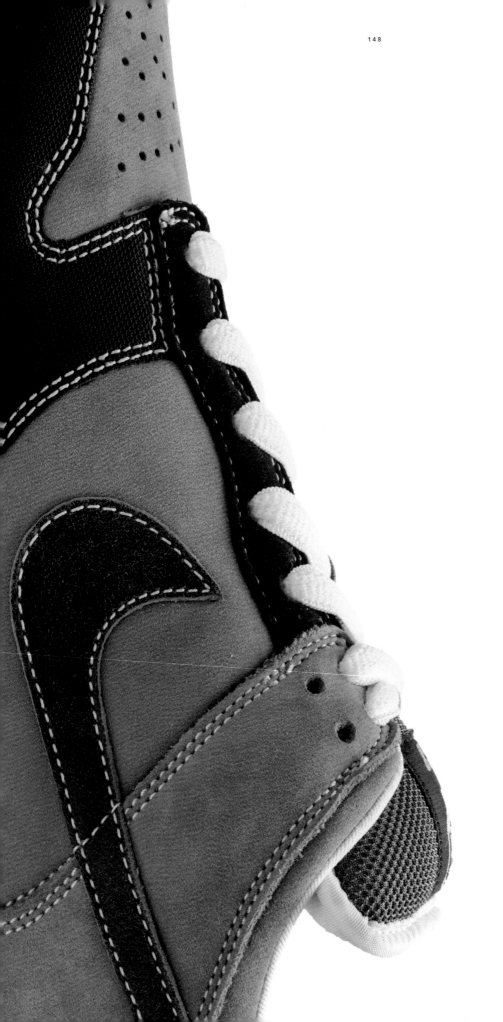

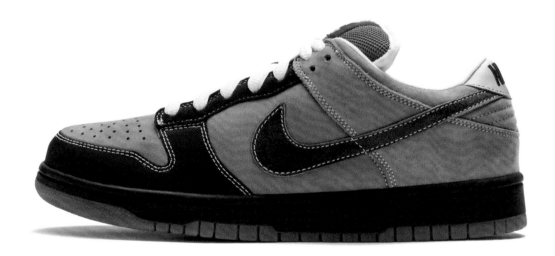

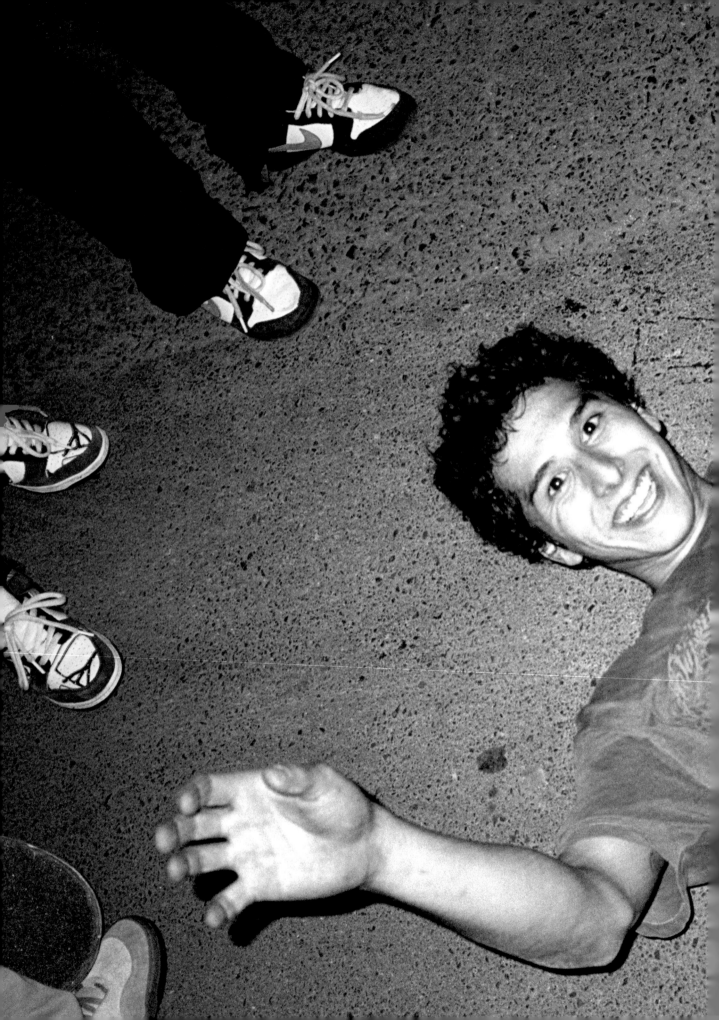

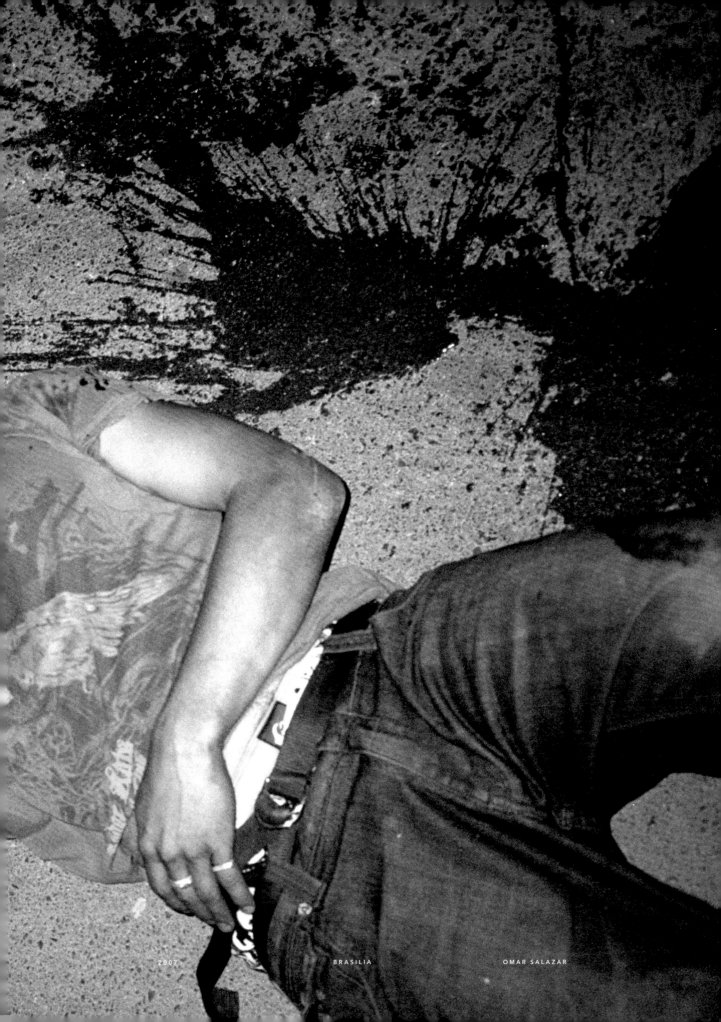

2007 BRASILIA OMAR SALAZAR

PAUL RODRIGUEZ

PORTLAND

2004

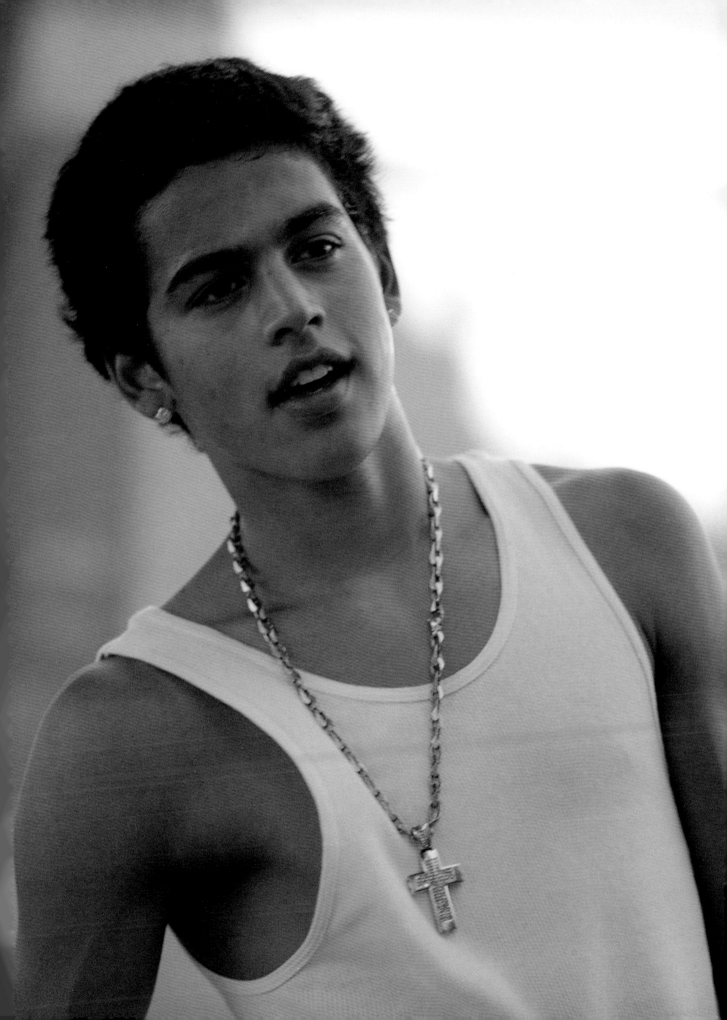

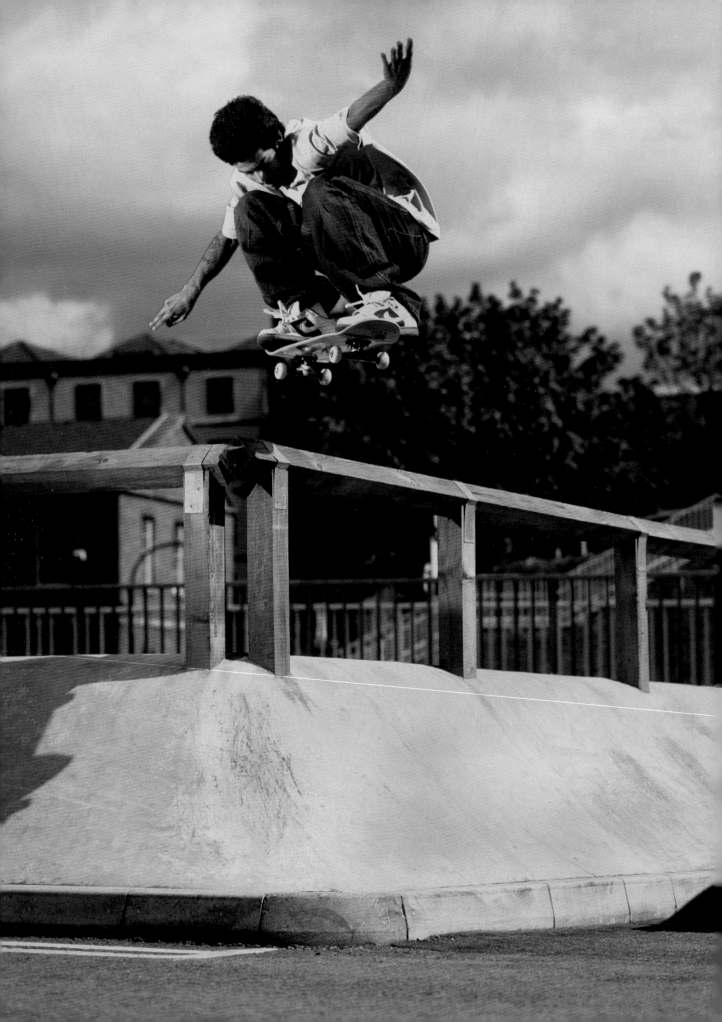

2005

MANCHESTER

PAUL RODRIGUEZ

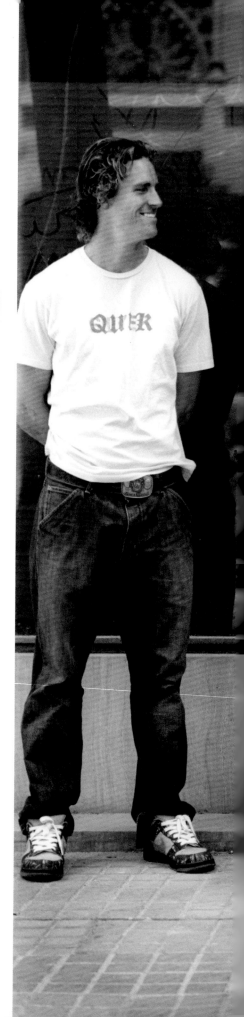

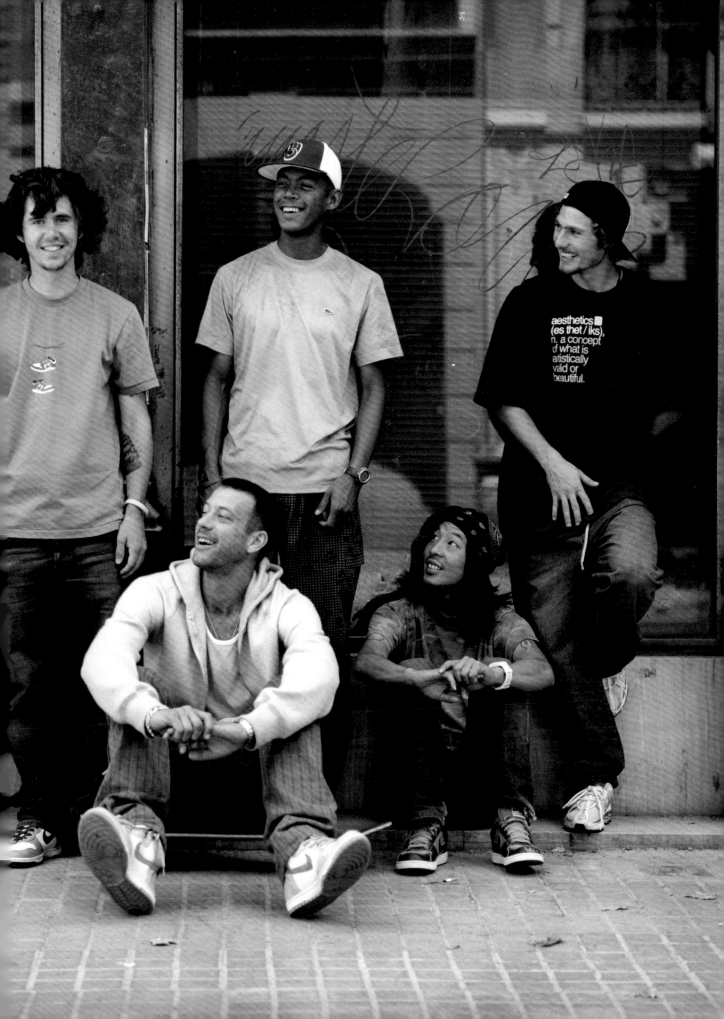

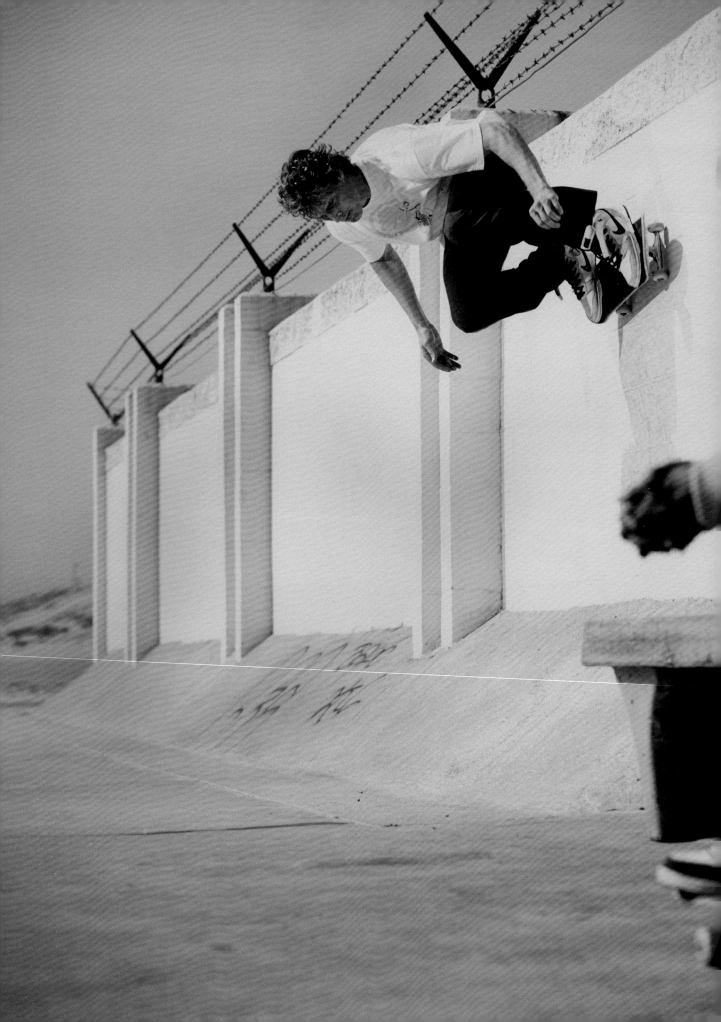

2007

LOS ANGELES

REESE FORBES

SHENZHEN THEOTIS BEASLEY

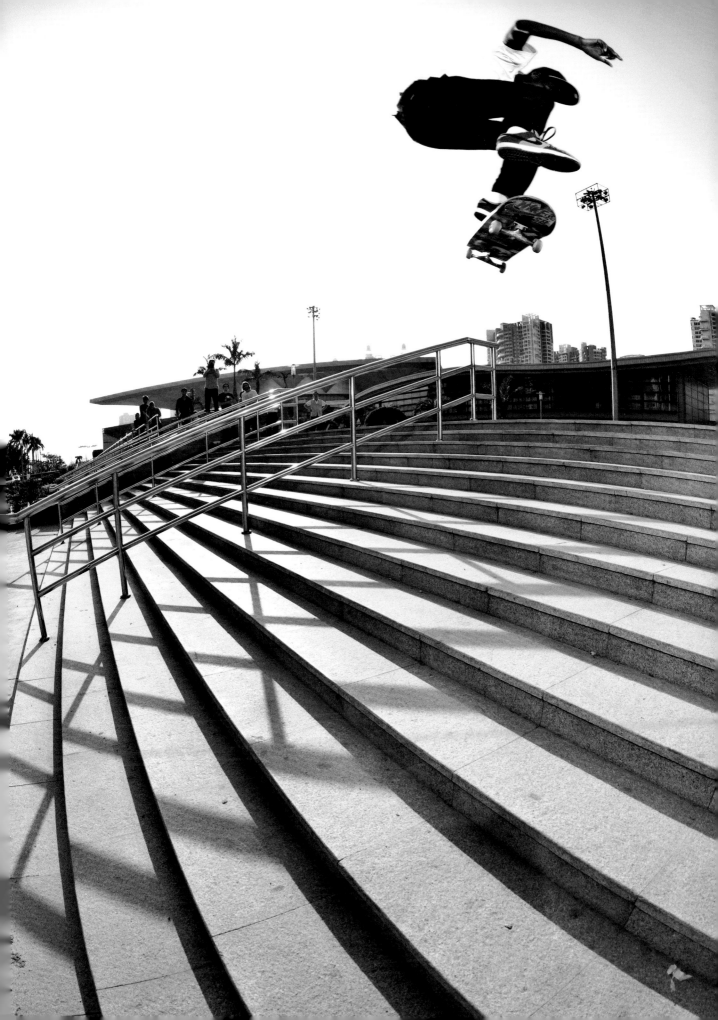

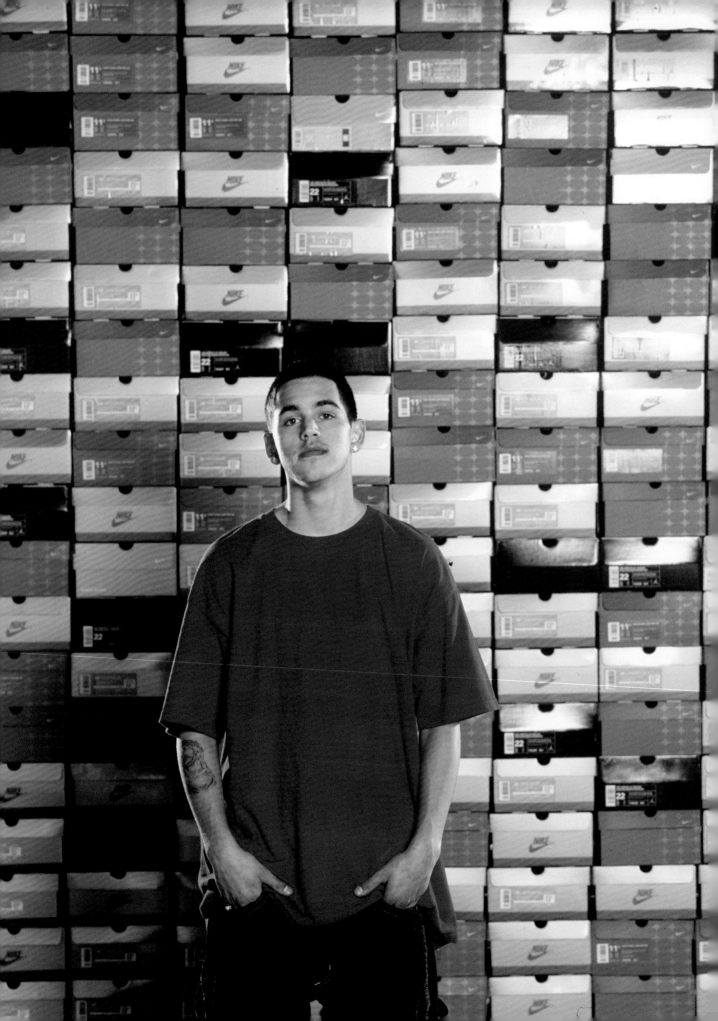

2005

LOS ANGELES

PAUL RODRIGUEZ

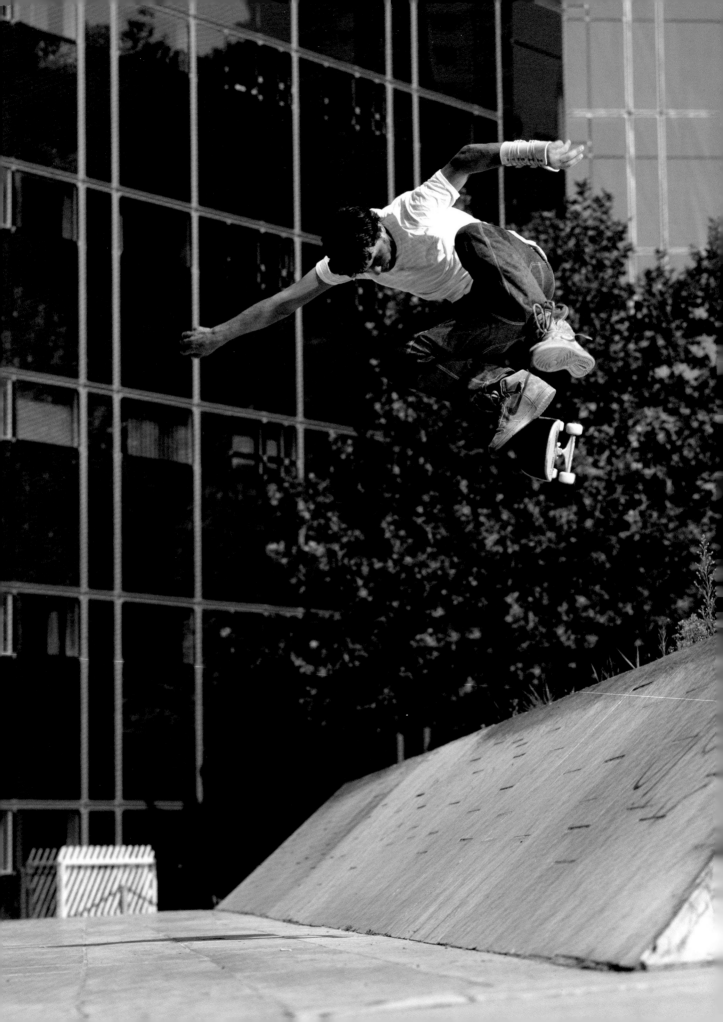

2005 LYON TODD JORDAN

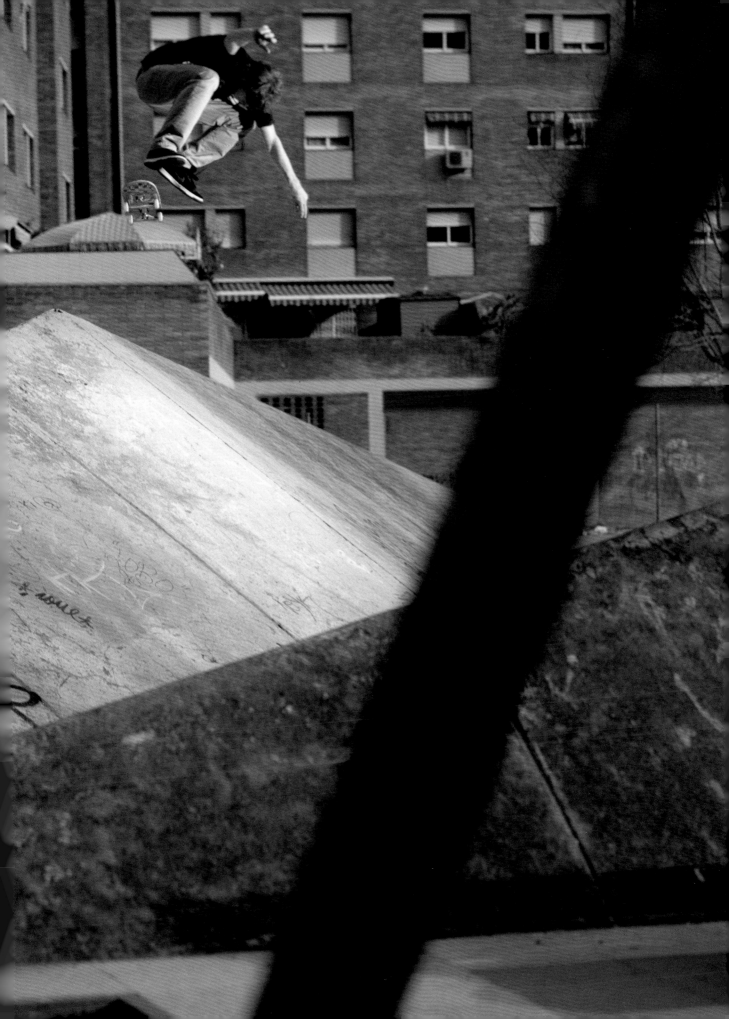

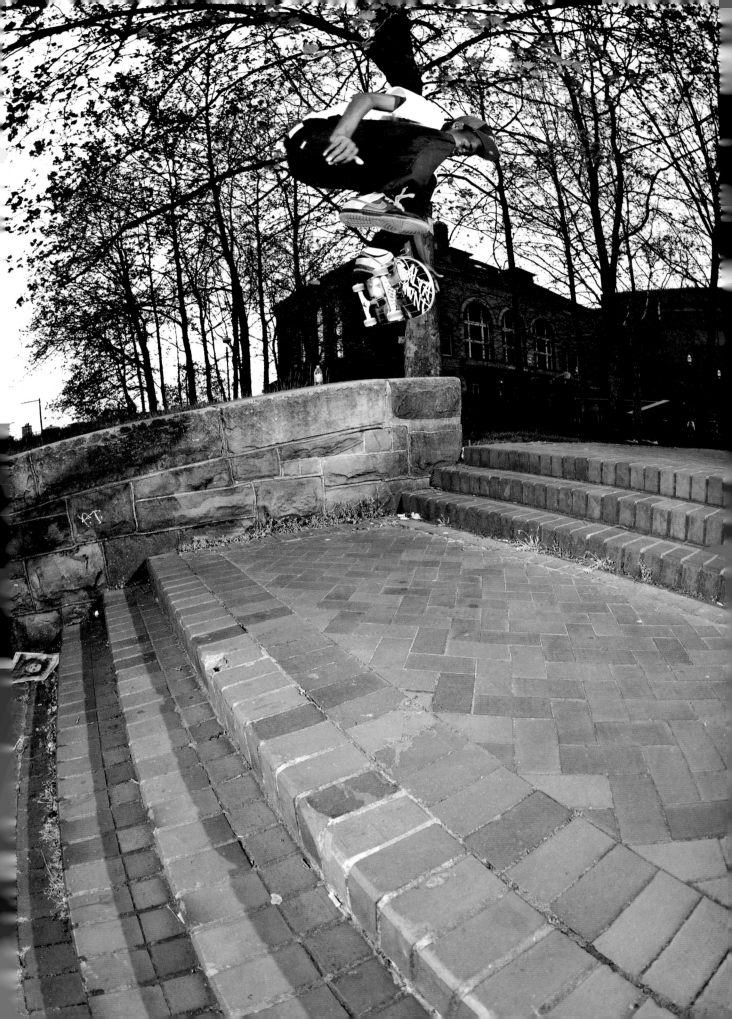

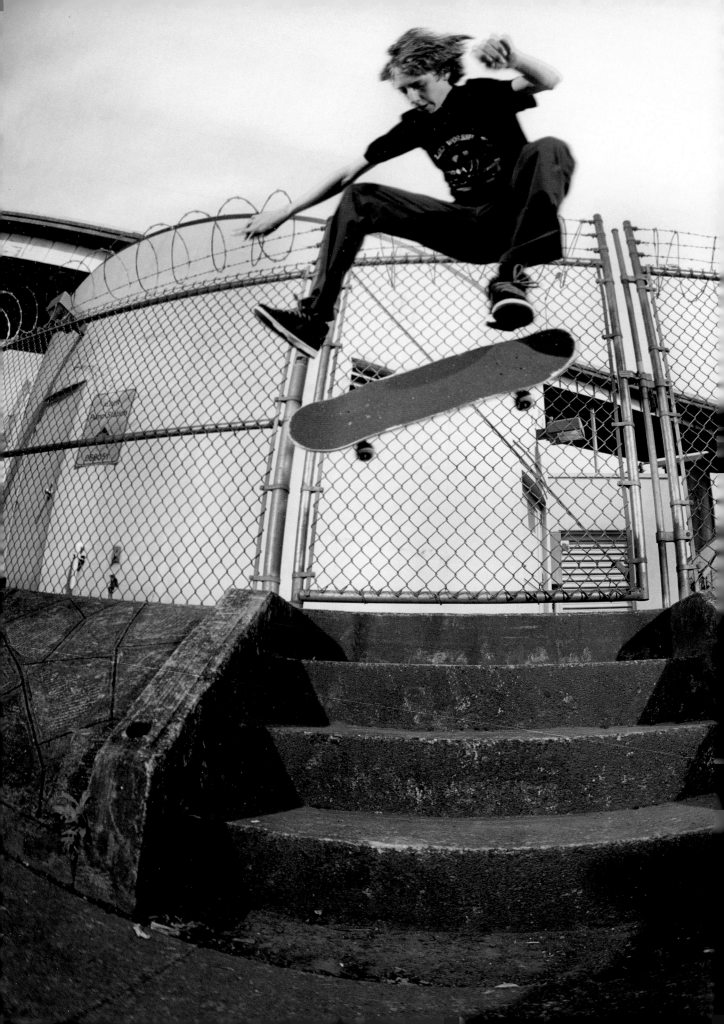

2006

PORTLAND

GRANT TAYLOR

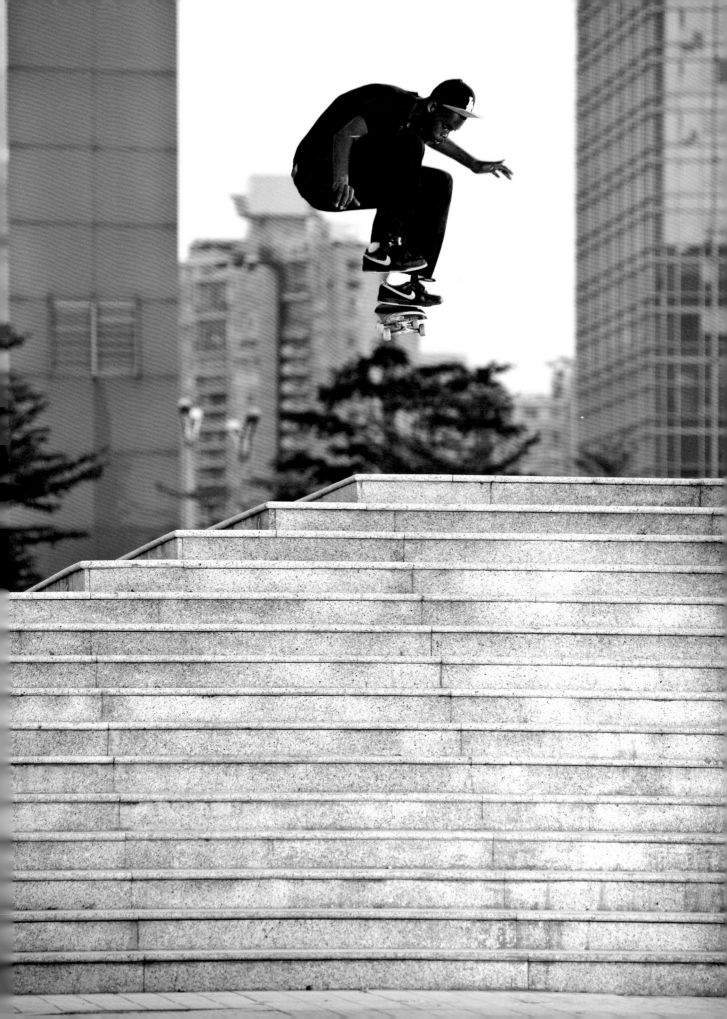

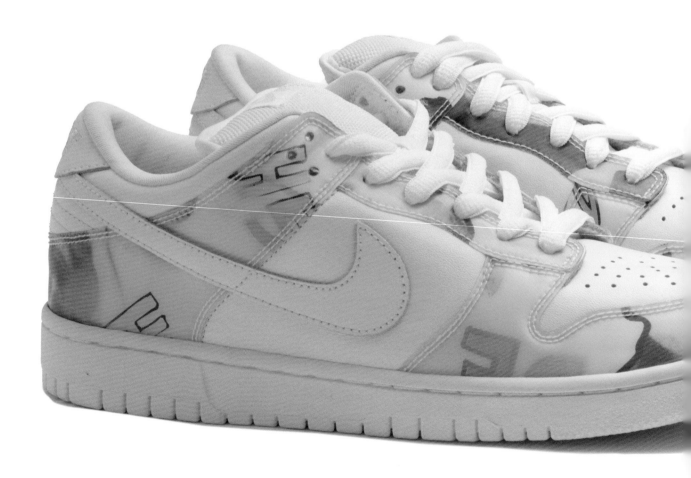

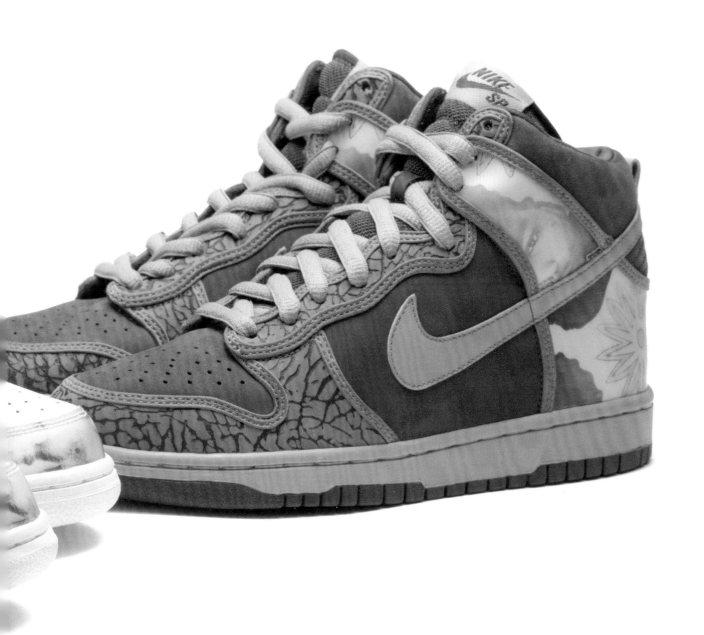

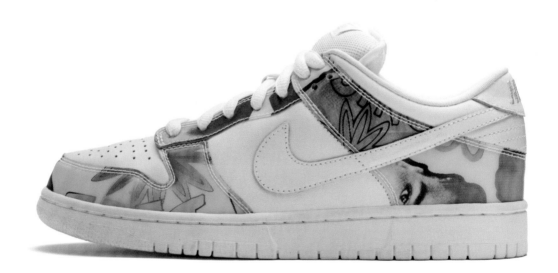

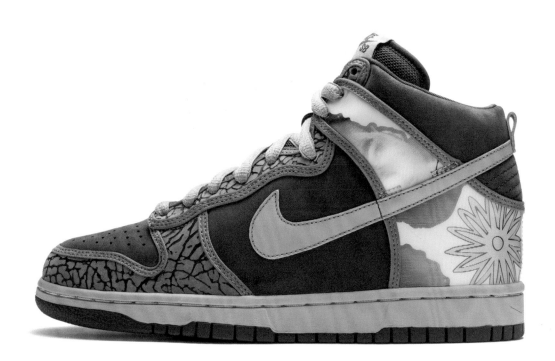

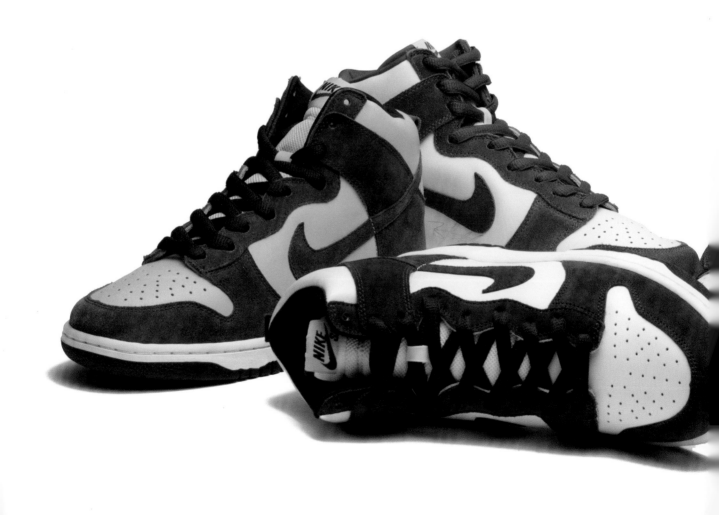

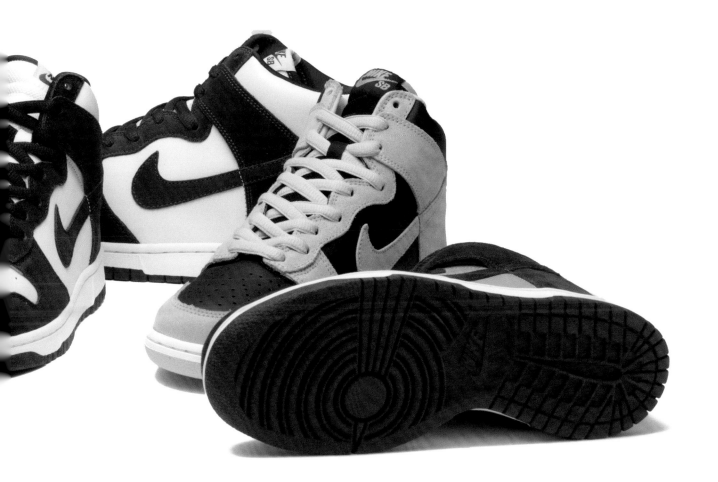

REESE FORBES

ATLANTA

2007

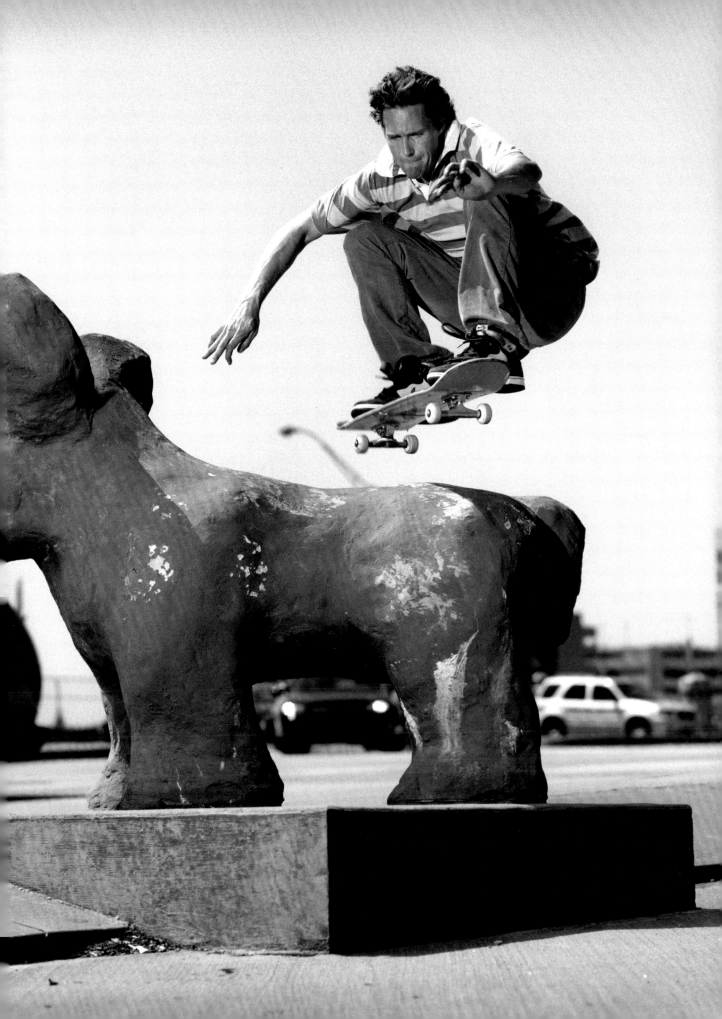

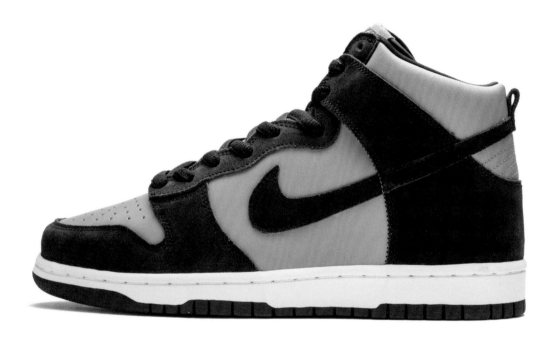

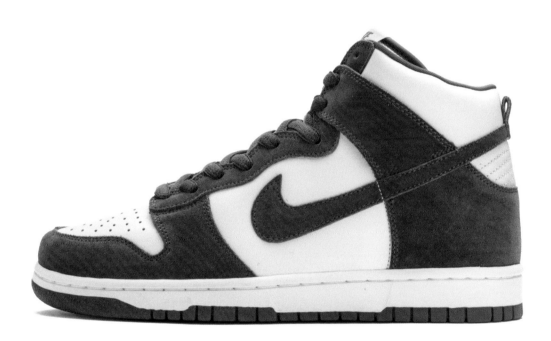

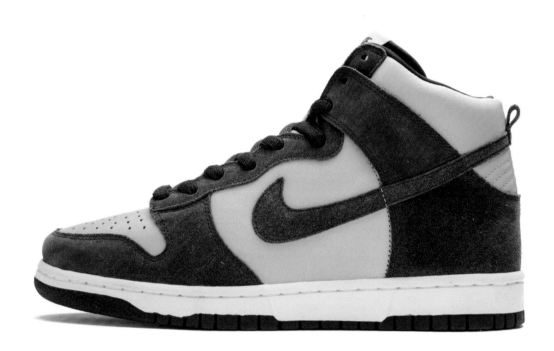

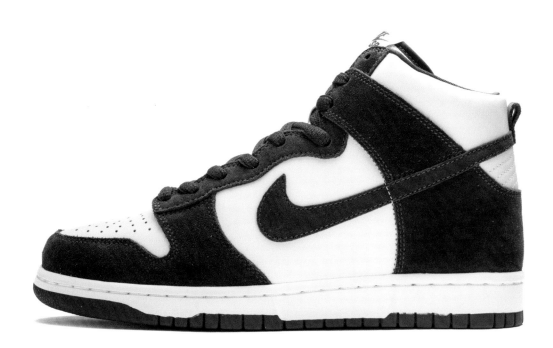

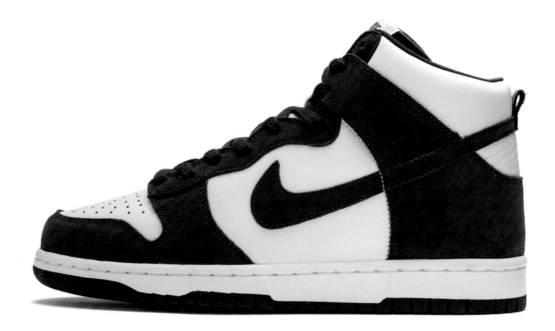

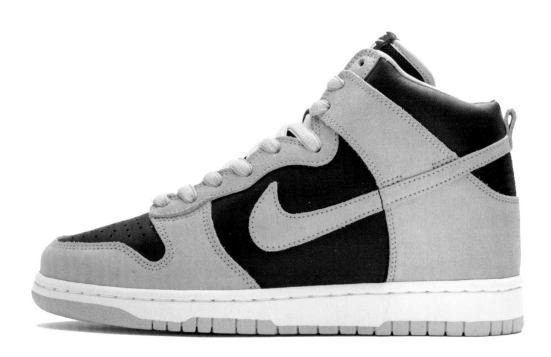

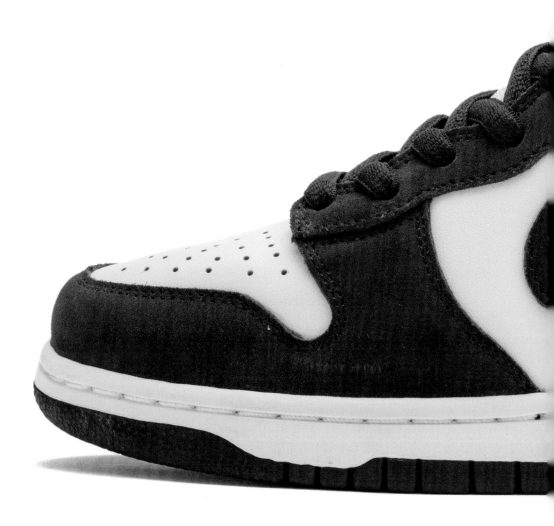

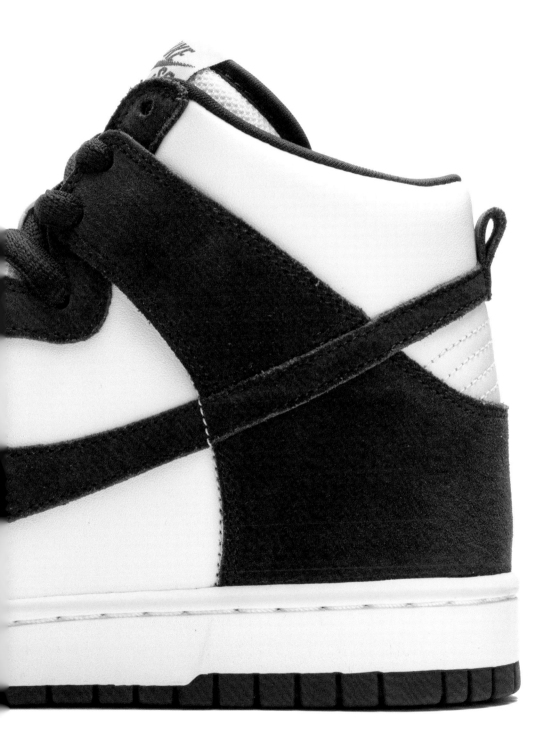

REESE FORBES

BRASILIA

2007

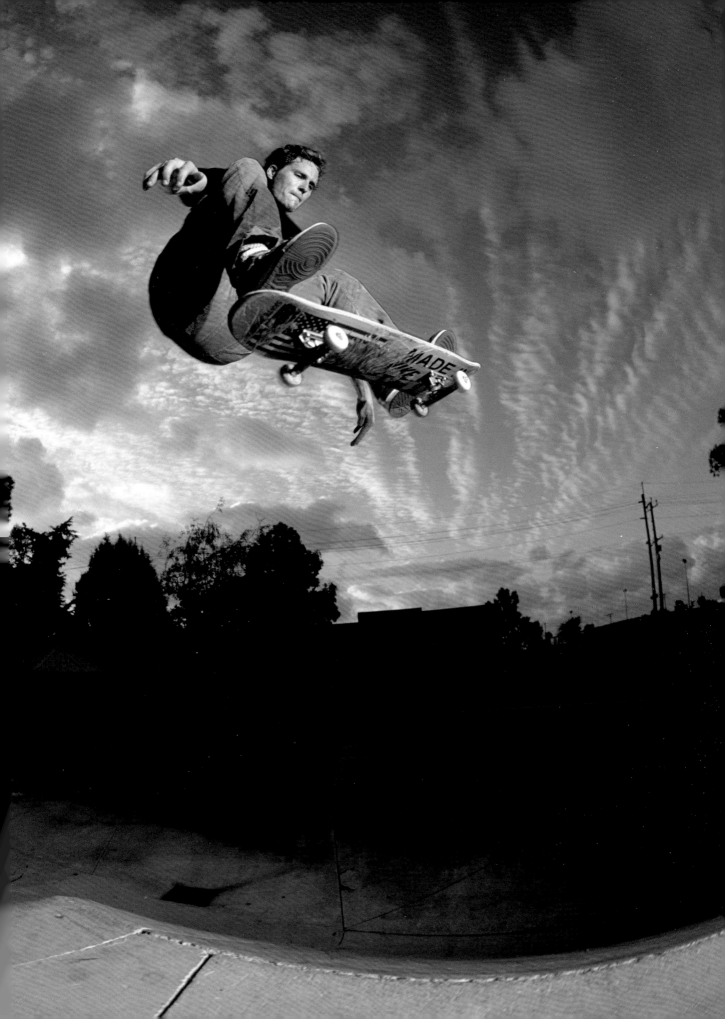

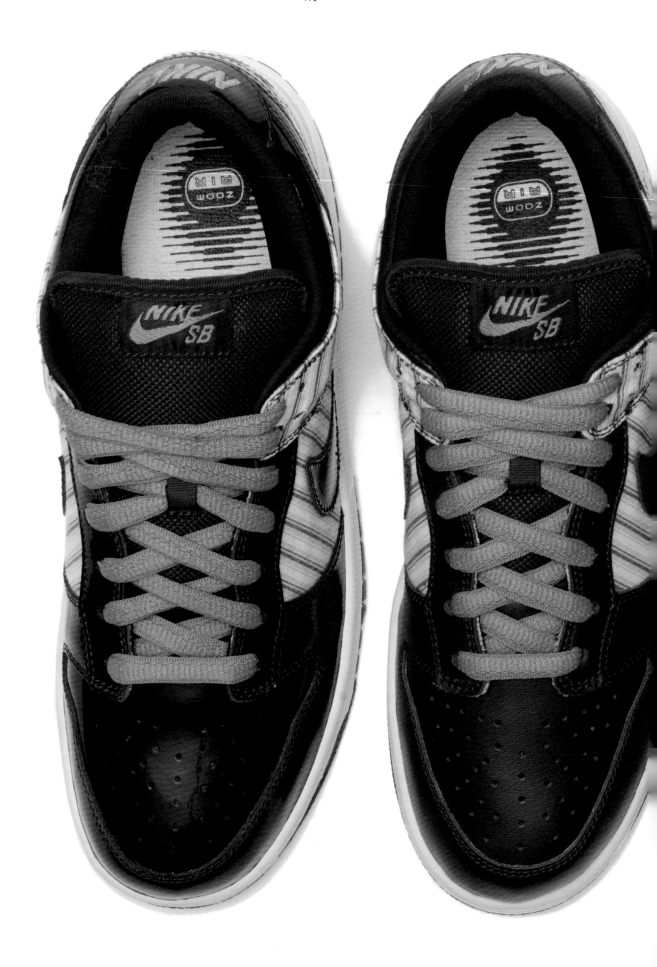

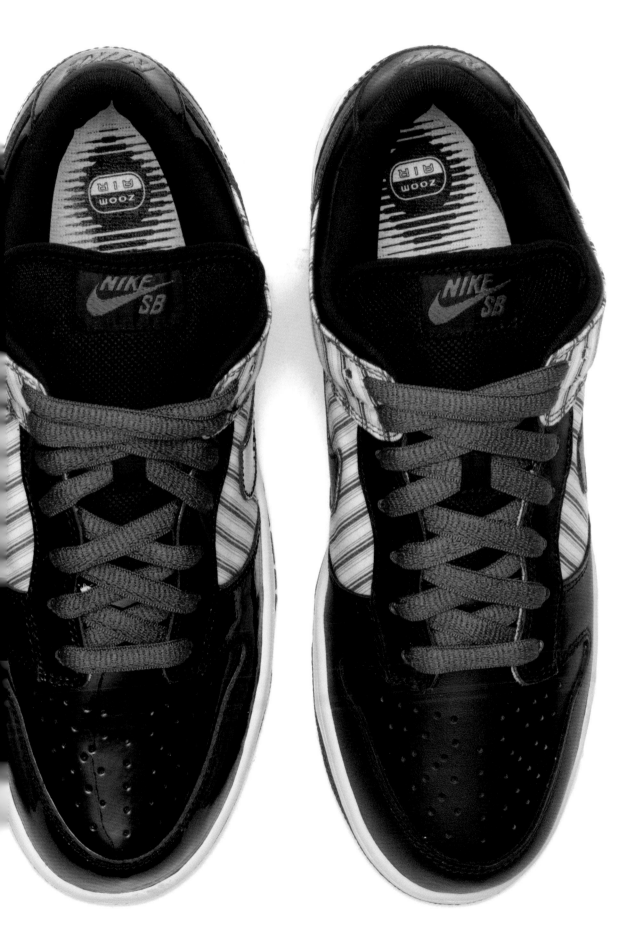

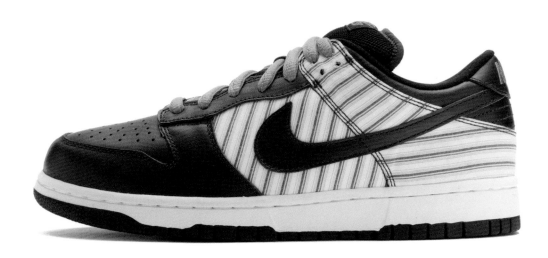

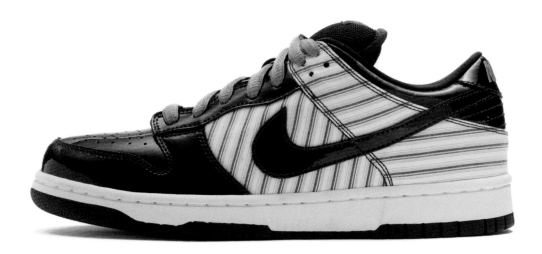

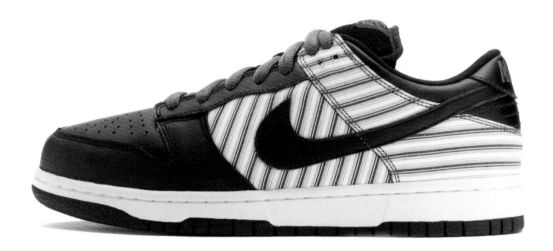

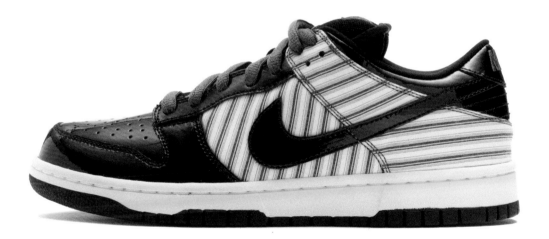

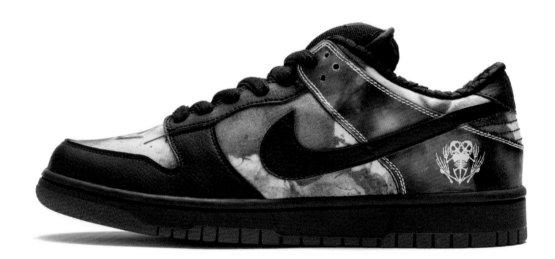

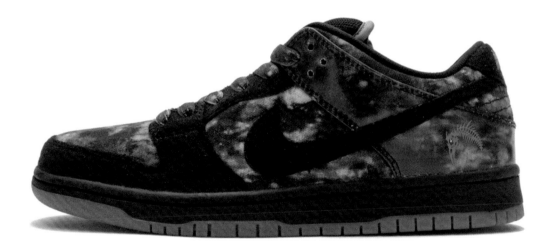

SEND HELP

Visiting Beaverton in the early days of SB, it was literally two offices back there somewhere and a handful of people. It honestly felt more like a small, independent skate brand than a lot of the small, independent skate brands felt at the time. It literally was a hole in the wall: two offices with four desks, huge piles of junk, and people crammed in there. But everything was coming out of just those two little offices. It was pretty cool.

That led to the first Send Helps. They didn't ask me to design a specific anything. They just said feel free to turn in some stuff, and that was one of them. At the time, I was already wearing the Dunk a lot. It was my preferred skate shoe, the Dunk High. I had already kind of decided what material I liked best and what was the most skate-able and all that. That's how I approached that Dunk. I just wanted to make something that looked pretty clean and skated really good.

Todd Bratrud

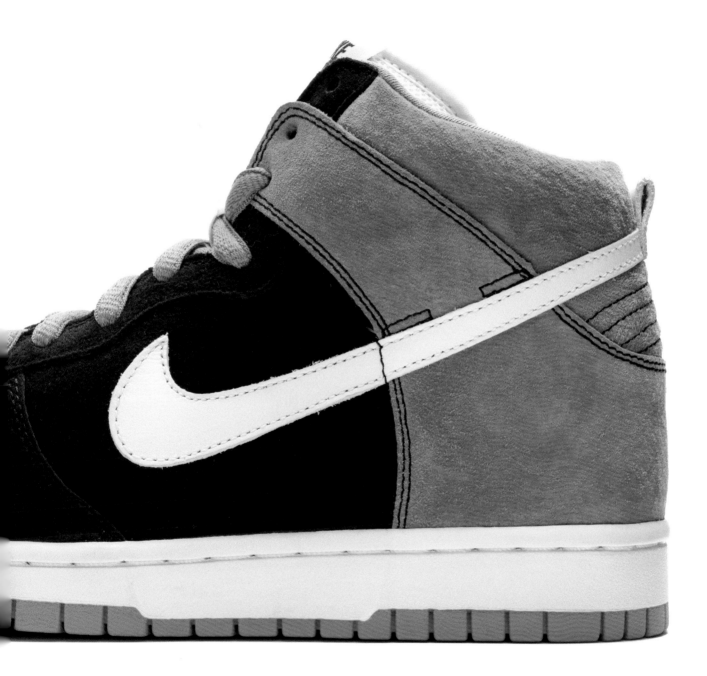

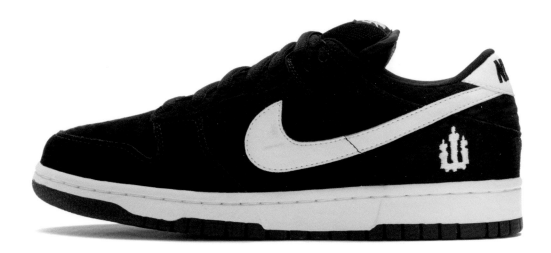

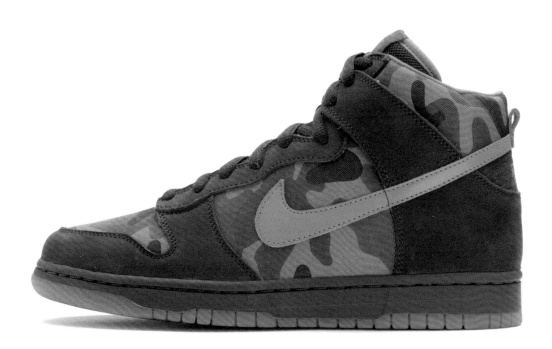

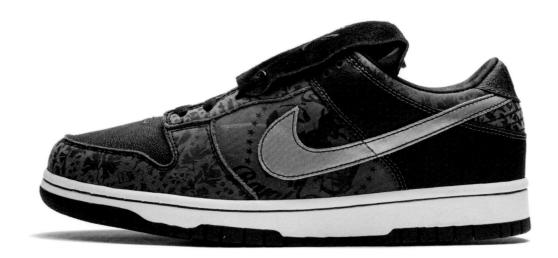

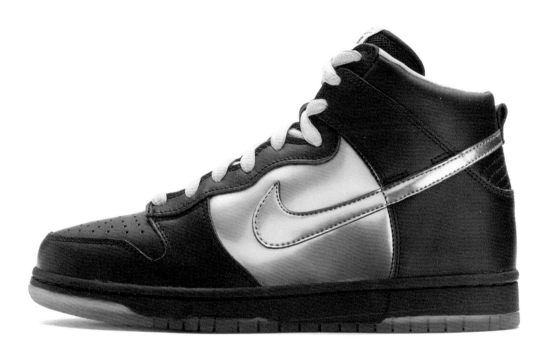

WHEAT MID

Lewis Marnell and Dunks go hand in hand. I may be biased but it is almost impossible to separate the 2 when you think of Lewis' skating. Lewis was all style, in everything he did. Being a skate child of the 90's and taking inspiration from a Mouse-era Guy Mariano and the Menace squad, Lewis' skating and his kits were always fresh. The Dunk came from the streets and matched Lewis' style, so when you think about it, it was almost inevitable that Lewis would be a part of the SB team.

Lewis didn't single-handedly make Dunks cool to skate in, that was a team effort. But he did make a long-term commitment to them and over time they became a part of his skating, so much so that it looked weird to see him not skate them.

Lewis would try all the new SB styles as they emerged and of course he made all these shoes look dope too. The P-Rod 1, the Team Edition, the Blazer, the Verona and the Janoski—he tried them all but would always inevitably return to his beloved Dunks. Nothing compared to the original for him.

Whilst we were filming Nothing But the Truth Lewis almost exclusively took control of the inventory of a certain work-boot colored brown Dunk Mid that kept him going for a long time. It was his favorite and he wore them like they were his own design.

Lewis had Type 1 Diabetes and his passing in 2013 from an unexpected hypoglycemic event was an incredibly difficult time for family, friends and anyone who had ever been lucky enough to meet him. He was a kind hearted and generous soul who left us with a legacy of amazing skating, smiles and good times. In 2018, to mark the 5-year anniversary of his passing, Nike honored Lewis by giving him the shoe that he always wished was his own. That work-boot colored brown Dunk Mid from 2006 rebranded with his Almost Lion insignia and the words "Lewis Forever" on the tongue. His brother created the sock liner artwork.

Chris Middlebrook

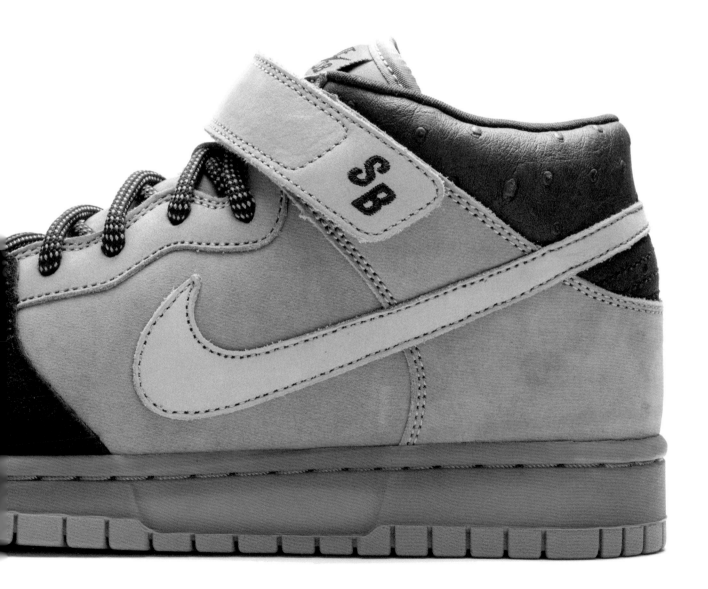

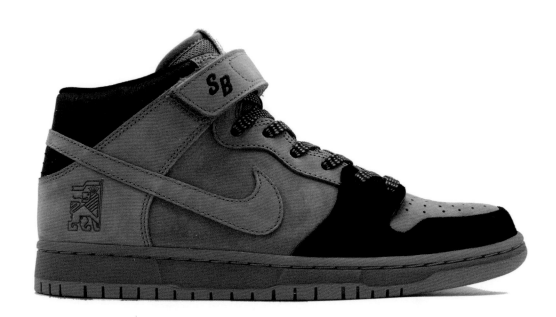

CAPPUCCINO/BRONZE WHEAT LEWIS MARNELL

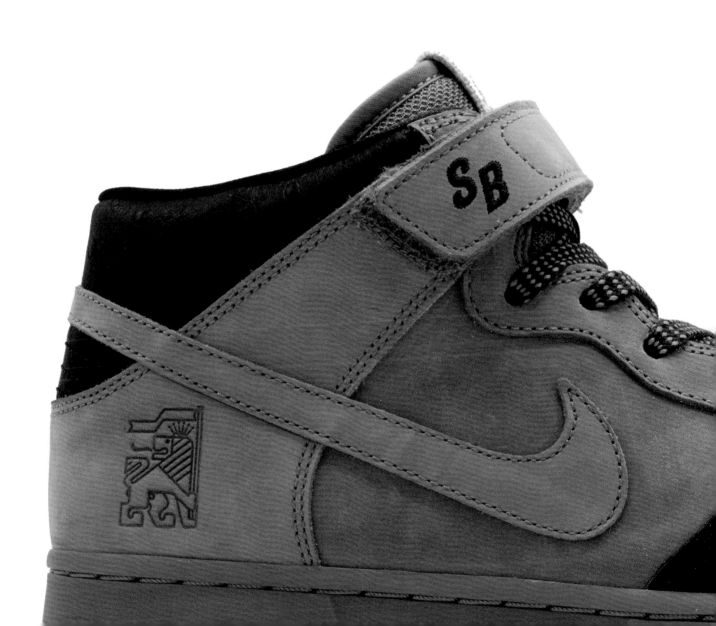

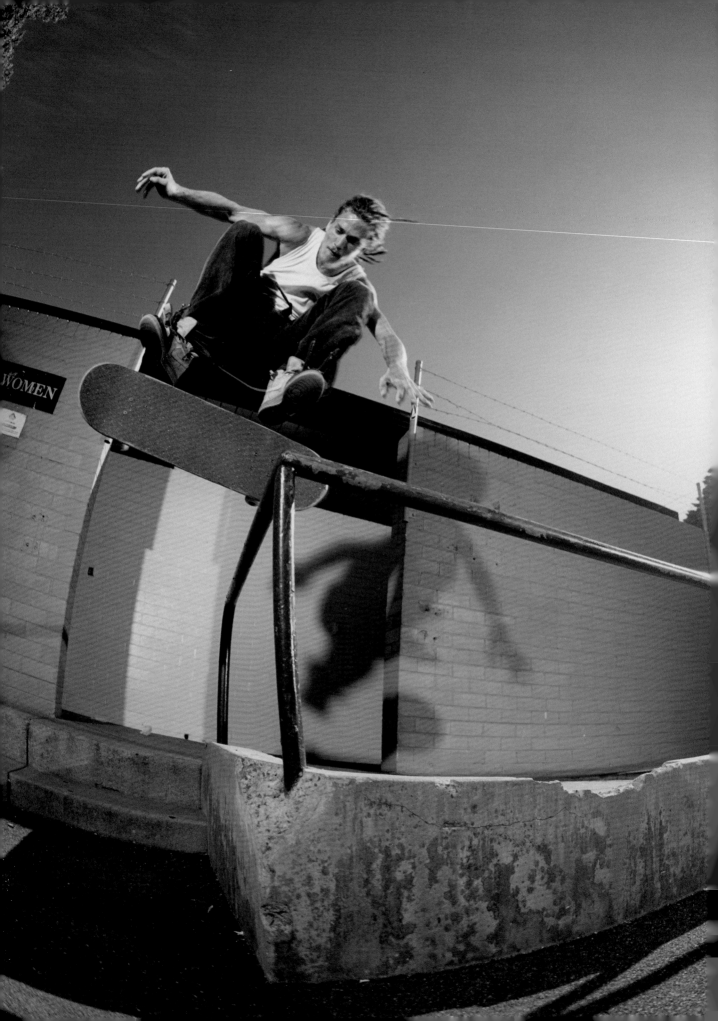

2007

MELBOURNE

LEWIS MARNELL

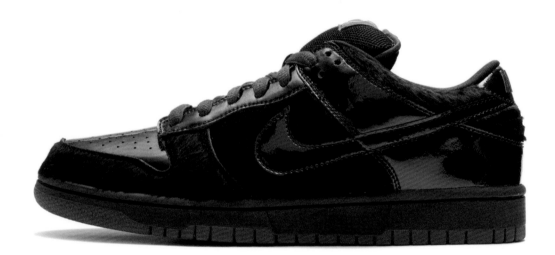

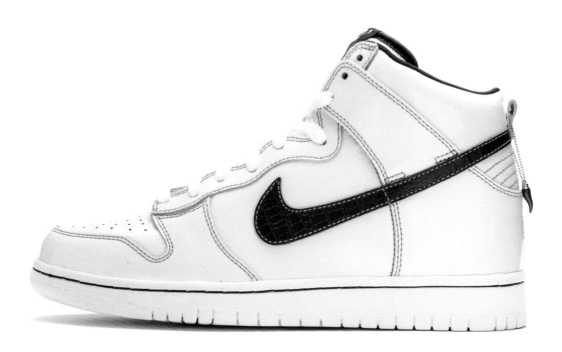

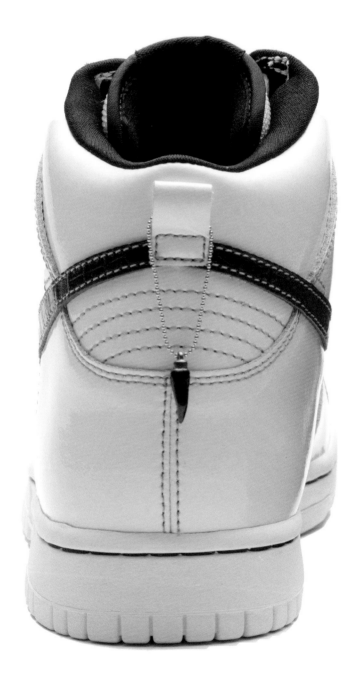

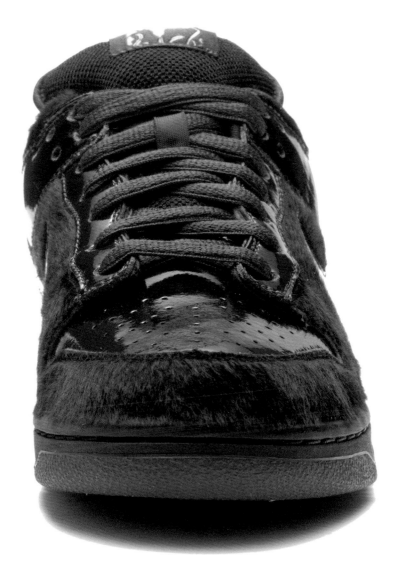

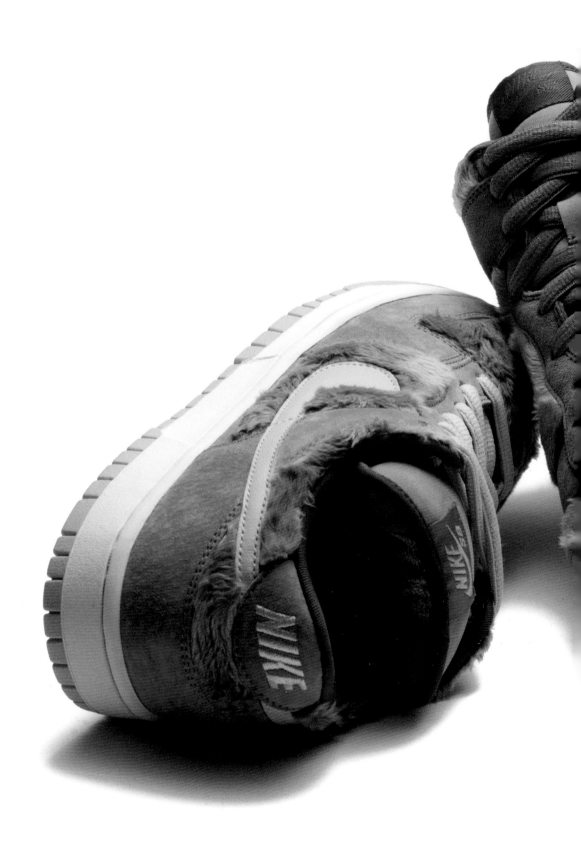

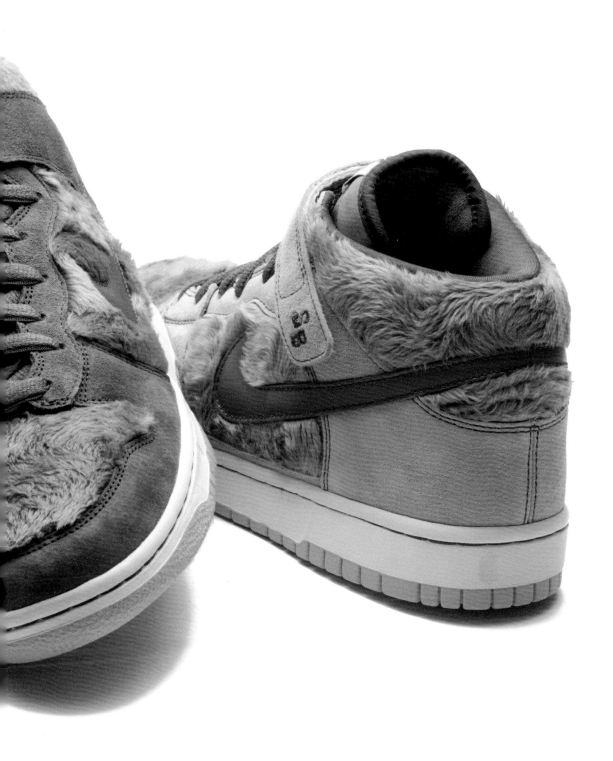

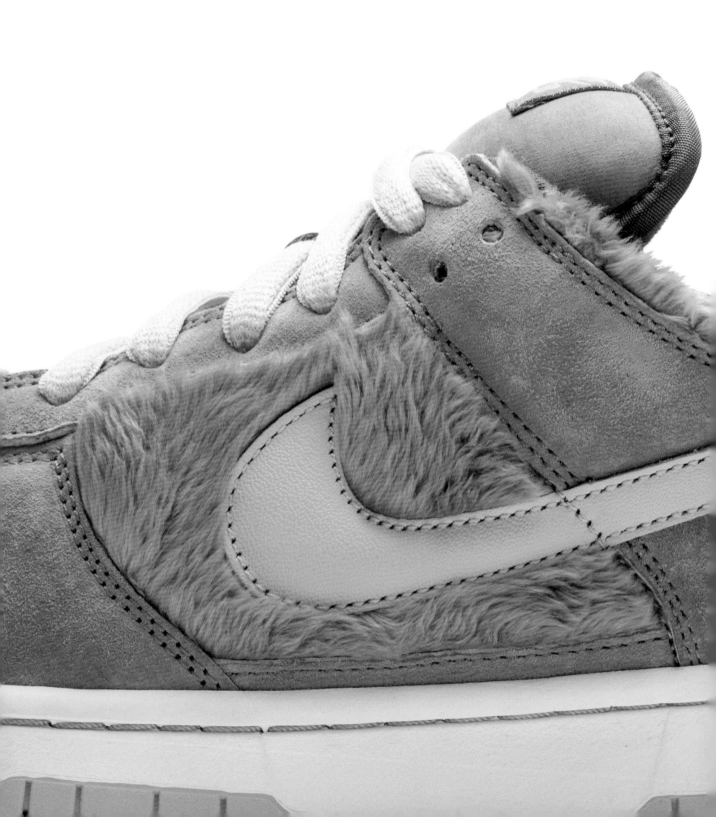

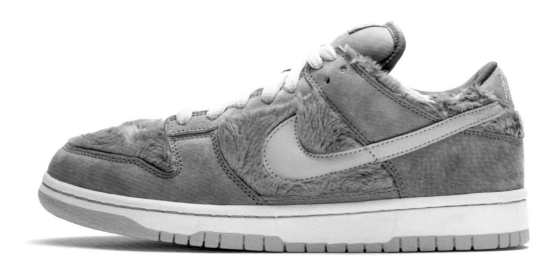

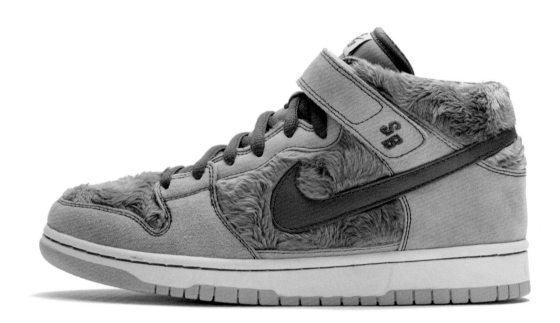

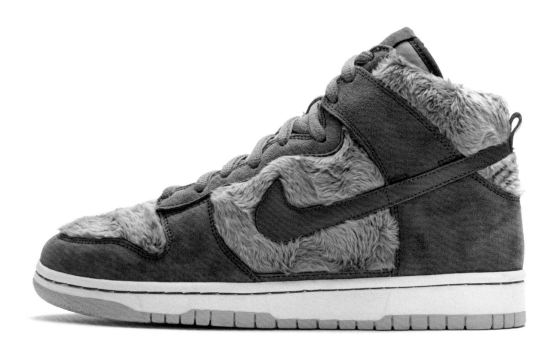

DINOSAURS

I just got the blank sheet and kinda wrote out what I wanted it to look like. I'm not sure how long it took them to make a sample of it. I was kind of inspired by Ace Frehley's stage boots.

I hated KISS until I started playing guitar in college and guitar friends of mine were like, "You should listen to Ace Frehley." So when I started playing guitar, I started getting into KISS.

I wore the silver ones on stage a lot when they came out. A lot of people seemed to like them. It was interesting getting a reaction just for the sneakers and not for the band. People who didn't know anything about the band were into the sneakers, which was good. Some fans of the band bought the shoes, but a lot of people just liked the shoes who like sneakers.

J Mascis

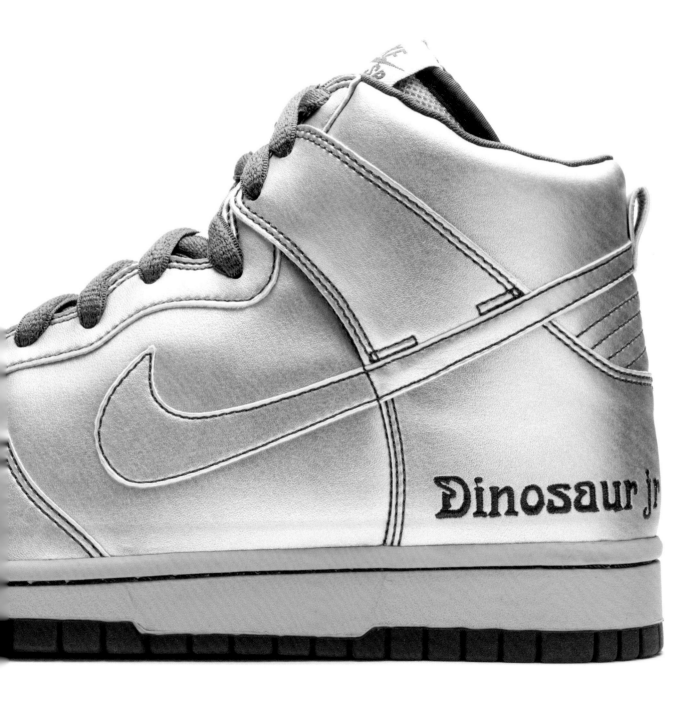

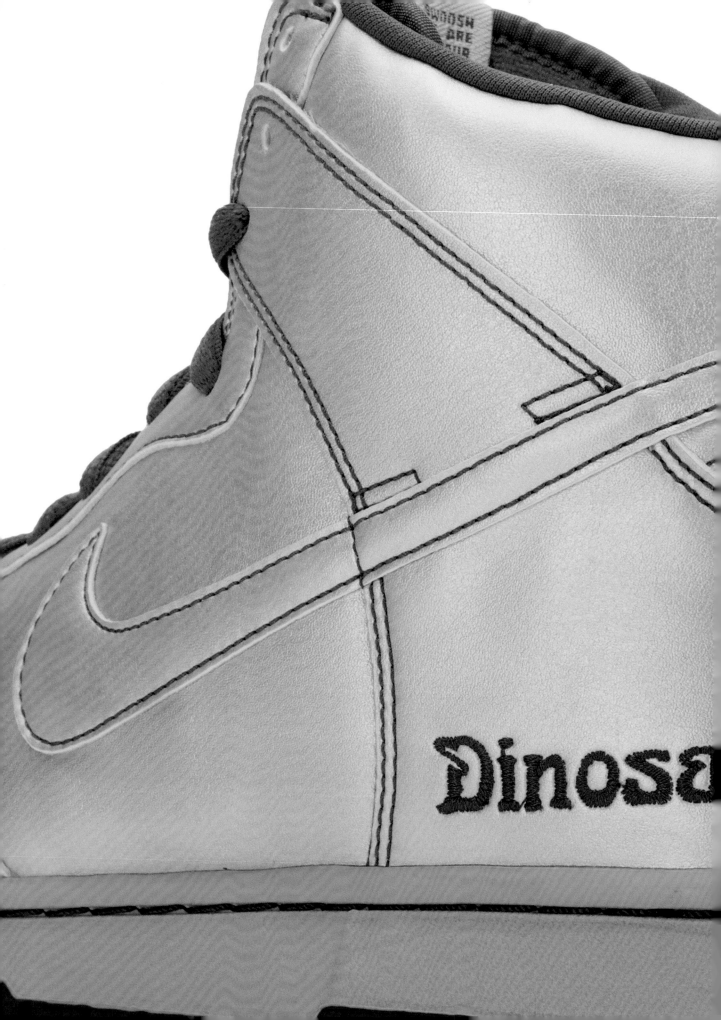

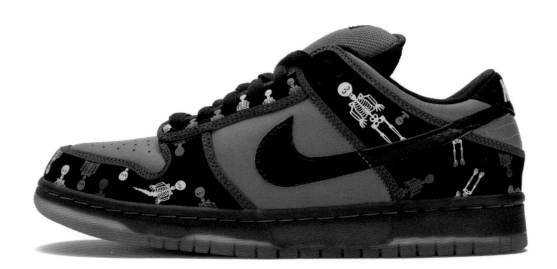

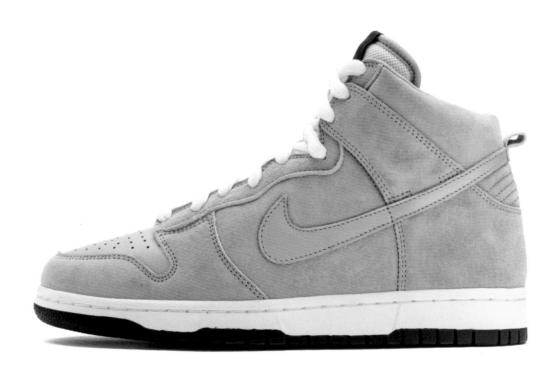

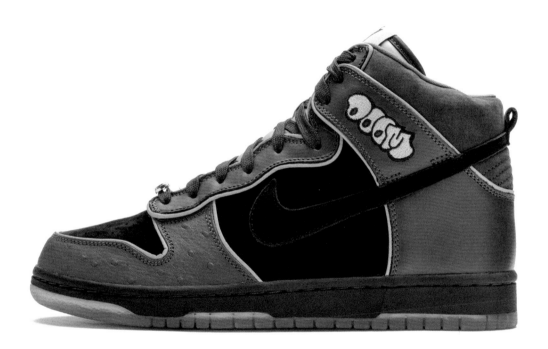

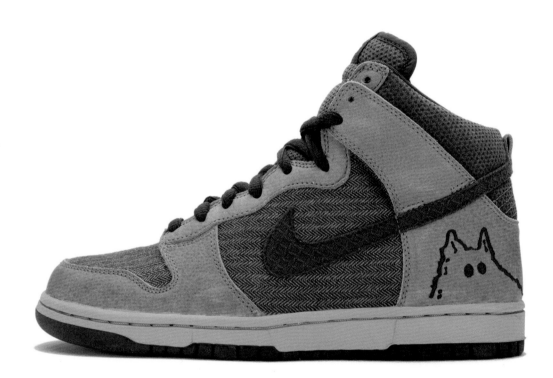

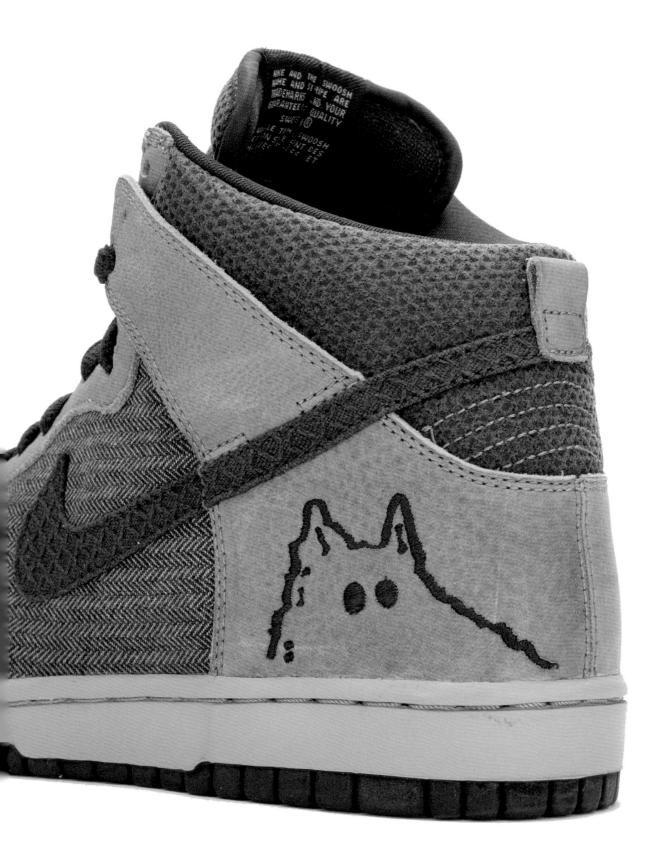

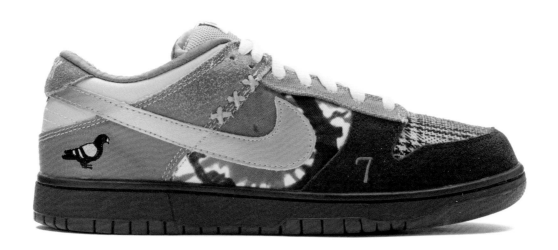

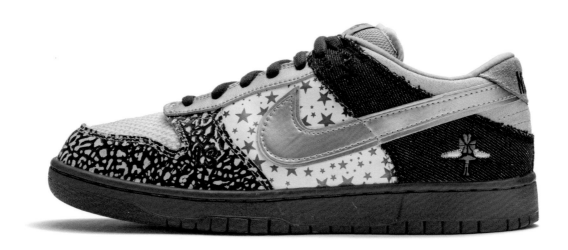

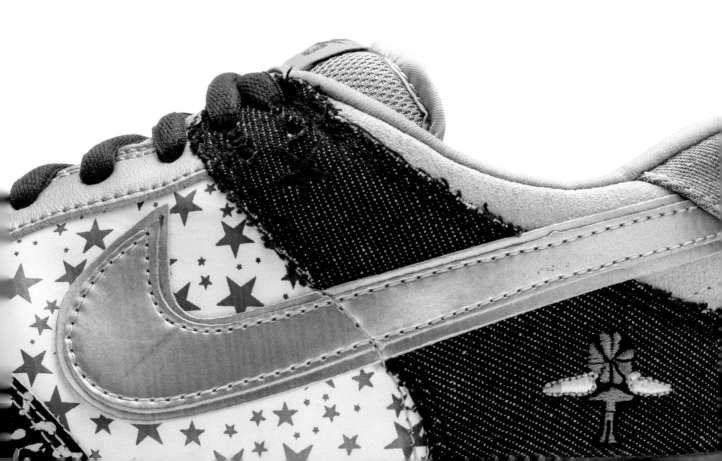

FREDDY'S

The one I did that I liked most is the Freddy Krueger. There was a lot of issues with that one. That's one I don't have. I have two left foot samples, that's it. As far as I heard, they'd landed in the States and were that close to coming out, but I think they had to destroy them all. That one was definitely an ask. It was part of something else they had already started. I didn't really question too much of how possible it is or if they're gonna get in trouble or how we even go about it. I just kind of went for it, right down to the insole art. It was Freddy's flesh, his burned-up flesh. It was really cool.

The whole thing came together great, but I went over the top. I made it blatantly obvious what this was. Sometimes with that Freddy one or the Cheech and Chong one, there was no denying what they were meant to be just to look at them. It takes two seconds to figure out what that is. There really was no arguing that it's just a similarity.

Todd Bradtrud

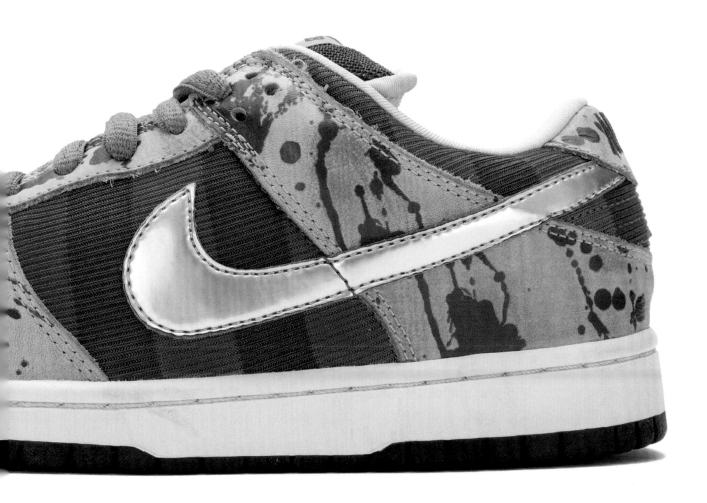

DUNK LOW PRO SB

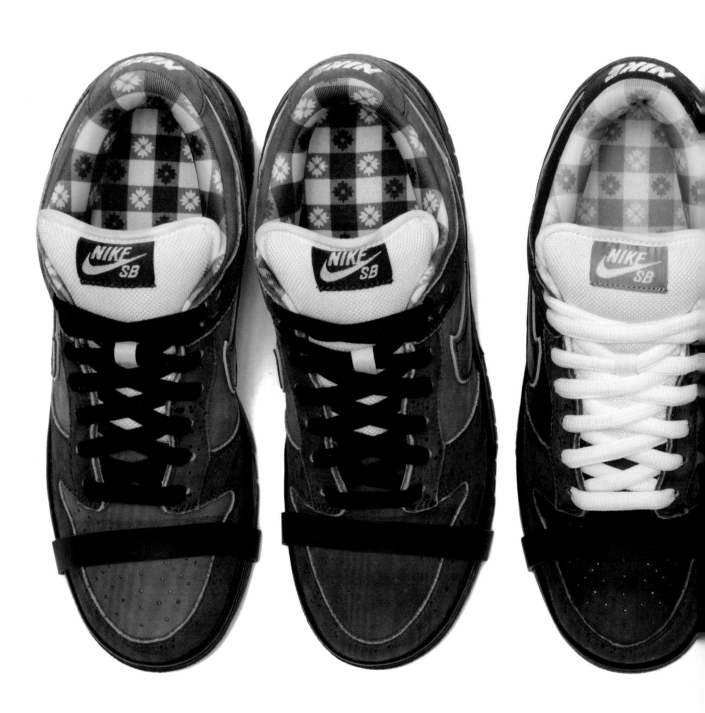

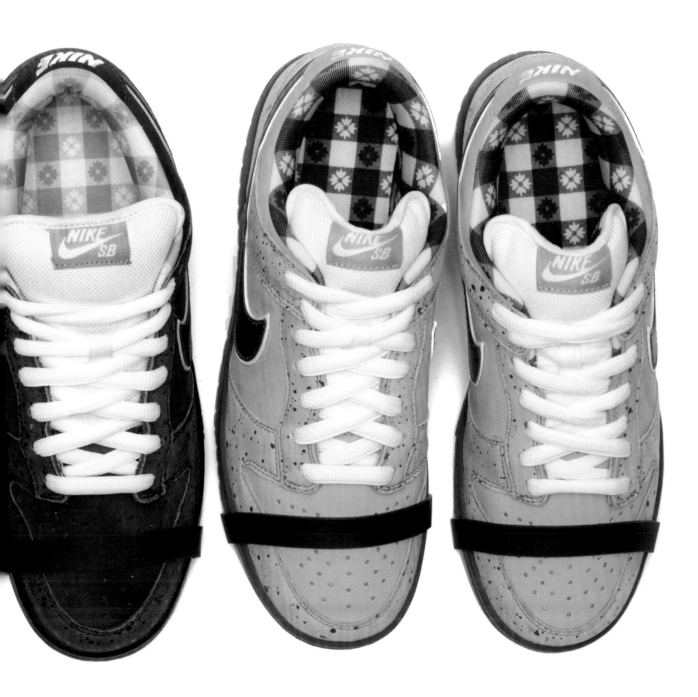

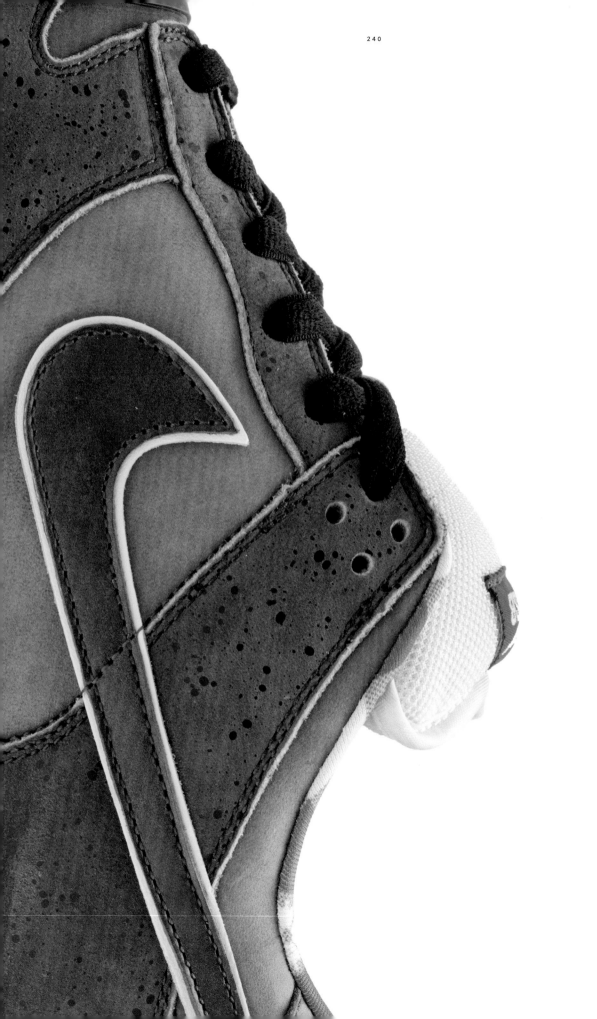

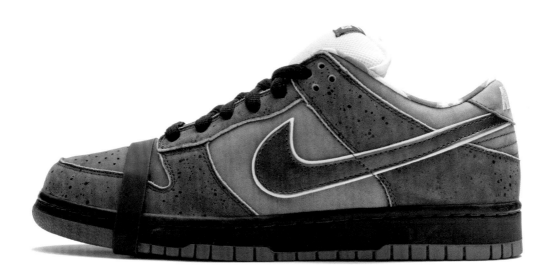

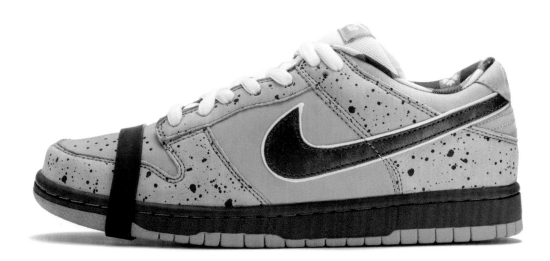

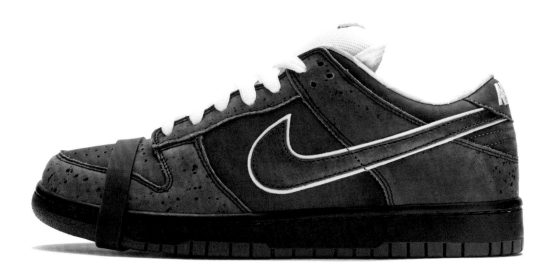

NIGHTSHADE/DARK SLATE BLUE LOBSTER

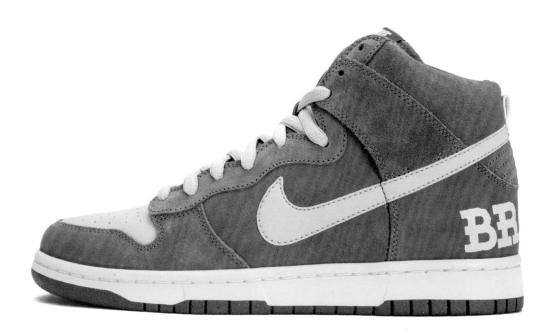

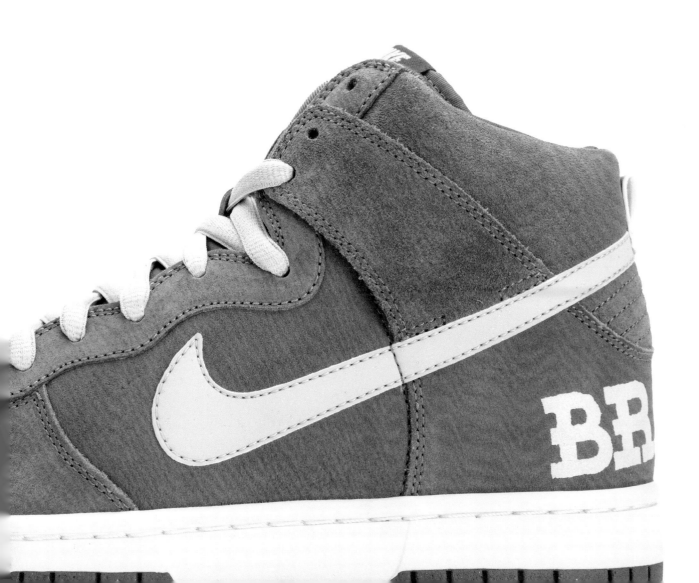

SKUNKS

For the Skunks, I kind of knew the drill as far as just alluding to something—never officially putting a name or a logo on anything—by choosing colors that definitely represent this or that. As long as you didn't talk it up and say exactly what it was beforehand, you could usually get away with it. I feel like nobody really even noticed at first what was going on or what it was or why it looked the way it did.

Todd Bratrud

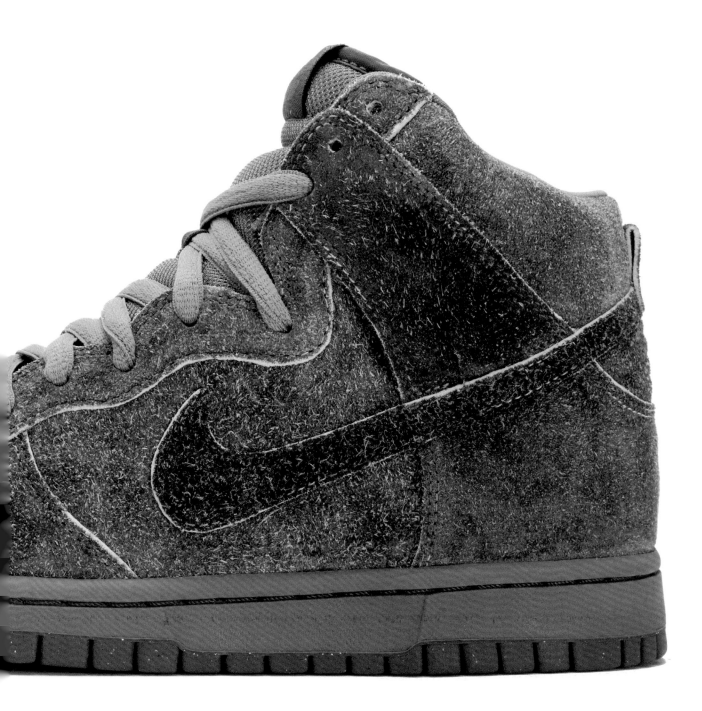

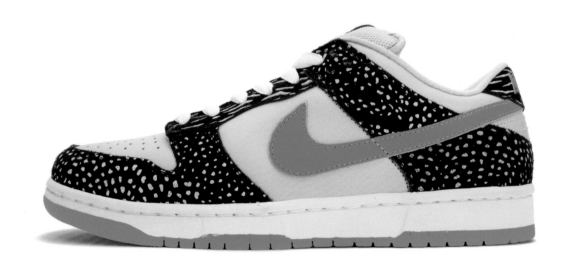

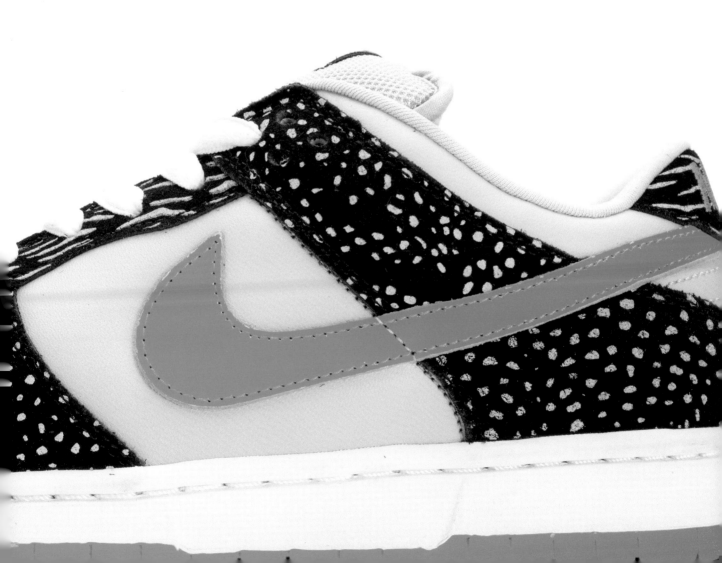

ERIC KOSTON DUNKS

When it was time to do the colors, I just thought back to my heritage. For the lows, it was the colors for the Thai flag and the high was based on the Thai temple.

If you look at a Thai temple it's all Thai symbols. It's all gold, and a lot of it's gold tiling. So we did this clear print over it and a matte clear over the metallic leather so it would have the tiling effect.

When I joined SB they wanted to make some changes to the Dunk and I was part of giving them insight on what to do. I was definitely helping out with making it more skateable. On the lows, you know, I didn't want to change much as far as the aesthetic of the silhouette at all. I wanted it to maintain the integrity. The low would slip off a lot. You wanted the fat tongue because the fat tongue actually helped keep the shoe on your foot. So we put in that little molded foam piece that kind of hugged over the top of your heel and basically wraps around your Achilles and the top of your heel.

My other thing was they were just using the standard rubber compound for the Dunk. And I always thought it got kind of slippery. After it wore down, it kind of got a little slick. I thought we should change that to a softer rubber compound so it's a little grippier.

Eric Koston

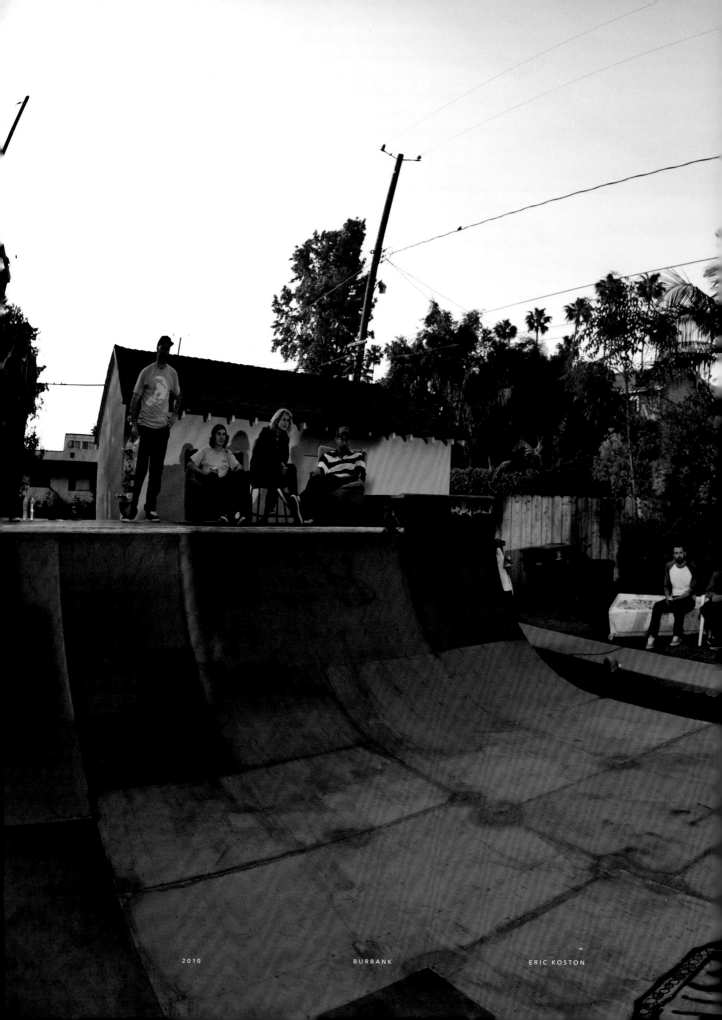

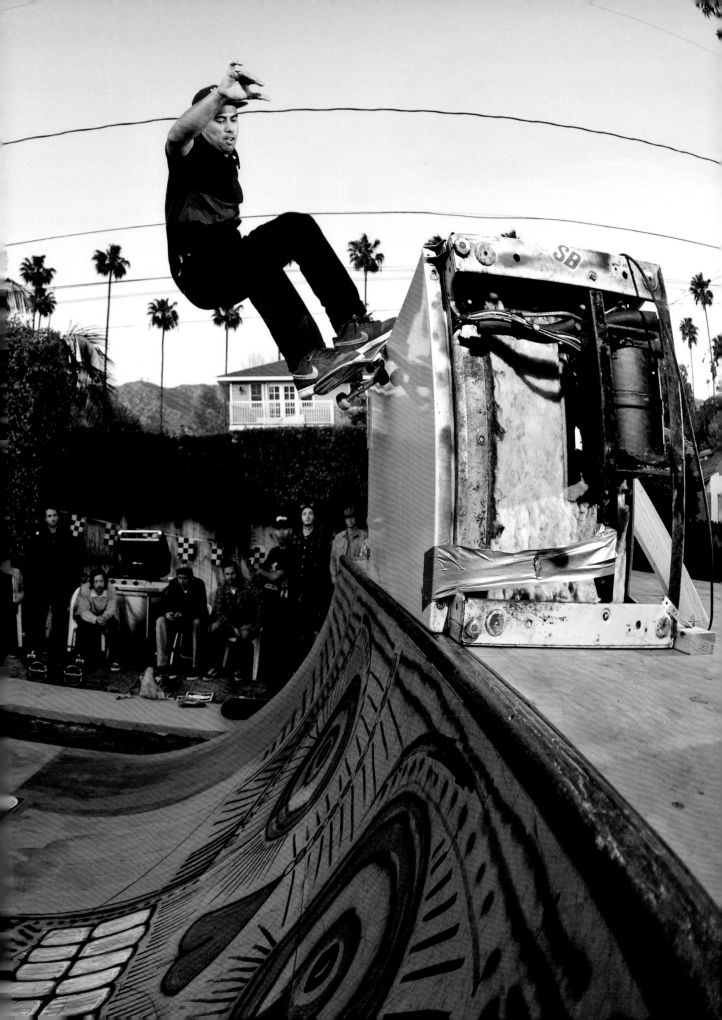

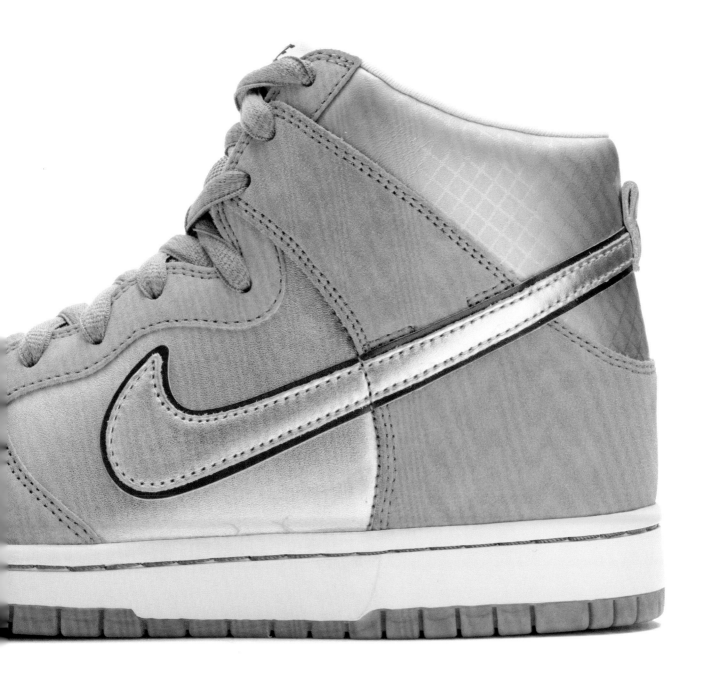

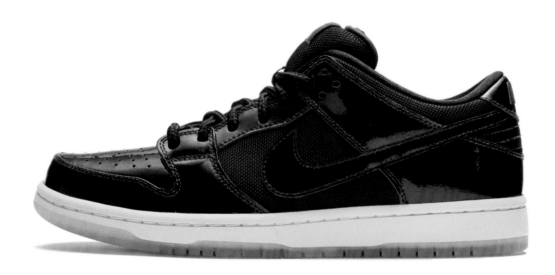

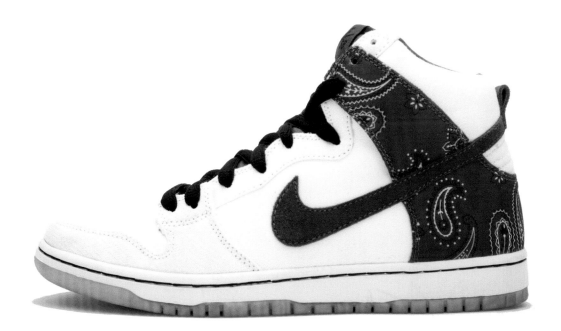

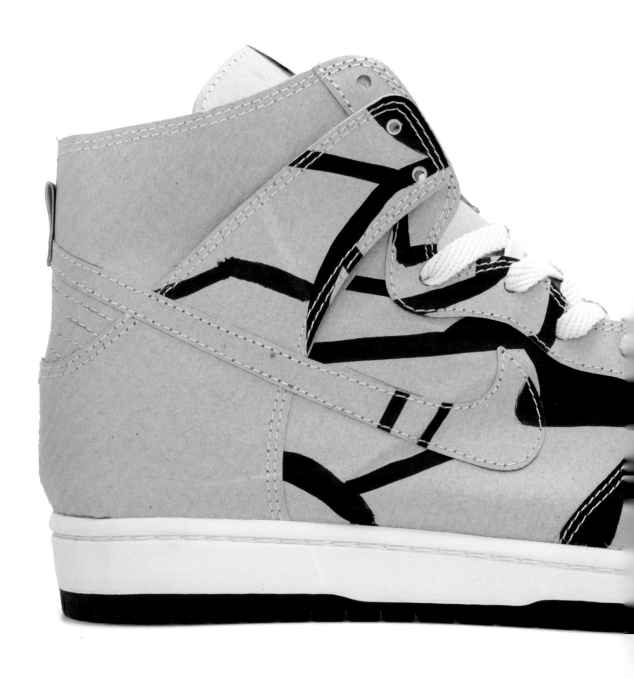

THE PAPER DUNK

The Paper Dunk was a fund raiser piece for the MOCA, Art in the Streets. It was a piece of art that needed to be destroyed to make the shoes. So it's a commentary on vandalism, destruction, and art work, making a product that is going to be collected, sold, it's rare, it's Nike, it's iconic.

Geoff McFetridge

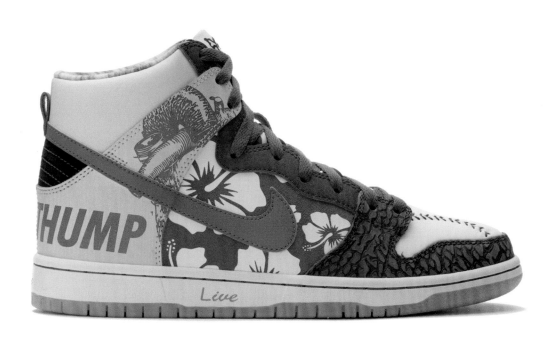

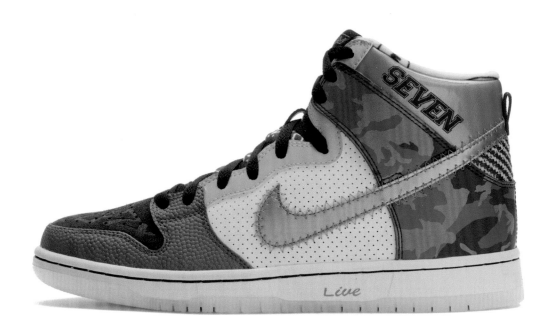

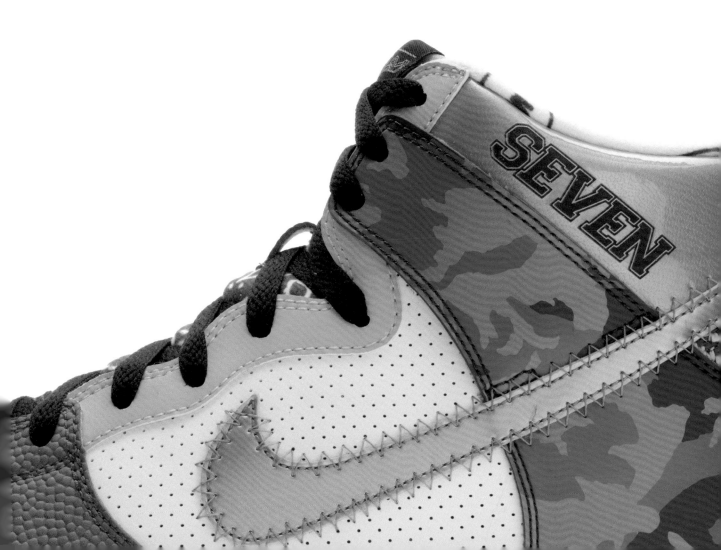

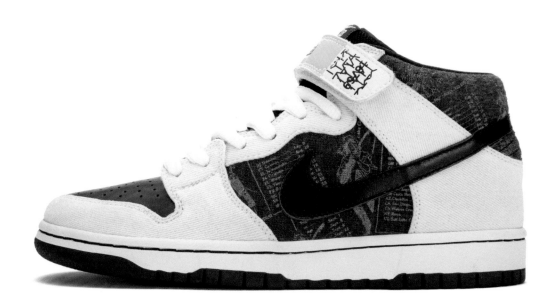

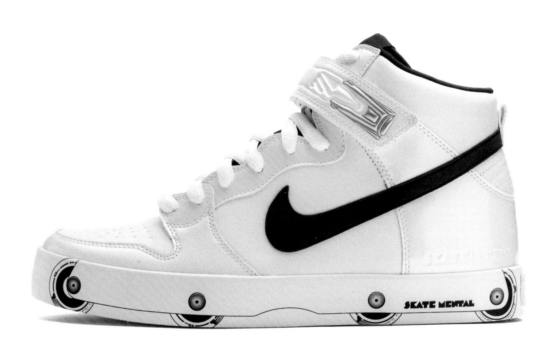

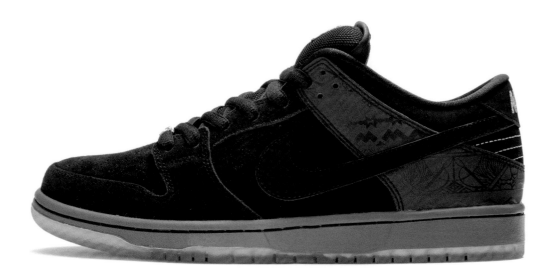

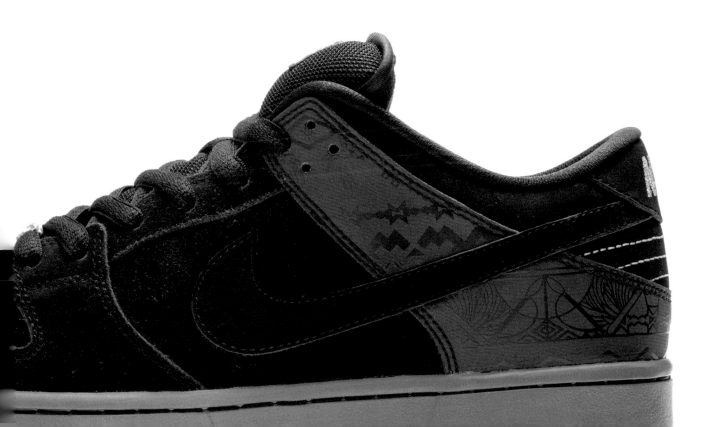

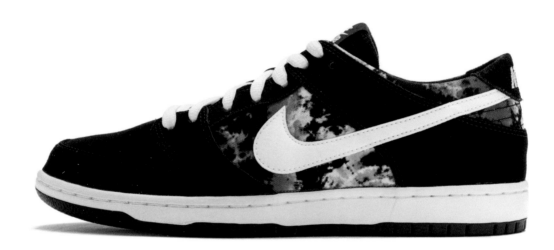

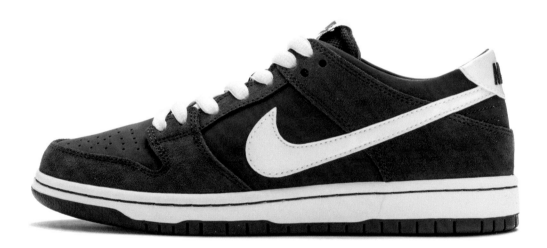

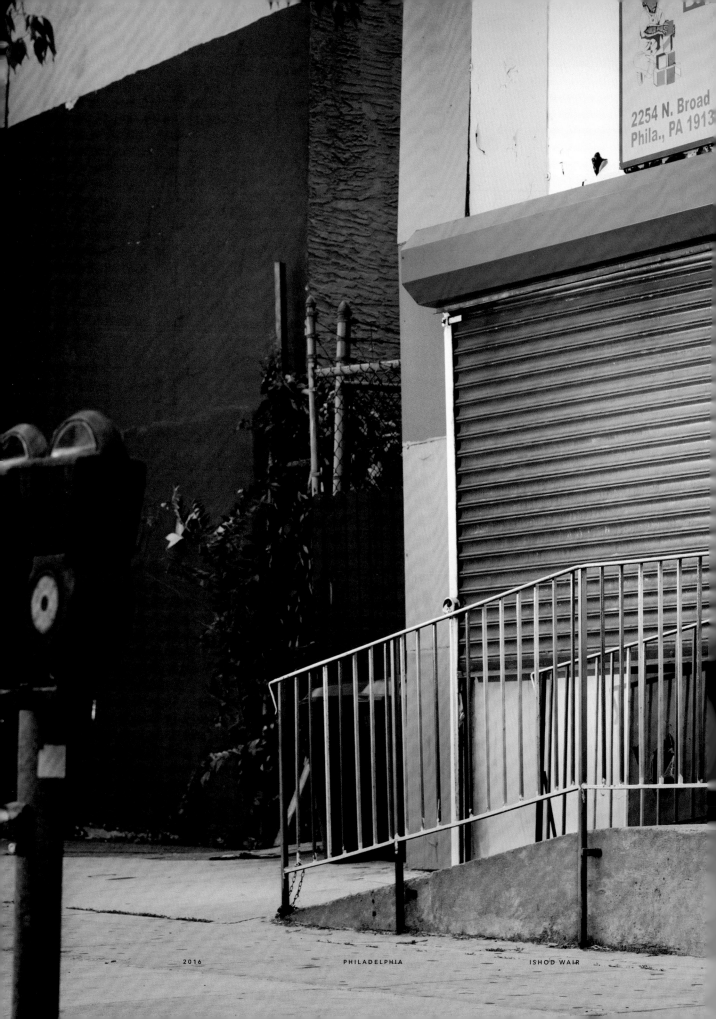

2254 N. Broad
Phila., PA 1913

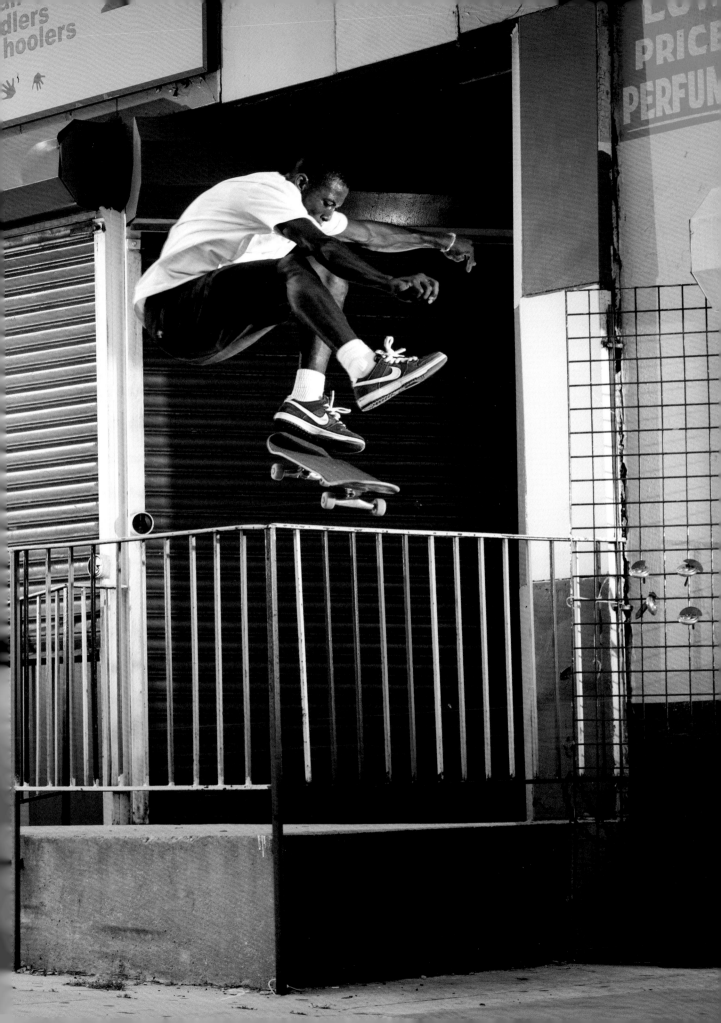

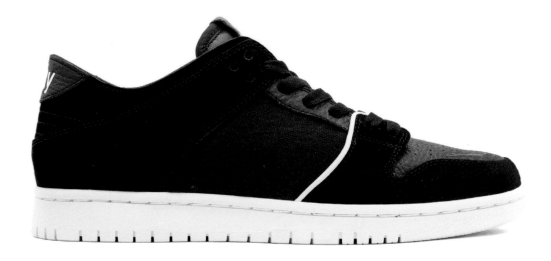

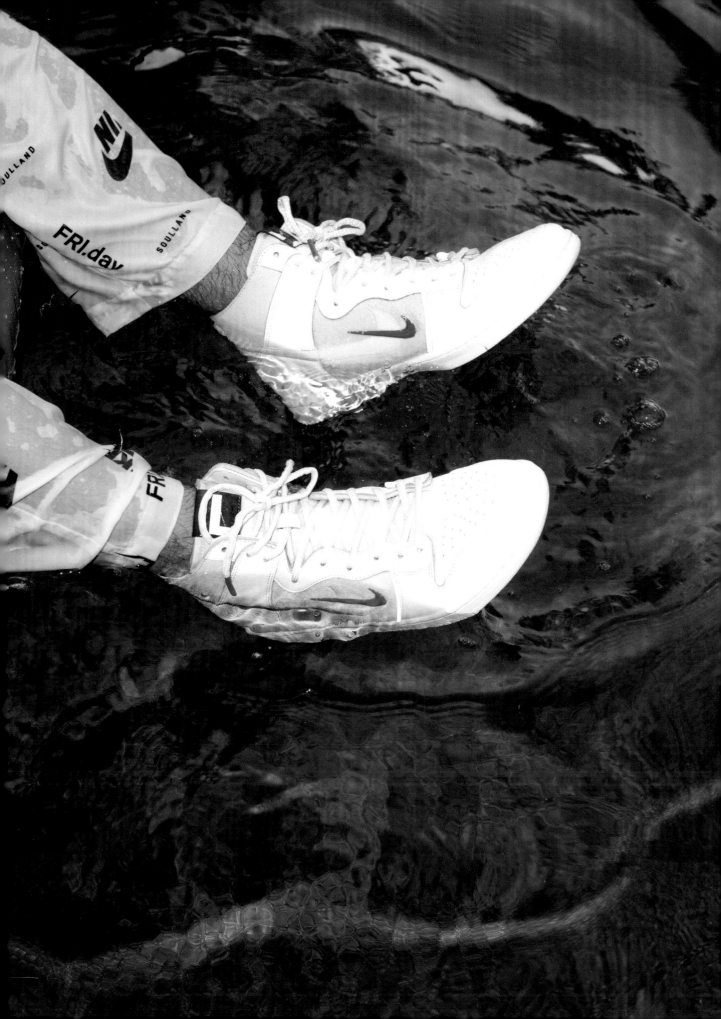

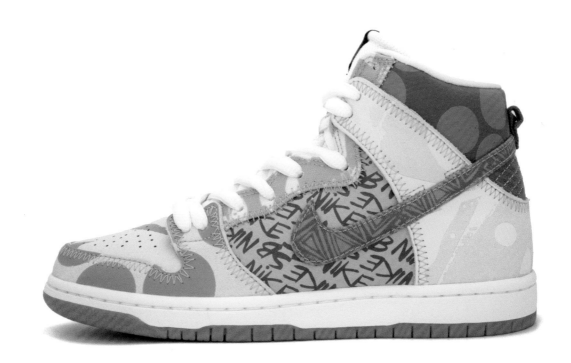

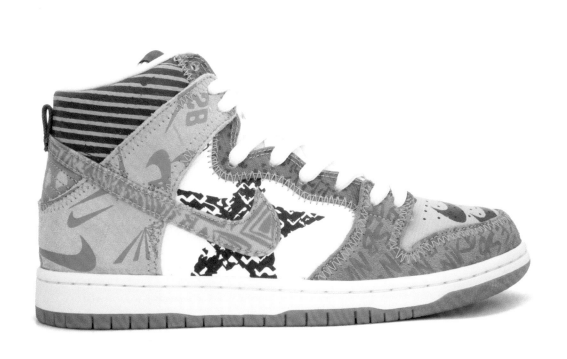

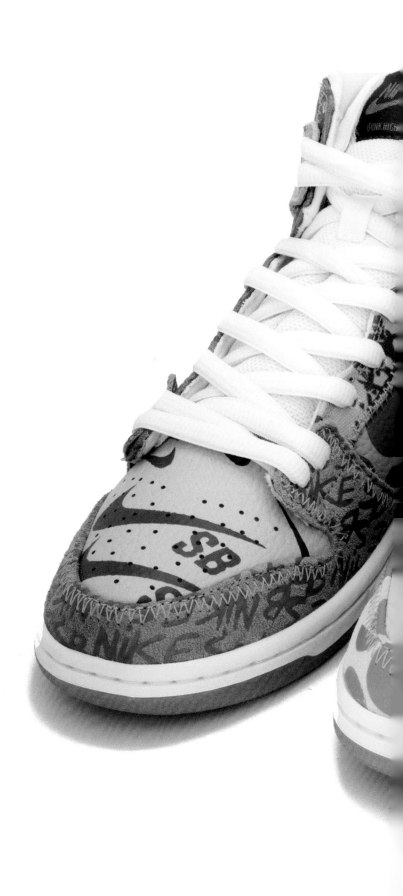

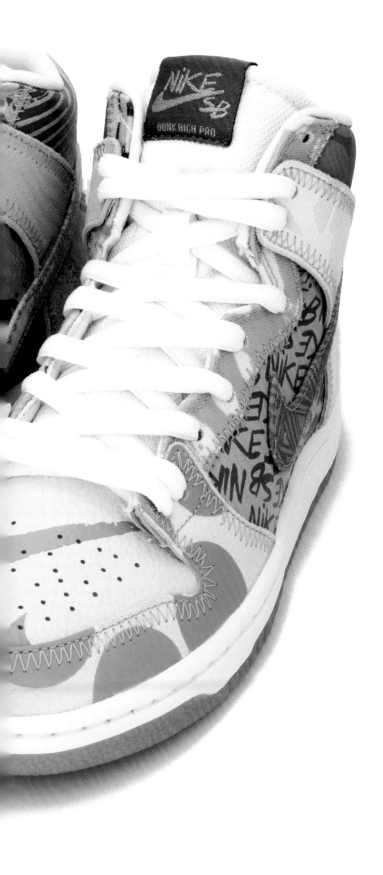

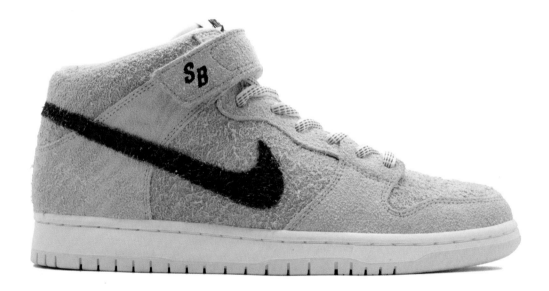

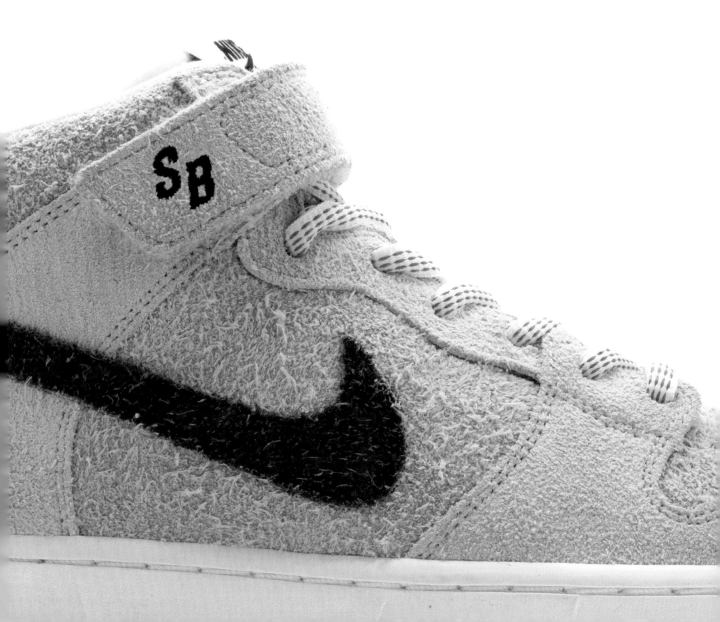

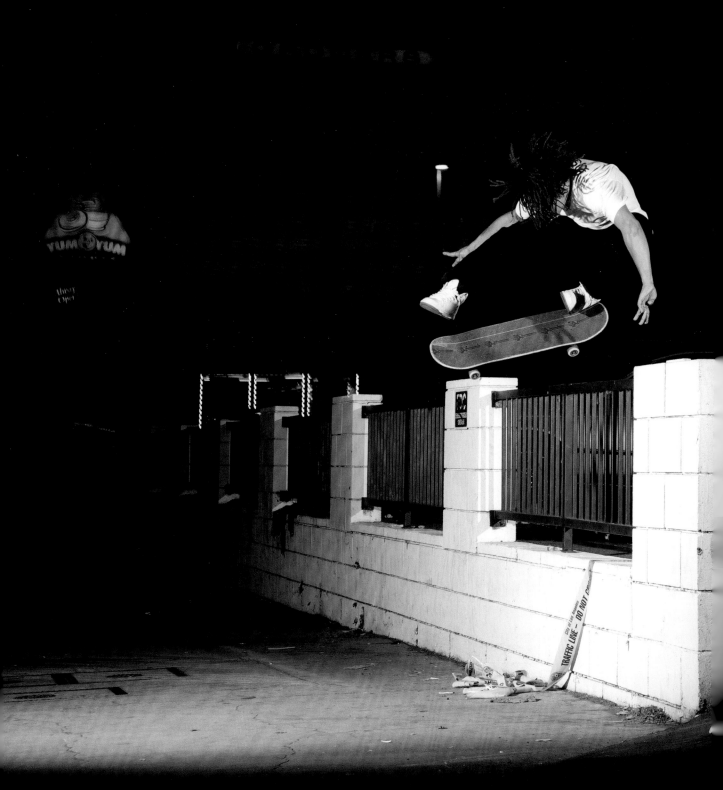

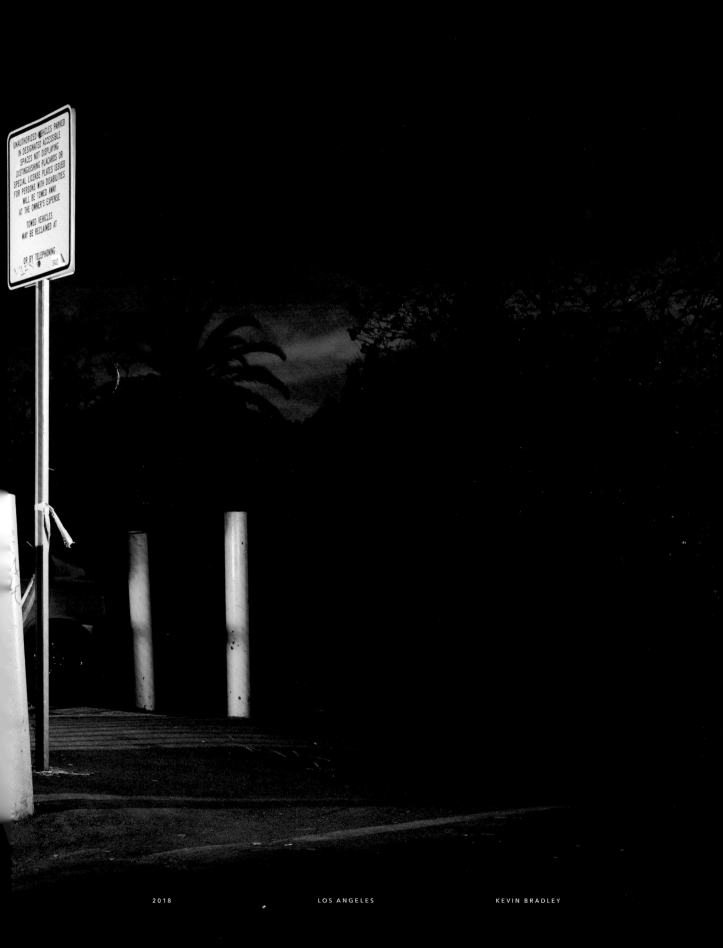

UNAUTHORIZED VEHICLES PARKED
IN DESIGNATED ACCESSIBLE
SPACES NOT DISPLAYING
DISTINGUISHING PLACARDS OR
SPECIAL LICENSE PLATES ISSUED
FOR PERSONS WITH DISABILITIES
WILL BE TOWED AWAY
AT THE OWNER'S EXPENSE

TOWED VEHICLES
MAY BE RECLAIMED AT

OR BY TELEPHONING

2018 LOS ANGELES KEVIN BRADLEY

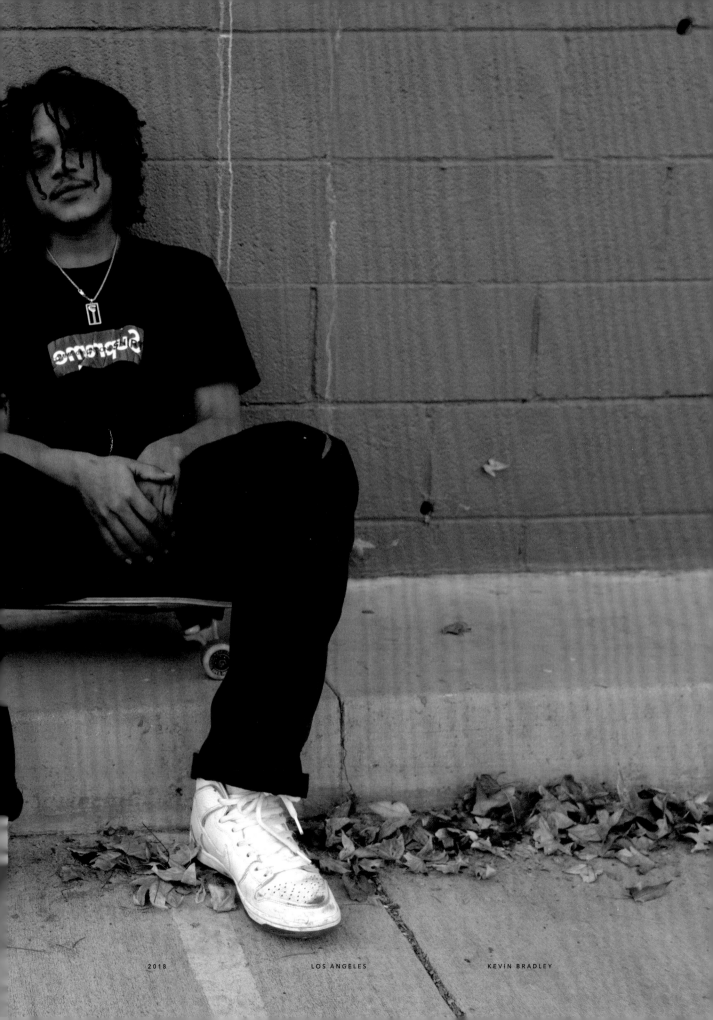

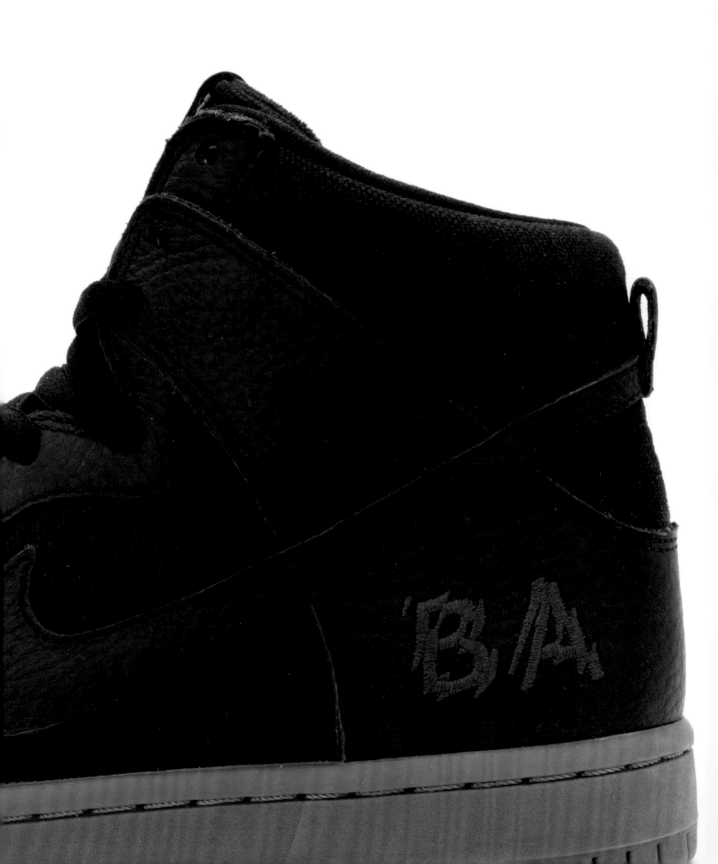

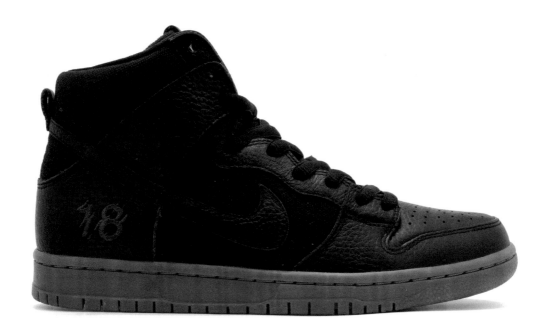

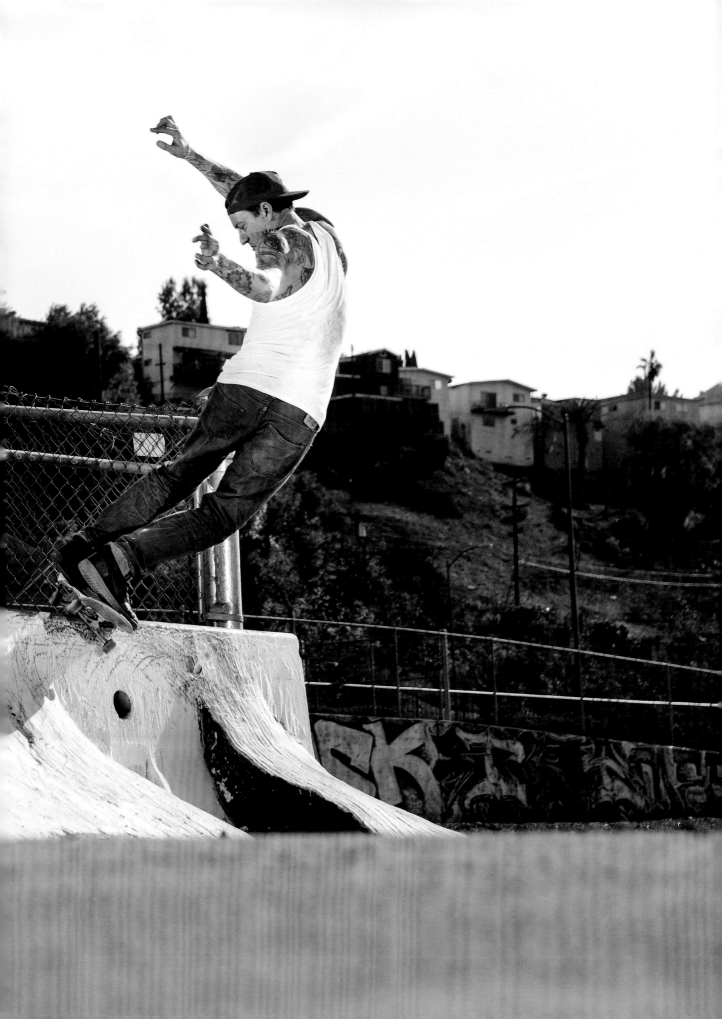

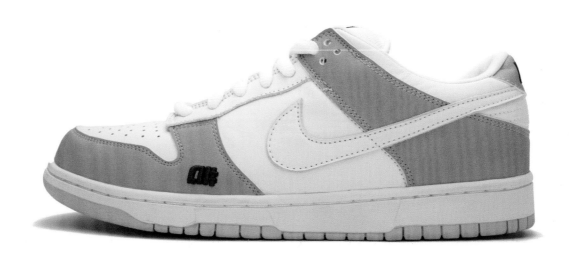

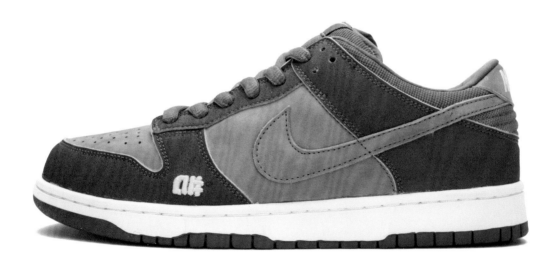

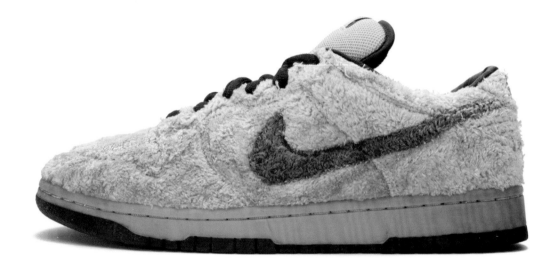

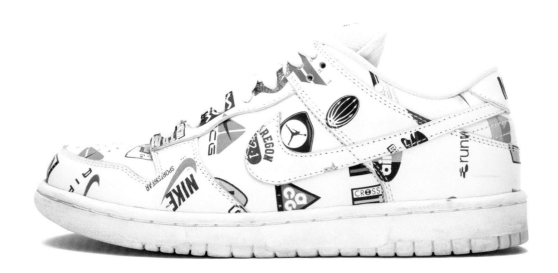

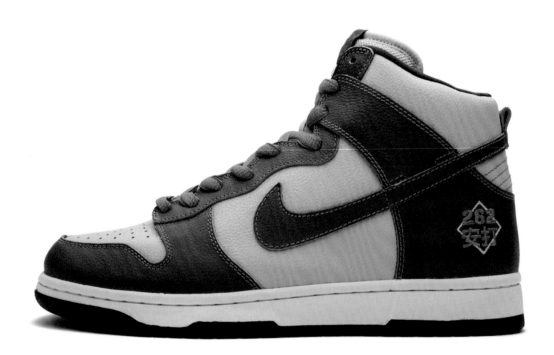

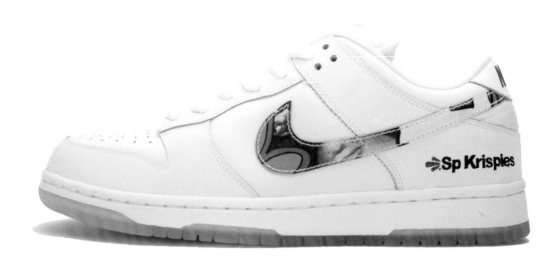

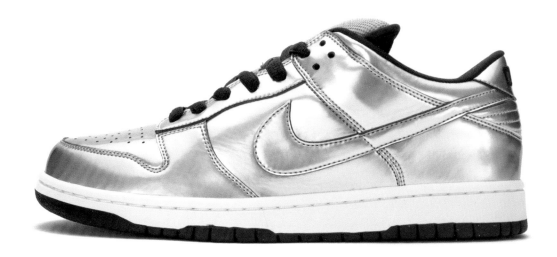

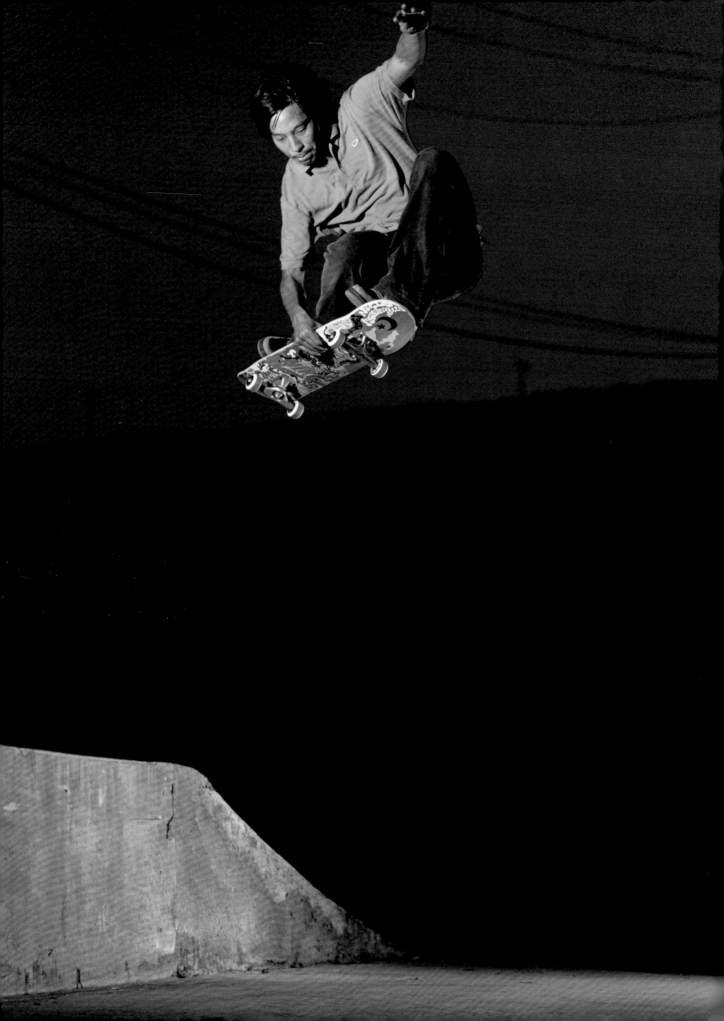

2005

LOS ANGELES

DANIEL SHIMIZU

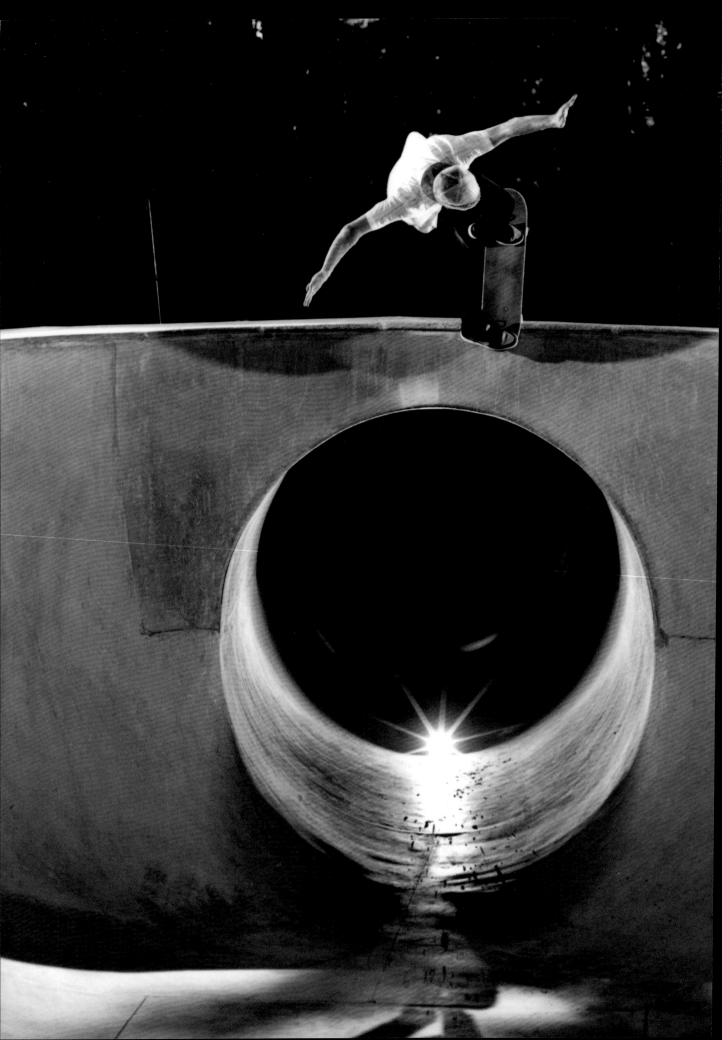

2006

MCMENVILLE

CHET CHILDRESS

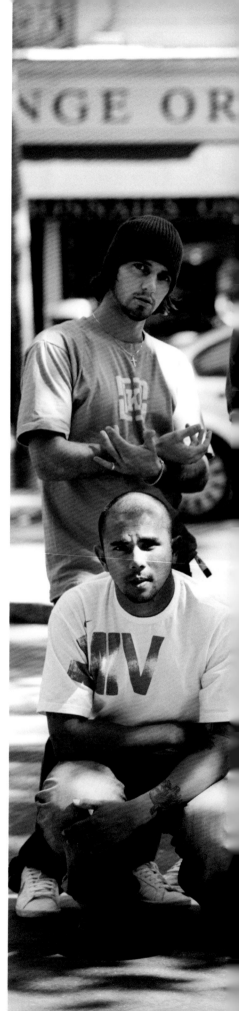

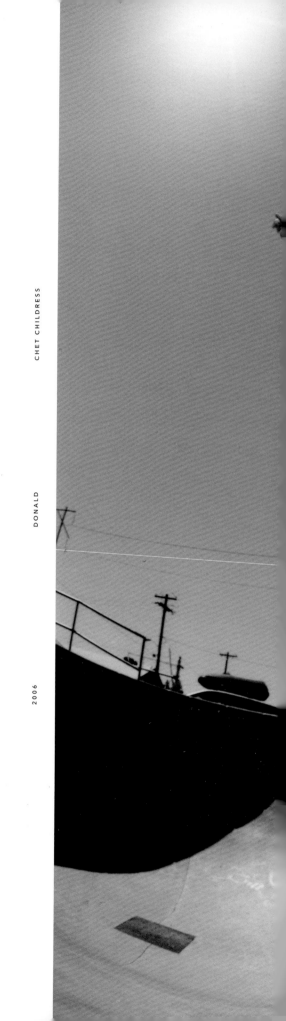

2006 DONALD CHET CHILDRESS

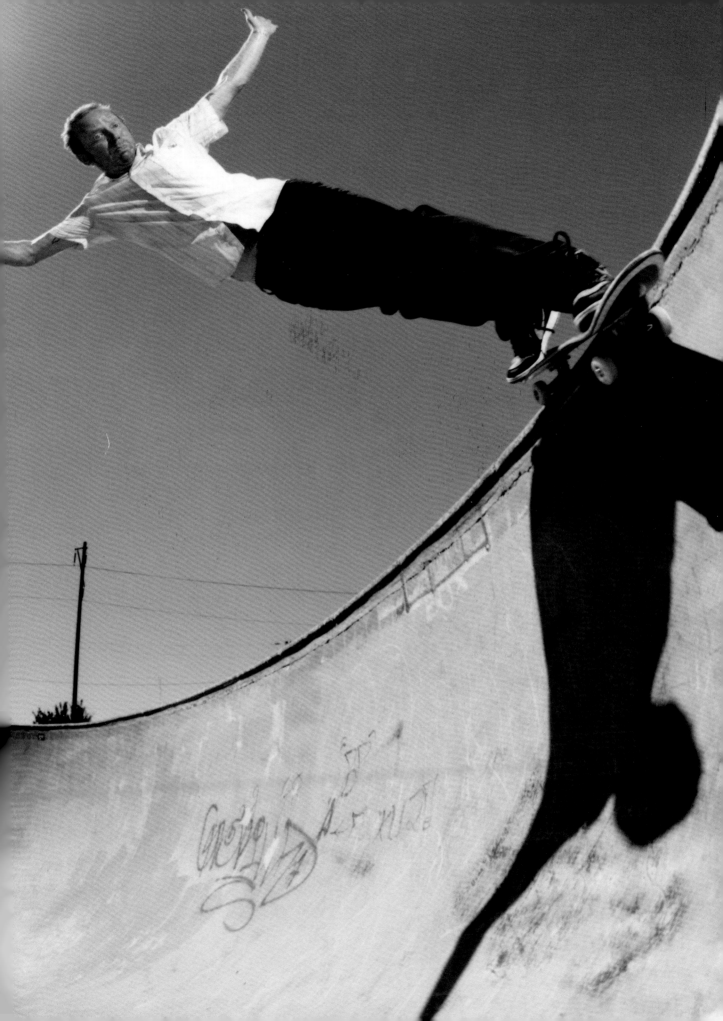

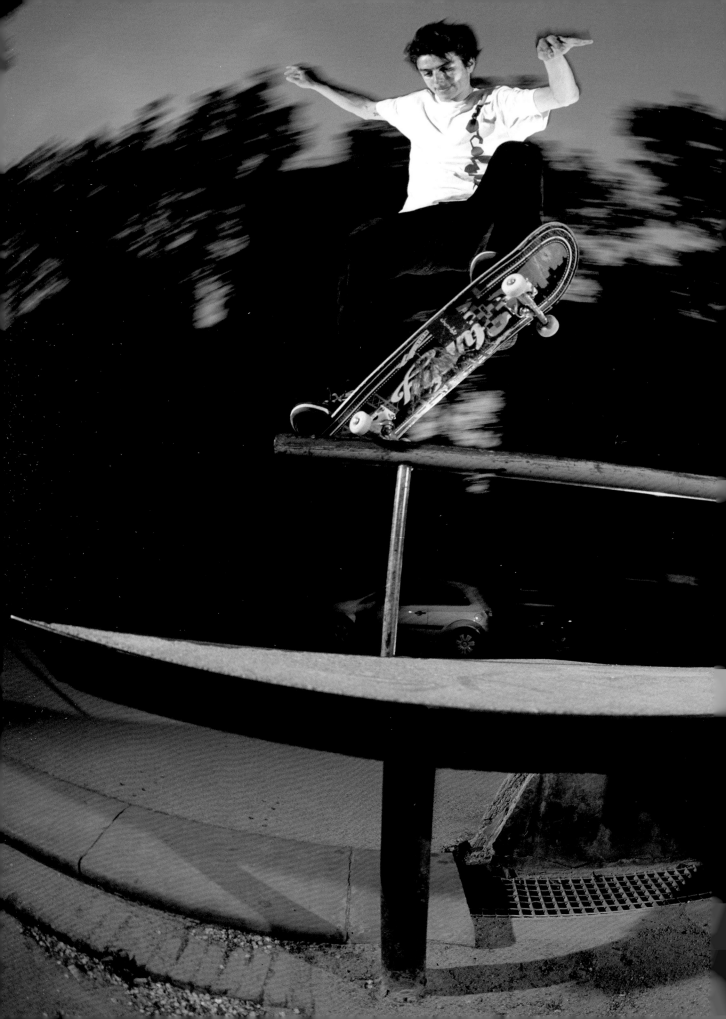

2007

BARCELONA

DARYL ANGEL

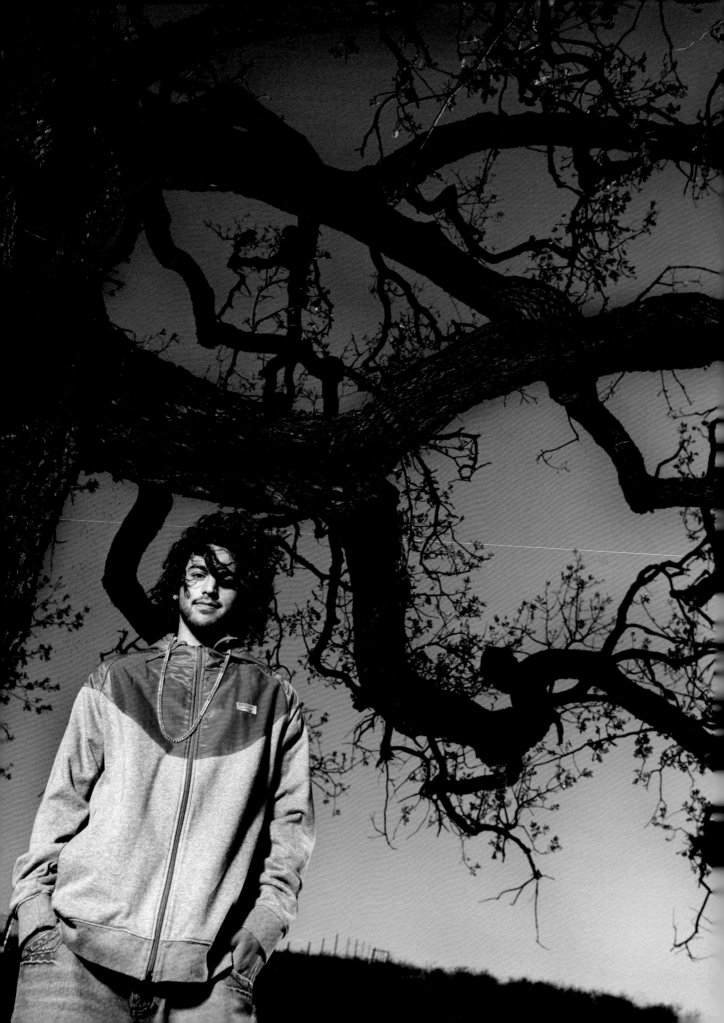

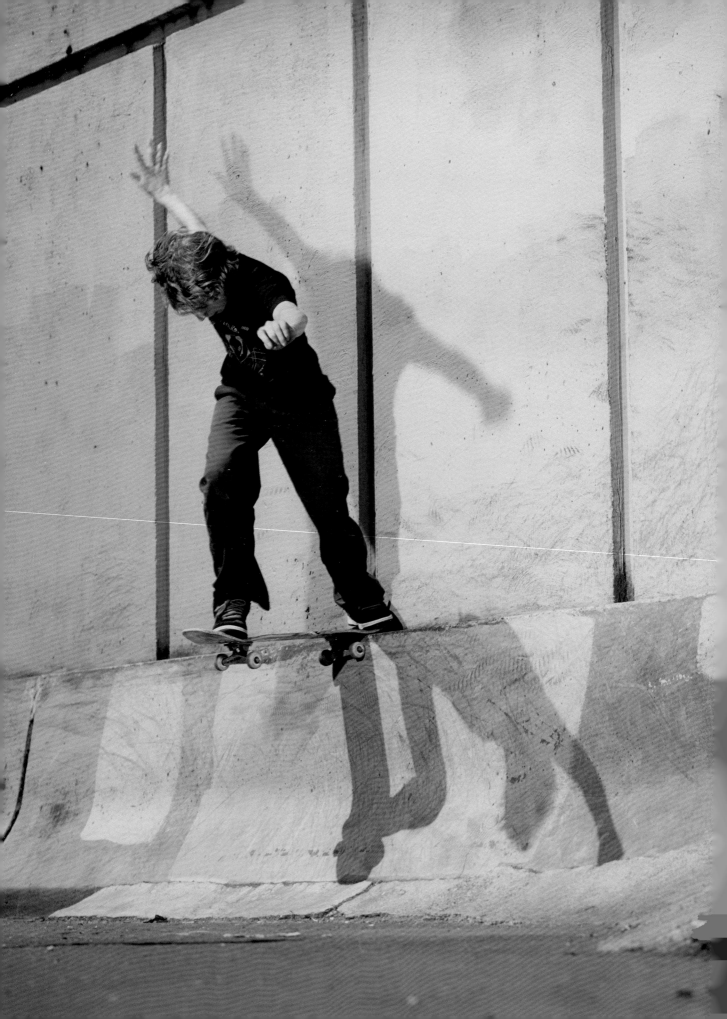

2007

PORTLAND

GRANT TAYLOR

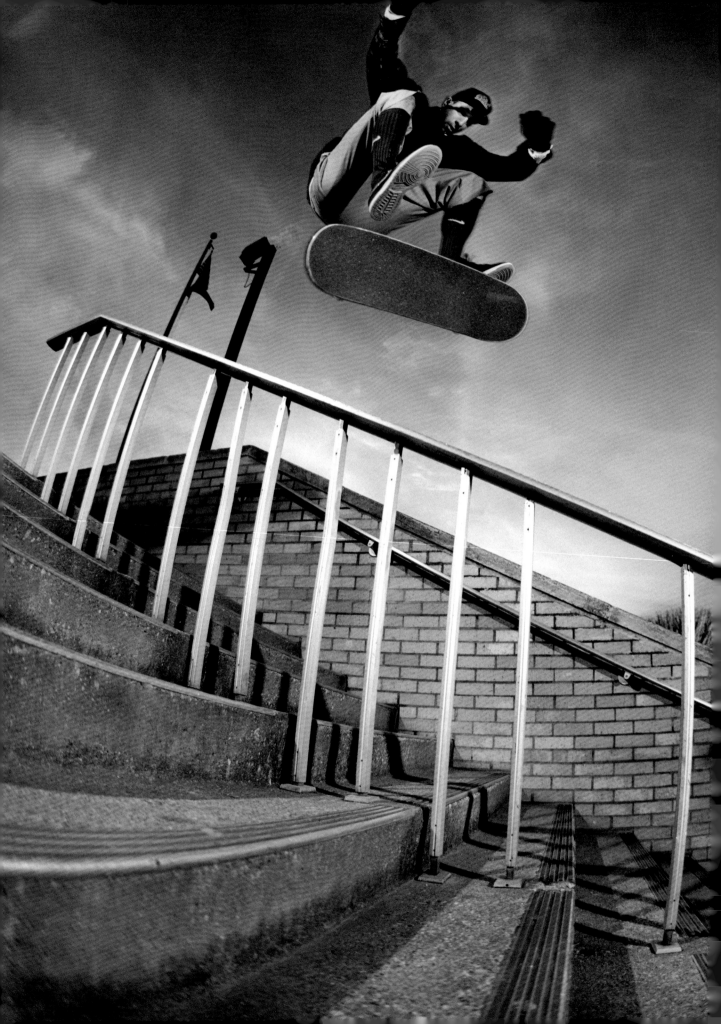

2006

DALLAS

BRIAN ANDERSON

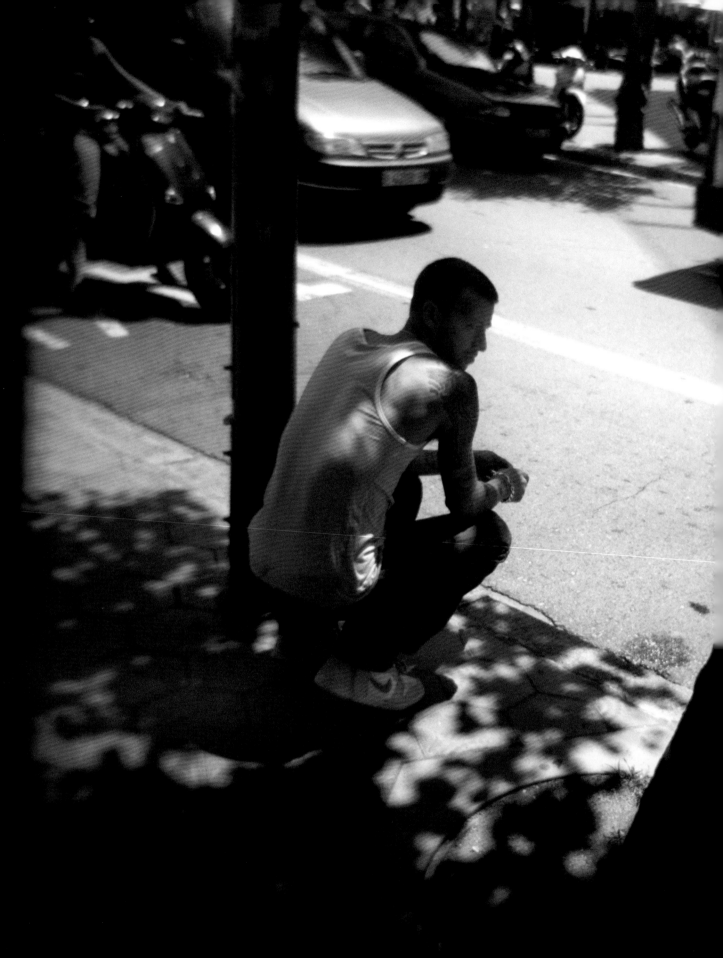

2004

BARCELONA

BRIAN ANDERSON

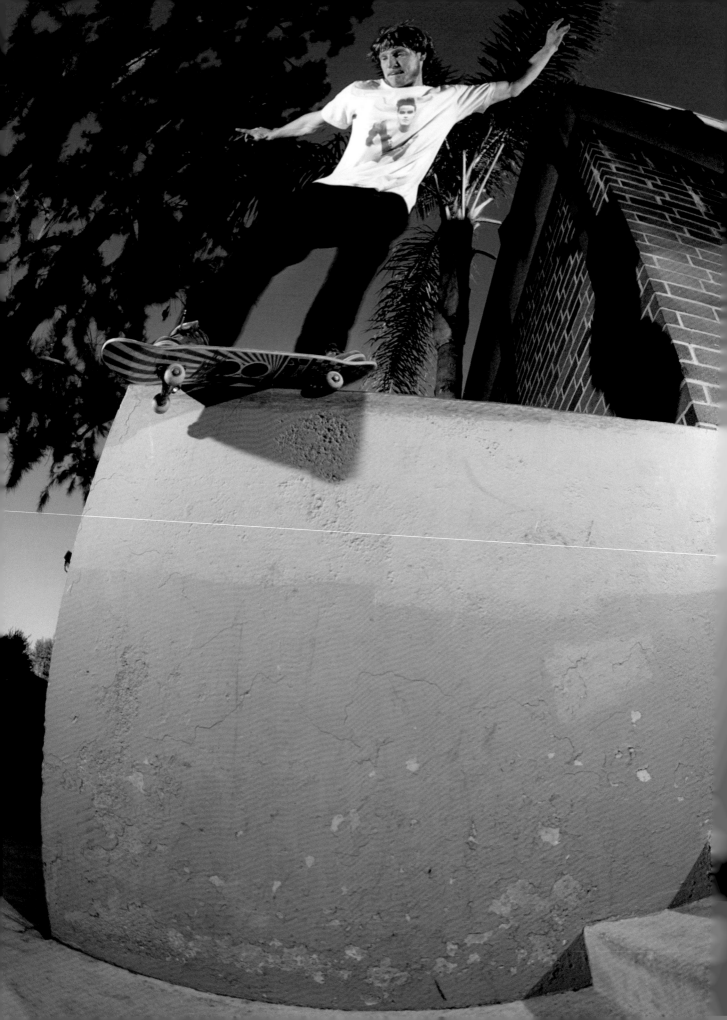

2007

WOODLAND HILLS

WIEGER VAN WAGENINGEN

GRANT TAYLOR

PORTLAND

2007

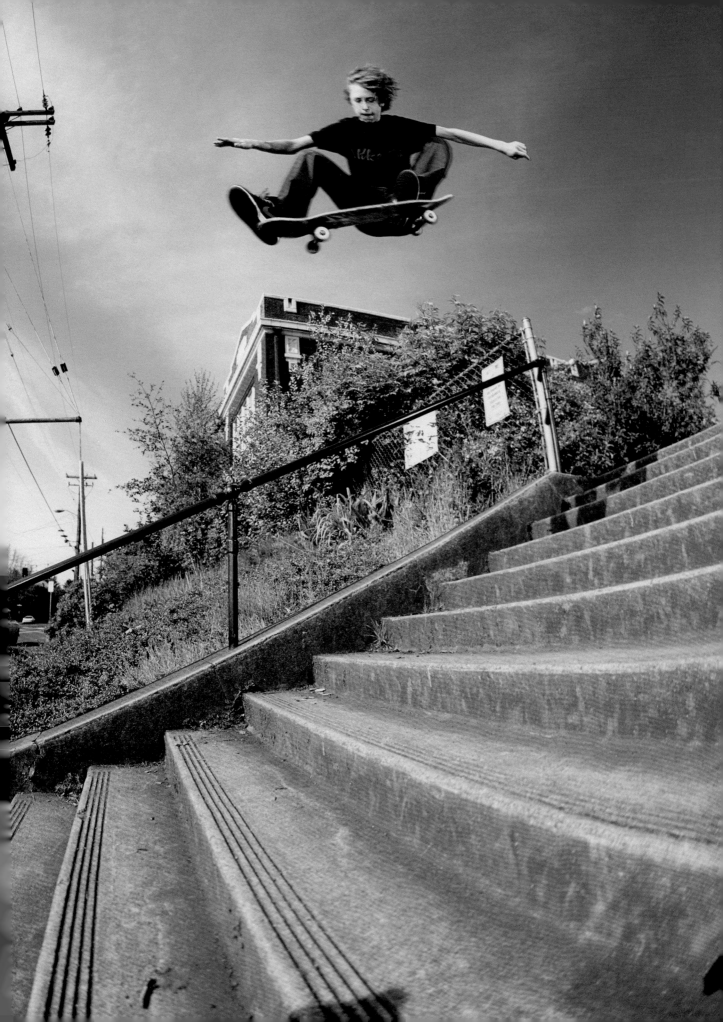

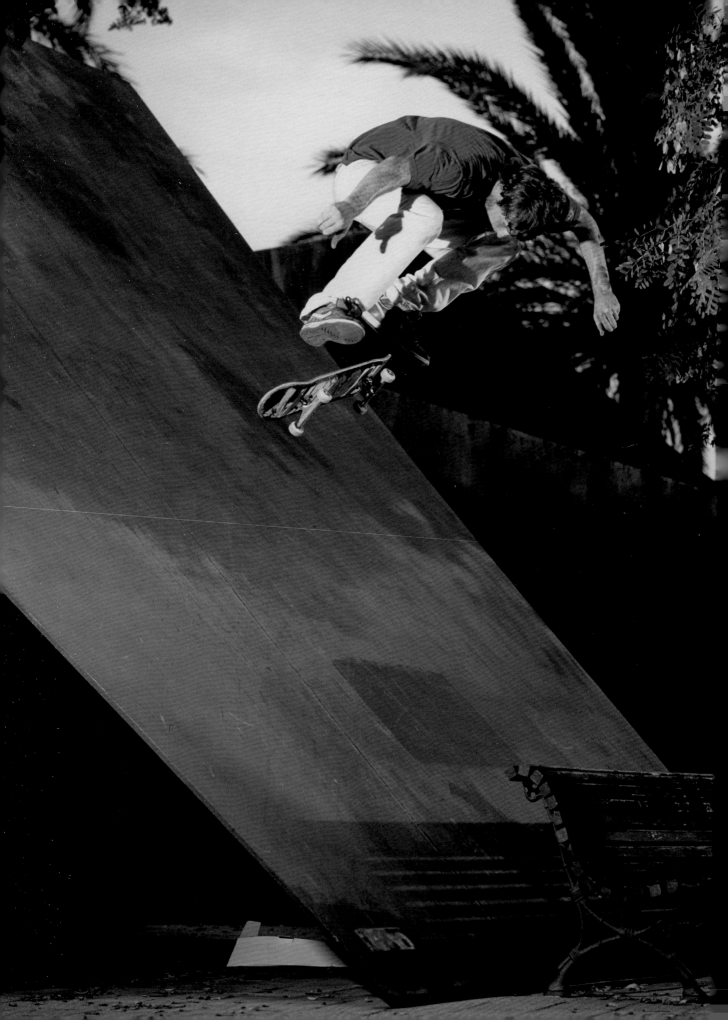

2006

BARCELONA

WIEGER VAN WAGENINGEN

GRANT TAYLOR

NEW JERSEY

2005

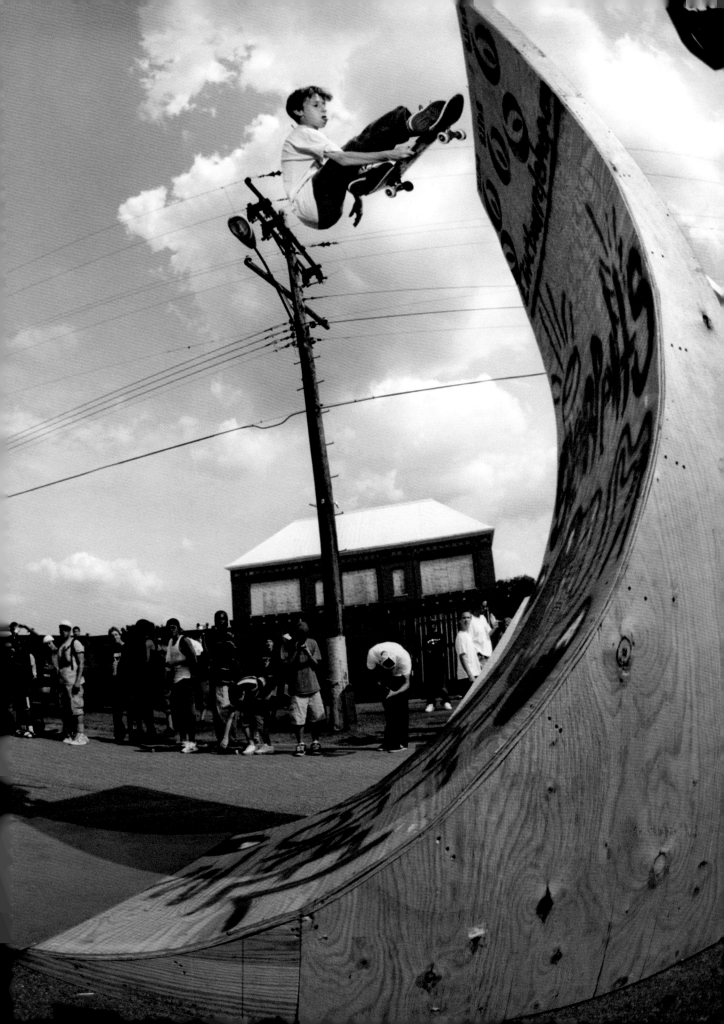

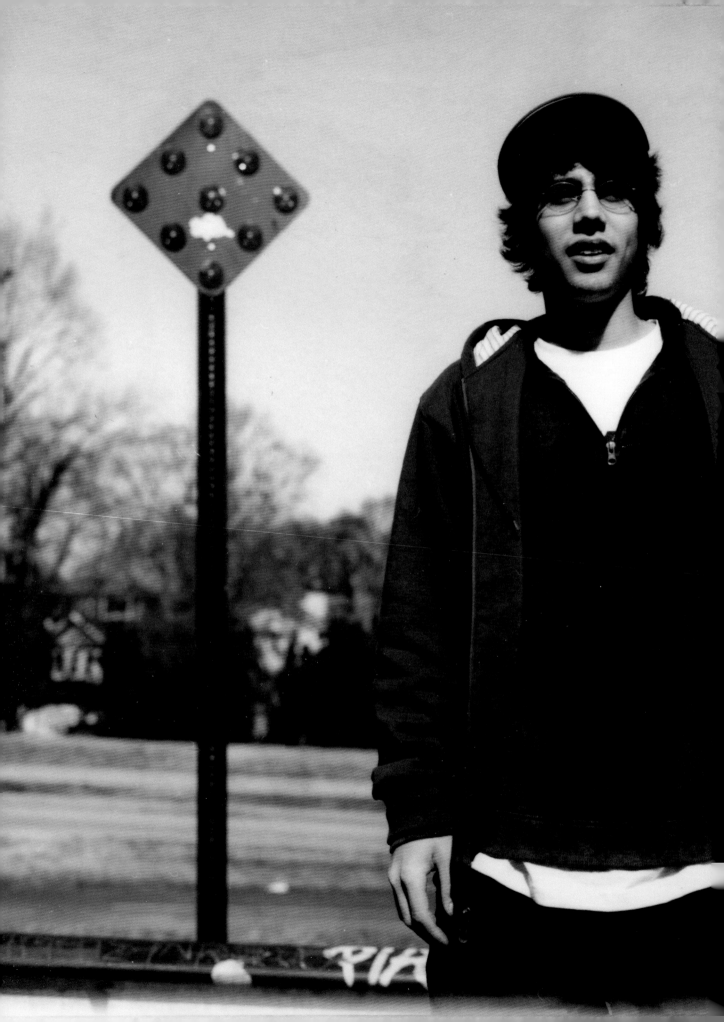

2006

ATLANTA

JUSTIN BROCK

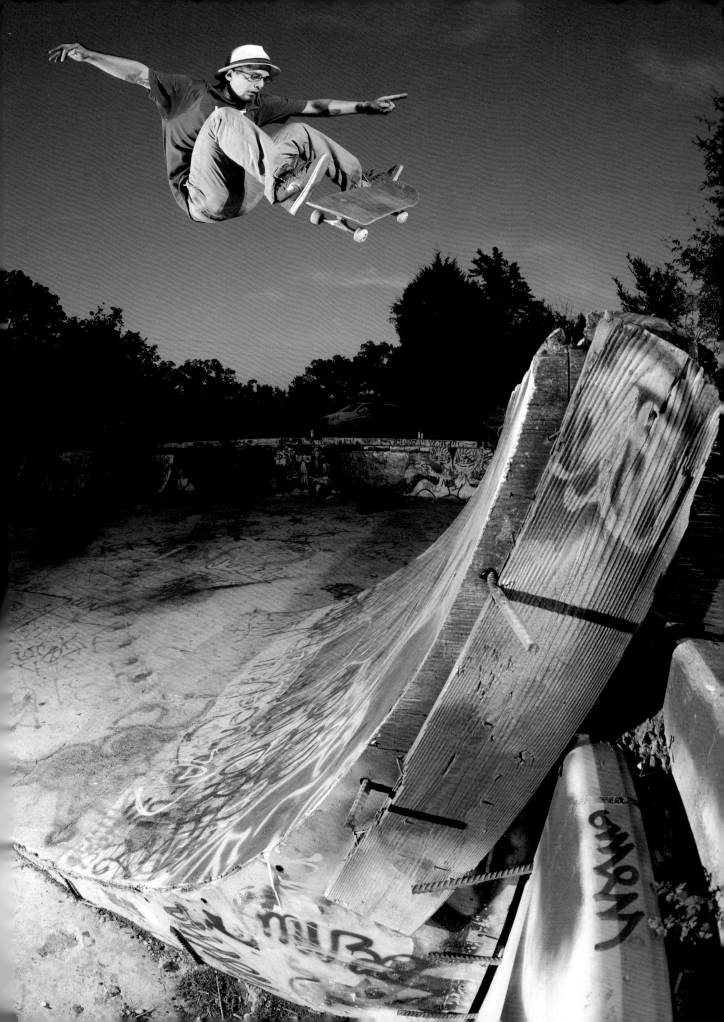

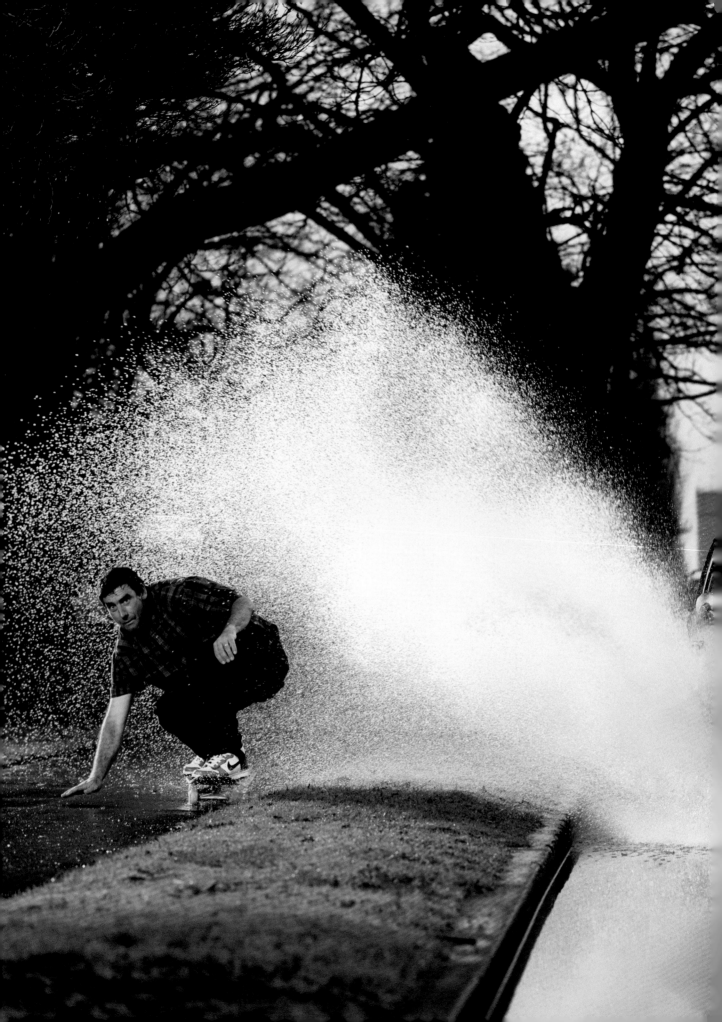

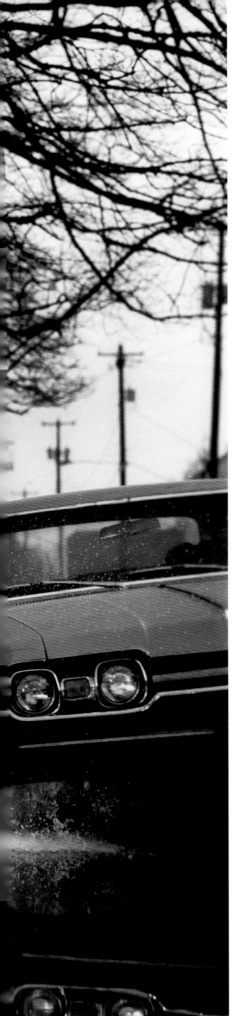

2008

PORTLAND

LANCE MOUNTAIN

WIEGER VAN WAGENINGEN

LOS ANGELES

2003

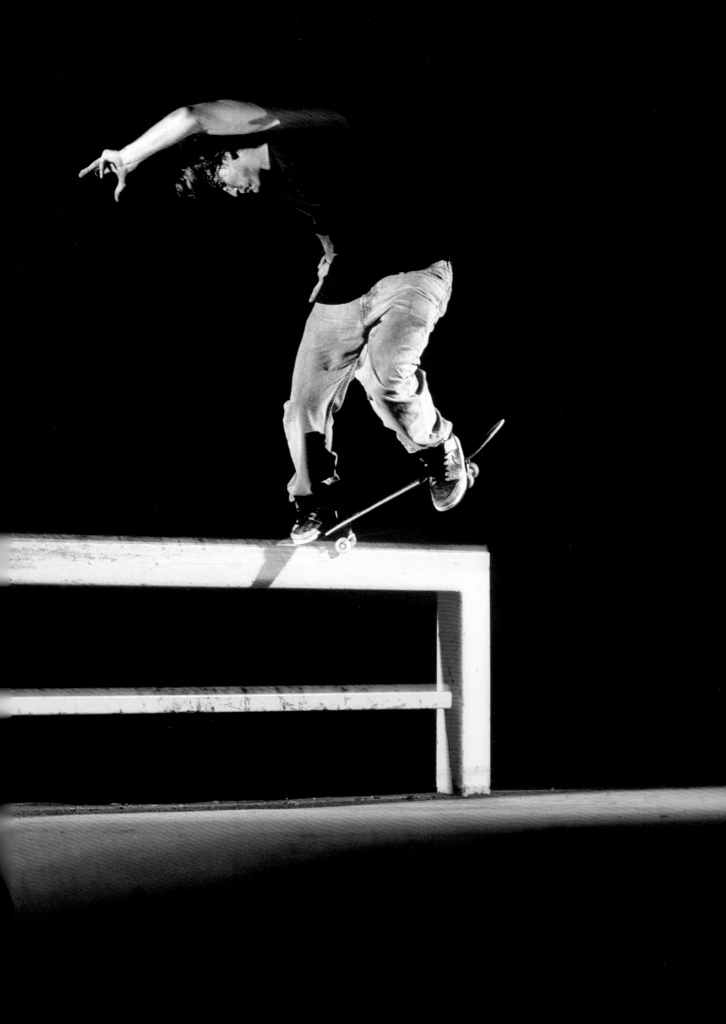

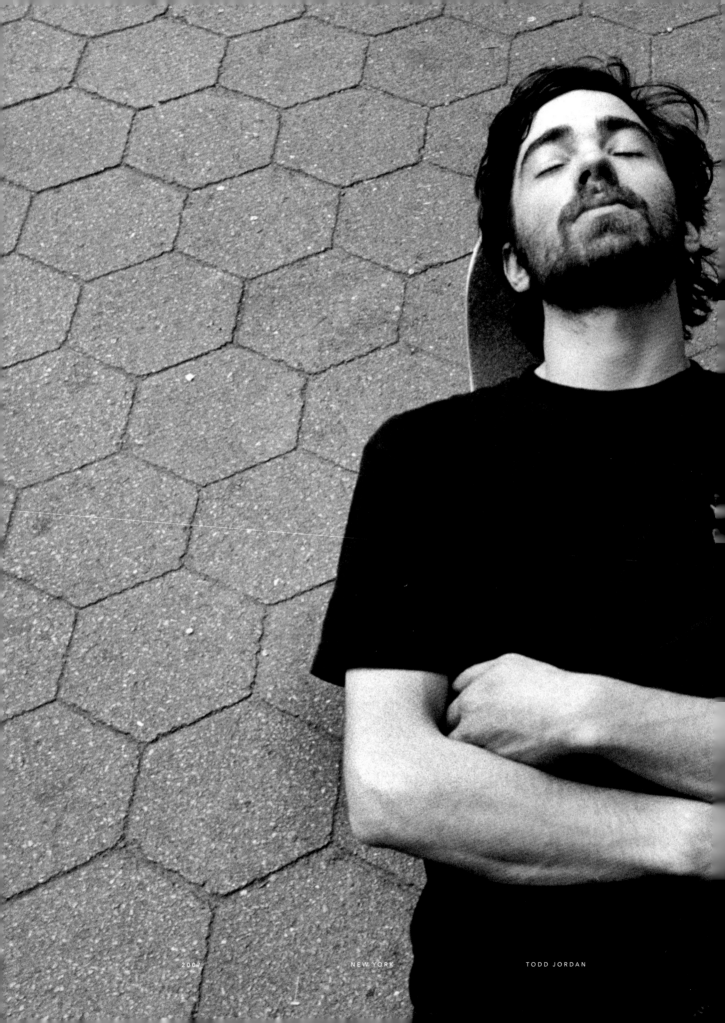

Thank you Peter Moore for the design, Sandy Bodecker for the vision, and to all the countless people who contributed to the SB Dunk's rich history.

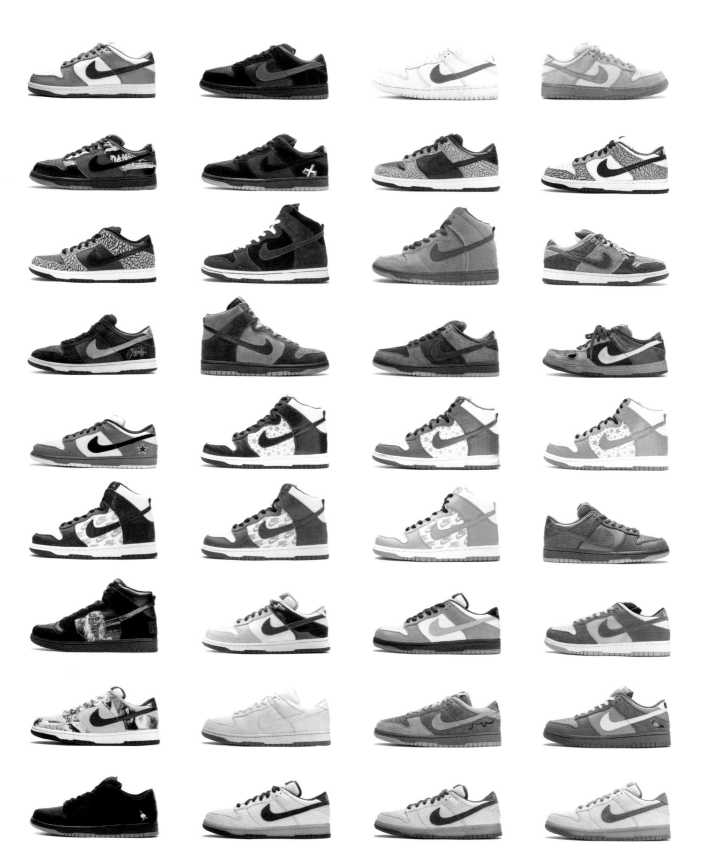

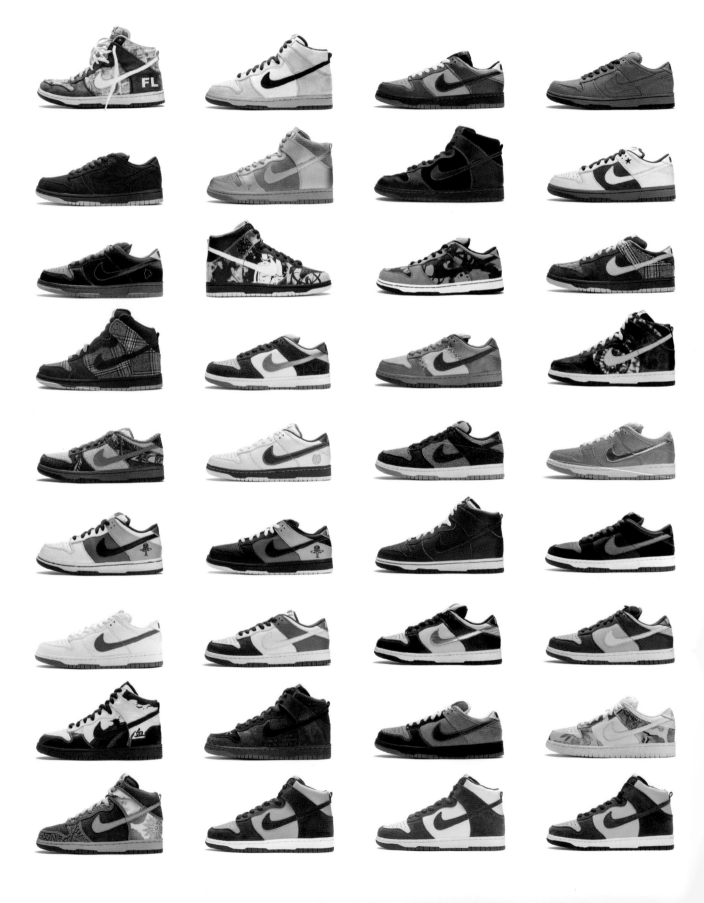

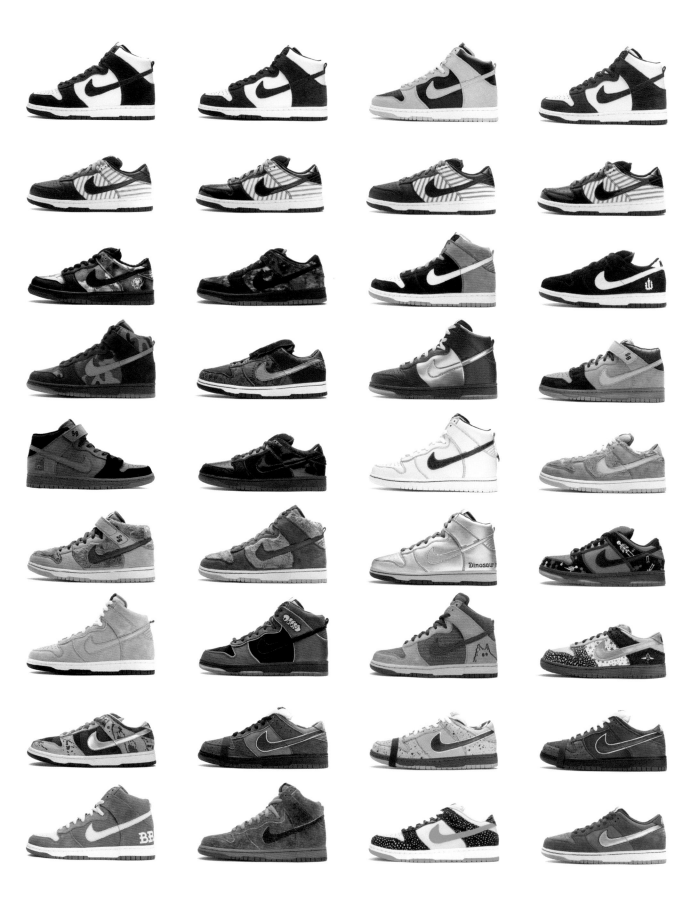

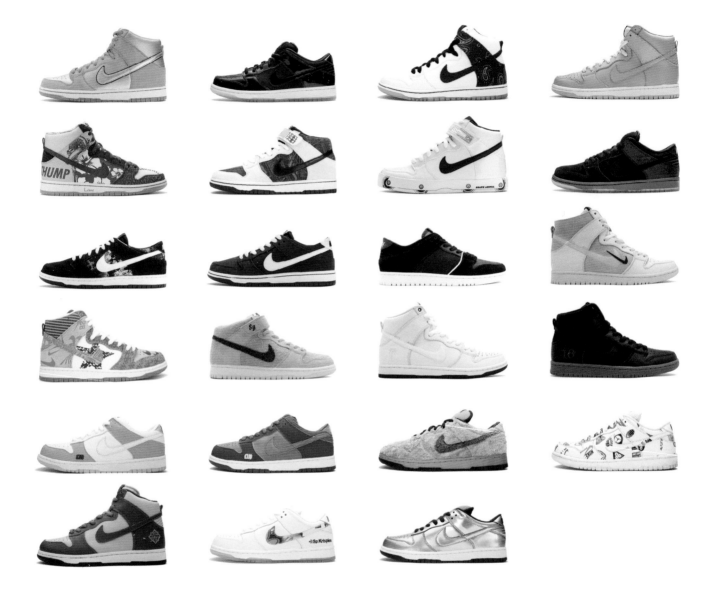